David Lynch
His Work, His World

For David Keith Lynch, who has either found all the answers,
or many, many more questions

And for Lindsey,
who made all my backwards-talking dreams come true

Quarto

First published in 2025 by Frances Lincoln,
an imprint of The Quarto Group.
One Triptych Place, London, SE1 9SH,
United Kingdom
T (0)20 7700 9000
www.Quarto.com

EEA Representation, WTS Tax d.o.o., Žanova ulica 3, 4000 Kranj, Slovenia

A catalogue record for this book is available from the British Library.

ISBN 978-1-83600-596-4
Ebook ISBN 978-1-83600-597-1

10 9 8 7 6 5 4 3 2 1

Design by Clare Noon
Publisher Philip Cooper
Senior Commissioning Editor John Parton
Senior Editor Laura Bulbeck
Senior Designer Isabel Eeles
Senior Production Manager Alex Merrett

Printed in China, TT062025

David Lynch

His Work, His World

Tom Huddleston

F FRANCES
LINCOLN

Introduction 06

Introduction
A Real Character

Without David Lynch, our world will be a much more ordinary place.

As a filmmaker, screenwriter, designer, musician, photographer, visual artist and living avatar of all things uncanny, for more than five decades his influence pervaded every corner of our culture, from the rise of 'prestige' television to the ongoing interplay between arthouse and mainstream movies; from the 'dreampop' of artists like Lana Del Rey and Beach House to off-kilter video games like *Alan Wake* and *Immortality*; from cabaret acts and performance art to TV commercials, online ads, music videos and more amateur short films than any sane person could watch in a lifetime.

The man even had his very own, dictionary-approved[1] adjective, *Lynchian*, a term routinely applied to anything that dips even a single toe into the offbeat or unusual, whether that's perfume ads or art installations; fashion shows or poetry; dreams or nightmares or unlikely events in the real world. His work was so ubiquitous and so distinctive that it was almost possible to forget there was a man behind it, a regular person made up of flesh, bone and electrical impulses – albeit one who was, to quote James Hurley in one of the Lynch-directed episodes of his TV serial *Twin Peaks*, 'a real character'.[2]

The *real* part goes without saying. At the time of his death on 15 January 2025, David Keith Lynch (that middle name was almost comically ordinary) was 78 years old and 1.8m (5ft 11in) tall; he lived and worked at his home on Senalda Road in Hollywood, California, right around the corner from Mulholland Drive. He'd been married and divorced four times and was the father of four children; he was a coffee-drinker, a near-lifelong cigarette smoker, an enthusiastic proponent of the practice of Transcendental Meditation, and a global celebrity. He was as real as you or I.

But David Lynch was also, undoubtedly, a *character*. With his signature quiff, buttoned-up collar and idiosyncratic mode of speech – at once stiltedly old-fashioned, boyishly enthusiastic and suddenly, bracingly poetic – Lynch's public persona was as meticulously constructed as any of the figures who appeared in his films or indeed his paintings. Which isn't to say that Lynch was artificial, or in any way insincere; quite the opposite. Just as a character evolves naturally from an idea in the creator's head to a fully fleshed figure on the screen, so Lynch's persona developed organically over decades, weathered by circumstance and enlightened by experience, responsive to the expectations of his public but still recognizable as the same wide-eyed, peachy-keen young artist who broke onto the midnight movie scene in the late 1970s.

In cinema, Lynch was a singular presence, the last of the rock-star directors: a cliché, perhaps, but one which happens to be true.[3] How many filmmakers have an entire fanbase devoted to them, like a band? How many

(opposite) A regular guy: David Lynch poses
for press shots in California, *c.* 1986

8

Walkies with me: Michael Ontkean, Kyle MacLachlan and friends
in a publicity still for the first series of *Twin Peaks*

writer-directors have their faces on coffee mugs and t-shirts, and release LPs under their own names? Lynch's 1970s peers like George Lucas and Steven Spielberg may have legions of enthusiasts, but these tend to worship the work rather than the creator – there are countless *Star Wars* conventions, but as yet no LucasFest.[4] And while Lynch's fans may come to the director via his films and TV shows, the dedicated ones soon move past that into his music, his art, his photography, a whole world of creativity to which Lynch dedicated every moment of his waking (and, in a sense, his unwaking) existence.

There are those who find Lynch's films unpalatable, dismissing them as wilfully obscure, indulgent or just plain nasty (many of his fans would agree, they just don't respond to those things negatively). Others view his work as purely cynical; a common criticism levelled at Lynch was that he was detached and manipulative, more interested in mood, style and ironic weirdness than in emotions and people (a 2019 *Vanity Fair* article labelled him 'the winking auteur').[5]

But in fact, the opposite was true. David Lynch's work was not just humane, it was deeply personal, on a level that few other artists are able to attain. When we watch a Lynch film, what we're witnessing are his inspirations, his fantasies, his fears, often in the most literal sense. The traumas in his work were Lynch's traumas, and the joys were his joys. His films may not have been directly autobiographical, but aspects of his personal history crop up in every one of his major works, from broad strokes like the forest-nestled town of Twin Peaks, which recalls Boise, Idaho, where Lynch spent much of his childhood, to specific incidents like Dorothy's appearance from the shadows, naked and bruised, in *Blue Velvet*, which resembles exactly an incident Lynch and his brother John witnessed as children. At the same time, every one of his films was infused with his personal spirituality, his belief in transcendence, and his view of the world in terms of good and evil, light and dark – blending, of course, and shading, but always present and definable.

So how did David Lynch attain such heights of cultural significance? How did a clean-cut Eagle Scout from 1950s middle America come to define the surrealist avant-garde, and how did his inner world become not just his own private property, but something we all got to share in and marvel at? The purpose of this book is to search for some of those answers, to explore not just Lynch's output but also his personal history, and discover how the two informed one another. We'll approach Lynch not as some oddball mystic or lofty eccentric but as a human being – albeit a supremely talented and unconventional one. We won't attempt to psychoanalyse Lynch or – God forbid – to explain his work, but we will comb through his life and his influences for clues that might help us to experience his art a little more fully.

In doing so, we hope to echo one of Lynch's own primary motivations as an artist and storyteller, namely the act of discovery: 'I always say that people are like detectives and our lives are filled with clues. Some people wonder and look around and they take what they see and try to figure out what it all means ... We are all like detectives, trying to figure out the meaning of life.'[6]

Early Life and Short Films
1946-1970

'Euphoric 1950s chrome optimism'

The outward perfection of David Lynch's suburban childhood cannot be overstated. Time and again he would describe his earliest memories in bucolic terms: the freshly whitewashed fences, the welcoming wood-frame houses, the cars, the trees and the sunlight, the kids playing baseball. His parents adored him, his friends admired him, God and the President watched over him and all was bright and beautiful. 'My childhood was elegant homes, tree-lined streets, the milkman, building backyard forts, droning airplanes, blue skies, picket fences, green grass, cherry trees,' he would say, wistfully. 'Middle America as it was supposed to be.'[1]

David Keith Lynch arrived in this best of all possible worlds on 20 January 1946, in the mountainous, mid-sized city of Missoula, Montana, the first of three children born to research scientist Donald Lynch and his wife, homemaker Edwina Lynch nee Sundholm, known to all as Sunny. The descendants of European immigrants and homesteaders, they were caring, thoughtful parents. '(They gave me) tremendous freedom,' Lynch would recall in the 2016 documentary *The Art Life*. 'A foundation of love.'[2]

A twist on reality: Richard White as Lynch's stand-in
The Boy, with Dorothy McGinnis as the eponymous
Grandmother in a surreal short by Lynch

Thanks to Donald's job, the Lynch family were a mobile unit, moving first to Sandpoint, Idaho, where David's brother John was born, then on to Spokane in Washington State, birthplace of their little sister Martha. Following a relatively brief stay in Durham, North Carolina, the majority of David Lynch's childhood would be spent in Boise, Idaho, where Donald had taken a job with the US Department of Agriculture, carrying out arboreal research at the Boise Basin Experimental Forest.

Young David may have loathed school – 'we human beings block out school because it's horrible', he would write. 'I barely remember ever being in a schoolroom'[3] – but he loved to work with his hands, helping his father out with numerous building projects and inventions, and looking forward to family trips to Hamilton, Montana, where Donald's parents owned a farm. He would also accompany his father on long walks in the woods, developing a love and respect for nature, and particularly forests, that would resonate throughout his work.

Indeed, it was in examining trees that Lynch would, in his own recollection, get his first inkling that there might be something going on beneath the apparently perfect surfaces that he saw all around him. 'On the cherry tree there's this pitch oozing out,' he would recall, 'some black, some yellow, and millions of red ants crawling all over it. I learned that if one looks a little closer at this beautiful world, there are *always* red ants underneath.'[4]

Soon, he would discover that the same rule applied to people and places as much as trees. First there was the encounter with the naked, traumatized woman – 'she had skin the colour of milk, and she wasn't walking quite properly ... there might have been some blood on her mouth ... I knew that she was hurt, in trouble'[5] – and another with a boy whose father had just died, a concept that shook Lynch deeply. There were also trips with his mother to her birthplace, New York City, where Lynch would be confronted with an

12

Goodness and decay: The forests of North America
as seen in *Twin Peaks: The Return* (left), and riders
on the New York Subway, 1953 (right)

entirely different America, one that was far noisier, more dangerous, and in many ways more thrilling than the one he was used to. 'In a large city I realized there was a large amount of fear, because so many people were living so close together,' he would recall. 'You could feel it in the air … Going down into the subway, I felt I was really going down into hell … the wind from the trains, the sounds, the smells and the different light and mood – that was really special in a traumatic way.'[6]

These glimpses of hidden pain, of public disarray, of urban abrasiveness, revealed to Lynch that the life he knew wasn't all there was to experience. 'I learned that just beneath the surface there's another world,' he would say. 'And still different worlds as you dig deeper … There is goodness in blue skies and flowers, but another force – a wild pain and decay – also accompanies everything.'[7]

—

Echoes of the 1950s – its unique sights, sounds, tastes, cars and clothing – recur throughout David Lynch's work, and would become the cornerstone of his public persona: the manner in which the director often expressed himself, peppering his speech with words like 'Gee!' and 'Neat!', was firmly rooted in that era. A time of political moderation, emotional restraint and relative economic equality, the music, mood and imagery of America in the late 1950s and early 1960s have become ossified thanks to nostalgic TV shows like *Happy Days* (1974–1984) and movies such as *American Graffiti* (1973), *Back to the Future* (1985)

13

Matinee idols: 'Blue Velvet' hitmaker Bobby Vinton (left),
and Michael J. Fox in *Back to the Future* (right)

14

Kids in America: 1950s-style clothes and cars in Lynch's
Blue Velvet (top), George Lucas's *American Graffiti* (bottom left)
and its TV spin-off *Happy Days* (bottom right)

> 'The fifties are still here. They're all around us.
> They never went away'

and Lynch's own *Blue Velvet* (1986). And while Lynch's film may not actually be set in the 1950s – its hero wears a very 1980s earring, and slow-dances to synthesized drones – the world of the film is pure '50s nostalgia, from Packard automobiles and crinoline gowns to cheery radio jingles and the music of Roy Orbison and Bobby Vinton, whose dreamy, chart-topping 1963 version of the title track was a key inspiration.

For the young Lynch, the music of the 1950s was a revelation – 'rock 'n' roll makes you dream',[8] he wrote in his 2018 autobiography, *Room to Dream* – and again, it would reverberate throughout his career. In *Twin Peaks* (1990–1992), songs like 'Rockin' Back Inside My Heart' and 'Just You' offered an ersatz take on 1950s doo-wop, while *Wild at Heart* (1990) features a hero who dresses in snakeskin, talks in a cod-Elvis mumble and bounds on stage to croon the King's swooning 1956 ballad 'Love Me', incongruously backed by the Minneapolis speed-metal band Powermad. In the twenty-first century, the music Lynch would create himself as a songwriter and vocalist is built on the bones of rock 'n' roll, on repetitive riffs and a pounding backbeat.

But while Lynch may have held a deep nostalgia for the era he grew up in, he wasn't blind to the reality of the time, which beneath its whitewashed veneer masked civil unrest, racial injustice and ecological malfeasance. 'Little did we know we were laying the groundwork for a disastrous future,' he would admit. 'All the problems were there, but it was glossed over. And then

15

Coolest of the cool: Nicolas Cage in *Wild at Heart* (left), and
Elvis Presley in his prime in the 1968 Comeback Special (right)

'I like to think of myself as one of the happy generation'

the gloss broke, or it rotted, and it all came oozing out.'[9] Again we're back to those beautiful cherry trees, and those millions of red ants.

Lynch's observation about the ants also illuminates another key facet of his work: his painstaking attention to detail. Admitting that even as a child he 'saw life in extreme close-up,'[10] Lynch's youthful fixation on the tiniest details, from swarming insects to the specific textures of light in the New York subway, would echo through his art: think of the tiny black hairs that grow inside the severed ear in *Blue Velvet*, or the flaking textures of rusted factories that would appear in so much of his photography. Ever the perfectionist, Lynch may have been one of the few major filmmakers who took the time to craft his own props – not simply from necessity, as with the mutant baby in his DIY debut *Eraserhead* (1977), but also because he knew down to the millimetre precisely what he wanted, and it was easier to make it himself than to explain his vision to someone else.

This obsessive scrupulousness – combined with the can-do spirit he inherited from his father – would be an asset when Lynch joined the ranks of the Boy Scouts, earning his badges and working his way up until he attained the highest rank possible: Eagle Scout. Not only was this an achievement that he would boast of on his resume for the rest of his life, but it also led

16

him to one of the most impactful experiences of his young manhood, when he was invited to act as an usher at the inauguration of John F. Kennedy. And this same attention to detail would also serve Lynch well when, at age 15, he discovered the first real love of his life: painting.

—

It was following yet another family move – this time to the mid-sized city of Alexandria, Virginia – that David Lynch's gift for art would reveal itself. He'd always had a compulsion to draw: 'even when I was little I would draw guns and knives and airplanes, bombers, fighter planes, these flying tigers, and Browning automatic water-cooled submachine guns'.[11] Now, at age 15, he stumbled across a truth that had been hidden from him: art didn't have to be just a hobby. The bestower of this secret knowledge would be Lynch's new friend Toby Keeler, an Alexandria resident whose father, he told Lynch, was a painter. 'I thought maybe he might have been a house painter,' Lynch would recall, 'but further talking got me around to the fact that he was a fine artist. This conversation changed my life.'[12]

His name may not be widely known today – almost the only mention of him online, except in the context of his relationship with Lynch, is a 2012 obituary in *The Washington Post* – but Bushnell Keeler was a true and dedicated artist, a man who returned from the Pacific theatre in the Second World War determined to commit himself to creative pursuits, working as a teacher and picture framer to fund his artistic ambitions. For Lynch, his influence would prove crucial: Keeler did all he could to encourage the young artist, offering Lynch space in his studio (along with an endless supply of 'peanut butter jelly sandwiches ... three deckers'),[13] and pressing upon him a gift that would electrify the young Lynch: a copy of the American-born, French-educated painter and teacher Robert Henri's 1923 book, *The Art Spirit*.

A collection of ideas and observations regarding the creation and understanding of art, Henri's book would be a bombshell for Lynch. 'It sort of became my Bible. It helped me decide my course.'[14] That course was something he would come to call *the art life,* an entire existence spent at the task of making art, to the exclusion of almost everything else: 'you drink coffee, you smoke cigarettes and you paint'.[15] It was a dream Lynch would carry with him for the rest of his life, symbolizing for him the ultimate goal of existence: the chance to dedicate every waking moment to the act of creation, to paint and daydream, to have ideas and put them into practice.

But Bushnell Keeler's influence was practical as well as aesthetic. When Donald Lynch became frustrated with his son's nocturnal painting expeditions, even threatening to throw David out of the house if he didn't start returning

17

Artist and author Robert Henri, whose book *The Art Spirit*
opened up Lynch's imagination

18

The missing artist: An expressionist *Self-Portrait* (1917)
by Oskar Kokoschka, whom Lynch failed to track down
in Salzburg, Austria

from the studio at a responsible hour, it was Keeler who intervened, explaining to Lynch's father how remarkable it was that a teenage boy would spend so much of his time working on *anything*, let alone making art. And once high school was over, Keeler would be instrumental in pushing Lynch towards art college, initially at the School of the Museum of Fine Arts in Boston, which he hated, and abandoned after a year. 'I was not inspired at all in that place,' he would say. 'In fact it was tearing me down.'[16]

Instead, Lynch decided to take his first shot at attaining the art life, searching for it in the most obvious place he could think of: Europe. And he wouldn't be going alone – with him would be someone Lynch would always describe as 'my best friend':[17] Jack Fisk. The pair had been introduced in high school: 'I met Jack when we were in the ninth grade ... We became great friends because out of 4,000 people in our high school we were two of the few who wanted to become painters.'[18] The fact that Lynch was hot for Fisk's sister Mary can't have hurt: 'she was a fox and ... we dated a little bit and I made out with her and I think Jack got really upset'.[19] How Fisk felt when Lynch later married her remains undocumented.

Saving up a couple of hundred dollars and scoring free flights via Bushnell Keeler's travel-agent brother, Lynch and Fisk set off for Salzburg in Austria, carrying a letter of introduction to the world-renowned expressionist painter Oscar Kokoschka, who taught classes at the Academy of Fine Arts. But on arrival, they discovered that not only was Kokoschka absent, but that Salzburg was not the sort of city Lynch felt able to be creative in: 'Salzburg was about the cleanest city I'd ever seen in my life,' he would complain later, 'and as a consequence I got no inspiration.'[20] Intending to be away from home for three years, the pair lasted all of 15 days, abandoning Salzburg for Venice, Athens and Paris, where Lynch frittered away all their money on home comforts like Coke and Marlboros.

It wouldn't be the last European sojourn for this most American of artists, but it would be the most disappointing, and for some time afterward Lynch felt a deep sense of failure. He took up lodgings in the Keeler family home (his own family having moved to California), worked odd jobs from which he was regularly fired, and exchanged frequent letters with Fisk, who had shaken off his own disillusionment and headed off to study at the Pennsylvania Academy of the Fine Arts in Philadelphia, and was trying to persuade Lynch to join him. Again, it was Bushnell Keeler who came to Lynch's rescue, putting in a phone call to the Academy and convincing them to give the young artist a shot. As a result, in November of 1965, David Lynch would leave Alexandria for the final time, moving into a shared apartment with Jack Fisk and getting his first taste of the city that would forever haunt his work, and his nightmares.

In the mid-1960s, Philadelphia, PA was a ruined city, rife with economic hardship and racial inequality, riddled with crime and largely abandoned by its more affluent residents. It was also cheap, challenging and, for Lynch, vividly

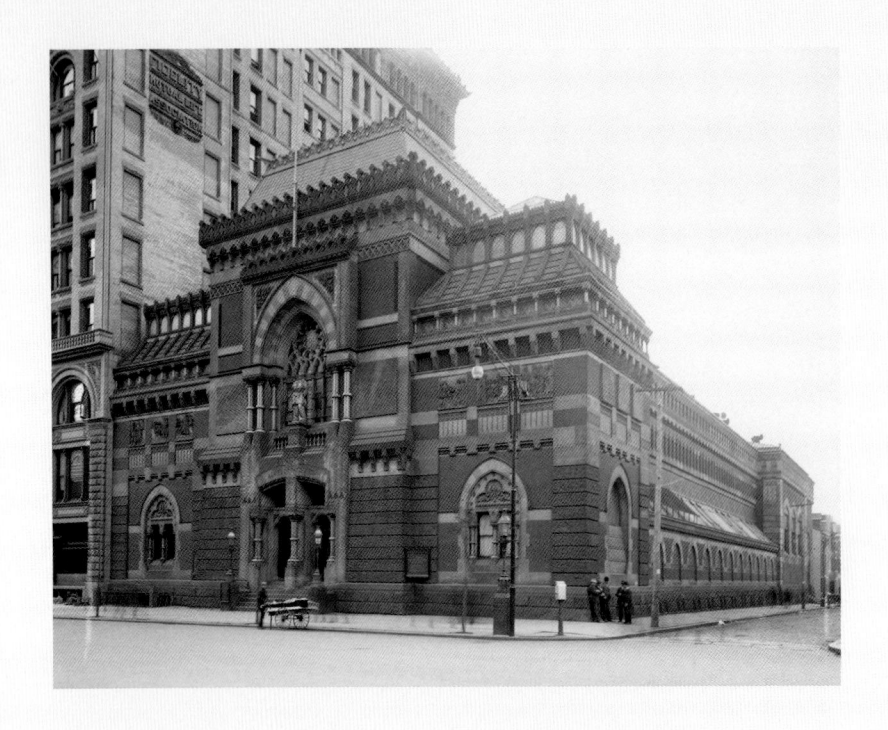

'Even though I lived in fear, it was thrilling
to live the art life in Philadelphia'

20

Factory town: The Pennsylvania Academy of Fine Arts,
photographed in 1900 (top), and the industrial outskirts
and city skyline of Philadelphia in 1968 (bottom)

inspiring – if his brief trips to New York had sparked his childhood imagination, here was his chance to be completely immersed in those 'other worlds' he had only glimpsed before. 'Philadelphia is my greatest influence,'[21] he would say, many times. 'It was a fear-ridden place, there was fear so thick in the air that it was unbelievable.'[22] It didn't help – or hurt – that he wasn't able to afford to live anywhere particularly salubrious: 'I lived in quite bad areas of town, so I would see things ... I saw a woman in a backyard squawking like a chicken, crawling on her hands and knees in tall, dry grass. I saw many strange things.'[23]

He was also, at the Academy, completely surrounded by like-minded souls: art students who took their work seriously, unlike the dilettantes he'd encountered in Boston. Around the campus, Lynch cut a dashing if idiosyncratic figure. 'He used to wear two or three ties,' Jack Fisk would recall. 'And ... a straw hat.'[24] Regarding these multiple neckties – and his ongoing propensity for keeping the collar of his shirt firmly buttoned – Lynch would offer a perfectly logical explanation: 'I felt too vulnerable with the top button opened. A wind on the collarbone was something that really disturbed me. And I like the tightness around the neck.'[25]

Soon, the darkness he felt in Philadelphia would begin to infuse his paintings: throwing himself into his work, Lynch would take inspiration from everything around him, from burned-out storefronts and abandoned homes to factories and industrial spaces: 'smoke and fire, all the noise, the machinery, the steel, the houses ... it just was thrilling to me'.[26] He would also be drawn to the morgue across the street, eventually persuading the nightwatchman to let him explore the place after hours. 'I spent a long time in there and I thought about each one of them (the bodies) and what they must've experienced. I wasn't disturbed. I was just interested.'[27]

He would soon begin to explore new ways of making art, collecting dead insects and other creatures that he allowed to decay - to the horror of his visiting father - and crafting mixed-media sculptures such as an award-winning contraption incorporating a lightbulb and a firecracker. And he would also study the work of other artists, including one in particular who he would go on to call 'my all-time favourite' who had a 'huge influence on me':[28] the Irish figurative painter and raw surrealist genius, Francis Bacon.

A charismatic, gregarious character whose work reflected a much bleaker, more troubling inner world, Bacon often created his art in series, focusing on a particular subject for a long period of time: among his best-known works are paintings of popes and crucifixions, of animals, often dogs, and of people, usually his friends or himself. Lynch's artworks would also tend to fall into groups, like his 'dark' paintings of the late 1980s and early 1990s, his 'Bob' series, in which the titular malformed figure wanders through a series of unearthly landscapes, and his 'Distorted Nudes' photographic series.

'He (Bacon) had the stuff,' Lynch would say later. 'The subject matter and the style were united, married, perfect. And the space, you know, the slow and the fast, the textures, everything ... I can always take off from his paintings, like

21

I can with a piece of music.'[29] In late 1968, Lynch would even get the chance to see the master's work in person, as part of a major Bacon exhibition at the Marlborough-Gerson Gallery in New York, describing it later as 'one of the most powerful things I ever saw in my life'.[30] Even the way the paintings were presented would thrill him. 'They were all framed, wide gold frames with glass … I've always wanted to show things that way (but) it costs a fortune!'[31]

—

'Please remember, you are dealing with the human form'

By then, however, Lynch's work would be – quite literally – moving in different directions. The legend of how David Lynch came to experiment with film as an artform has been told many times, but the essentials remain unchanged: in early 1967, he was working on a painting of a figure in a garden when 'all of a sudden, these plants started to move, and I heard a wind … I thought, *I'm going to do a moving painting*.'[32] The idea implanted itself, and before the year was out Lynch had designed and photographed his very first film.

But *Six Men Getting Sick* (1967) is not a movie, or even a short film, in the traditional sense. As much sculpture as film, this animated experiment features six abstract figures whose stomachs fill with red fluid until they vomit. Designed to be projected onto a resin 'screen' featuring casts of Lynch's own head made by Fisk, the film was shot on a rented 16mm camera. 'A little Bell and Howell camera that you put a magazine in, and it had single-frame capabilities … So I made this first film with that camera … taped to a dresser then nailed to the floor.'[33]

Approximately one minute in length, the film was designed to run on a loop – 'I built a kind of erector set above the projector so that the film could … play over and over'[34] – accompanied by the sound of a wailing siren. Presented as part of a painting and sculpture contest, *Six Men Getting Sick* would go on to share first prize. But what's especially notable about the film isn't its experimental nature, or its hand-to-mouth creation. What's fascinating is that here, right out of the gate, is so much of what we've come to understand as 'Lynchian': not just the fascination with blood and physical trauma but the sense of unease, the remorseless use of intrusive sound and the sense of repetition, endless and inescapable. Even at this early stage, Lynch was producing work that could be mistaken for that of no other artist.

This rings even truer for his second, far more sophisticated film, 1968's four-minute *The Alphabet*. To a large extent the result of happy accident, the film came about after Lynch was approached by a well-to-do fellow student with the striking name of H. Barton Wasserman, who wanted another sculpture-film in the style of *Six Men*. After weeks of work, however, Lynch discovered that the camera he'd bought was broken and all the footage was ruined. Generously

23

Screams of the damned: Francis Bacon's
Study after Velazquez's Portrait of Pope Innocent X (1953, top)
is echoed in a still from Lynch's *INLAND EMPIRE* (bottom)

24

'Now I've said my ABC ...': Lynch's wife-to-be Peggy Reavey
plays a troubled girl in three stills from the director's
second short, *The Alphabet*

allowing Lynch to keep the remainder of the budget and put it towards a new project, Wasserman would be rewarded with a producer credit.

This time blending live-action with animation – a technique Lynch would later describe as his 'bridge between painting and movies'[35] – *The Alphabet* is accompanied for the first time by a synchronized soundtrack consisting of shrieks, wails and eerie singing, as the screen fills with organic forms, sexual imagery, animated letters and blood. A surrealist vision exploring his hatred of rote learning, in which a girl confined to bed is beset by visions of animated letters until she vomits blood all over the sheets, *The Alphabet* is an early example of Lynch using his art to explore his own personal fears. 'A small world like a painting or a film gives you the illusion that you're more or less ... in control,'[36] he has said, and indeed much of his work, particularly in these early days, would be fuelled by his own deep-seated worries and anxieties.

Another notable aspect of *The Alphabet* is the central figure of the girl, or at least the grown woman who plays her. Lynch and Peggy Reavey had hooked up soon after his arrival in Philadelphia, but their relationship remained largely casual until, in August 1967, Reavey discovered that she was pregnant. Lynch would never speak publicly of his feelings when he learned this fact – perhaps his debut feature *Eraserhead* says more than words ever could – but nonetheless he did the decent thing, and before the end of 1967 the couple were married (Jack Fisk, naturally, was Lynch's best man). 'Peggy was the first person I fell in love with,' Lynch would write in his autobiography. 'But I don't know that we would've gotten married if she hadn't been pregnant, because marriage doesn't fit into the art life. You'd never know I think that, though, because I've been married four times.'[37]

Using money donated by both sets of parents, the Lynches purchased a house in a rundown Philadelphia neighbourhood, the kind of place that would be regularly broken into, sometimes while the couple were at home. Jennifer Chambers Lynch was born on 7 April 1968, by which time her father had left the Academy of Fine Arts and was once again working odd jobs, including a fairly successful run as a print-maker. For the final time it was Bushnell Keeler who stepped in and got things moving, urging Lynch to submit *The Alphabet* to the American Film Institute (AFI) in Los Angeles, along with an application for a grant to make another film. To his eternal surprise, he was successful.

—

If *Six Men ...* and *The Alphabet* had offered glimpses into the murky depths of David Lynch's subconscious, his next film, *The Grandmother* (1970), would be the first full immersion. Funded by the American Film Institute, shot almost entirely within Lynch's marital home and running 34 minutes in length, the film tells the mesmerizing story of a boy born into a cruel, domineering family, who grows a loving grandmother from a seed he finds in his attic. Again, many of the ideas and imagery that audiences would come to associate with Lynch

are present, from overarching themes like emotional violence, family trauma and sentimental yearning to specific visual moments: the bloated organic forms of the Grandmother's 'seed-pod' would recur in everything from *The Elephant Man* (1980) and *Dune* (1984) to the insects in *Twin Peaks: The Return* (2017), while the pitch-dark interiors of the boy's house clearly prefigure the use of shadows in *Lost Highway* (1997).

The Grandmother is another deeply personal piece of work. With his crisp haircut, suit and bow-tie, the boy is clearly a stand-in for the director, and while his traumatic upbringing may stand in stark contrast to Lynch's own, it's easy to see how the idea of such an oppressive existence might have captured the director's imagination. Lynch would later speak in interviews about how, as a child, he would yearn for his parents to have an argument, or for some kind of disaster to occur, just to find out what that would be like. 'I longed for some sort of … not a catastrophe, but something out of the ordinary to happen. Something so that everyone will feel sorry for you, and you'll be like a victim … I was sort of embarrassed that my parents were so normal.'[38]

The Grandmother would also be the final time Lynch would combine live action with animation, at least in such a striking and organic fashion – from now on, his visual art and his films would be kept largely separate, though each would of course inform the other. Post-production on the film would also lead Lynch to the next of his great friends and collaborators: Alan Splet. Registered as legally blind, Splet was a self-taught genius with sound who like Lynch was doggedly dedicated to his craft. According to Lynch, the pair would spend 'sixty-three days, nine hours a day'[39] building a soundscape for *The Grandmother*, and upon seeing (and hearing) the film the AFI would be so impressed that they would hire Splet on the spot, moving him out to LA to head their new sound department.

Happily, he wouldn't be travelling alone. With *The Grandmother* as his calling card and with the encouragement of AFI director Toni Vellani, Lynch had applied for a full scholarship to study at the Center for Advanced Film Studies in Los Angeles. To his astonishment, he was accepted, joining an august group of AFI attendees whose ranks included *Badlands* (1973) director Terrence Malick and *Taxi Driver* (1976) screenwriter Paul Schrader alongside future Lynch collaborators such as Caleb Deschanel and Tim Hunter.

Like many of these fellow students, Lynch already had an idea of the film he wanted to make, spending his first year working on a script and visual concepts for a project entitled *Gardenback*. A surreal horror film about adultery featuring a man plagued by a Kafkaesque giant insect, the idea was pitched to a number of small movie studios. But in the end they rejected it, as did the AFI. *Gardenback* wouldn't be the last Lynch project to fail at the first hurdle – but from its composted remains, new shoots would soon begin to grow.

'Everybody has a subconscious and they put
a lid on it. There's things in there'

27

Virginia Maitland and Robert Chadwick are monstrous
parents in *The Grandmother* (top); and the man who
crafted the film's sonic world, Alan Splet (bottom)

Eraserhead
1971-1977

Chapter Two
'In heaven, everything is fine'

The creation myth behind David Lynch's debut feature is a tale of artistic ambition and dogged, blind persistence as grand as that of any Gothic cathedral or Renaissance fresco. Painstakingly fashioned over five long years by a dedicated band of artisans working hand-to-mouth for little or no pay, the production of *Eraserhead* would become a kind of Beckettian boot camp, a relentless, interminable chipping away in the diamond mine of Lynch's imagination. This was independent filmmaking in the purest sense, a full-length film made entirely without interference or oversight, with no corporate sponsors or company men, just one single-minded artist and a small team of followers. But their efforts would cause a small earthquake in the cultural landscape, and its ripples would alter cinema forever.

29

The ultimate film school (l-r): Doreen Small,
Charlotte Stewart, David Lynch, Catherine Coulson
and Herb Cardwell on the AFI set of *Eraserhead*

As unusual as the film's creation was, however, and as abstract as it may be in its imagery, its sonic landscape and many of its details, the central narrative of *Eraserhead* is, in fact, fairly straightforward. In a hissing, thumping industrial netherworld inspired by the city Lynch and his family had recently escaped from, a young factory worker named Henry Spencer attends a meet-the-parents dinner at his on–off girlfriend Mary's home, only to discover that since he last saw her she's given birth to something that might or might not be a baby. Returning to Henry's one-room apartment with the creature, the new parents find themselves unable to cope with its constant wailing and need for attention. Mary flees back to her parents, leaving Henry to take solace in the arms of a beautiful woman who lives across the hall. Following a nightmare of his own erasure, Henry ultimately destroys the monstrous child and ascends into a dream of heavenly light, accompanied by an affectionate puffy-cheeked girl who lives inside his radiator.

Like *The Grandmother*, then, *Eraserhead* would seem to be another case of Lynch confronting his fears head on, taking the events surrounding

the birth of his daughter and imagining the very worst case scenario if the circumstances had been different. What if Peggy's family had been aggressive, unpredictable lunatics, rather than supportive middle-class suburbanites? What if Jennifer had been born a mewling monster, rather than a sweet little baby with a slight club foot? What if Peggy had snapped and abandoned Lynch with the child, and what if he'd succumbed to temptation and taken another lover? What if he'd found himself unable to cope, lost his mind and done the very worst thing a person can do?

Again, the central figure in the film is a stand-in for Lynch: not only does Henry echo the director's stiff mode of dress and awkward manner of speech, he even works as a print-maker for someone named LaPelle, just as Lynch did following the birth of his daughter. He's also, perhaps, Lynch's first detective figure, sharing his creator's keen attention to detail: 'Henry is very sure that something is happening, but he doesn't understand it at all,' Lynch would tell interviewer Chris Rodley. 'He watches things very, very carefully, because he's trying to figure them out.'[1]

But while Lynch's depiction of parenting as a relentless, bewildering nightmare may seem excessive to some viewers, anyone who has actually been through the birth of a child will find the film eerily, even painfully familiar, capturing in traumatic detail the almost dreamlike anxiety and hyper-awareness of early parenthood. For Lynch, suddenly landed with an unexpected and time-consuming responsibility just as his vision of the art life seemed to be approaching reality, this sudden shift must've been jarring to the core.

How to get a head: Thomas Coulson as The Boy in *Eraserhead*

Which is not to imply that Jennifer's arrival was entirely unwelcome. 'Sometimes a jolt of electricity at a certain point in your life is helpful,' Lynch would say later. 'It forces you a little bit more awake ... I had these new responsibilities; I think it really helped – it overlapped into the work ... I might have been drifting around for a lot longer had these things not happened.'[2] And besides: 'Once you have a child, the second you see them, you're cooked. You fall in love with them and it's a different world. And there's not much you can do about it.'[3]

—

Eraserhead began in 1971 with a 21-page script, submitted to the American Film Institute following the collapse of the *Gardenback* project. Disillusioned with his studies and on the verge of dropping out, Lynch was persuaded to stay with the offer of time, money and equipment to produce his film, along with space on campus to construct sets. Expecting something around 20 minutes long, the Institute would ultimately be rewarded with an entire full-length feature – but it would take time, effort and a whole lot of setbacks to get there.

Taking over the stables at the back of the AFI's main conservatory, Lynch began to build Henry's world piece by piece, treating the place as his very own movie studio and eventually moving into the stables when he could no longer afford his rent. By this point Jack Fisk had begun making his own successful inroads into the film industry, working as art director on AFI alumnus Terrence Malick's celebrated debut *Badlands*, whose star, Sissy Spacek, would later become Fisk's wife. Fisk would still be a part of *Eraserhead*, playing the pivotal role of the Man in the Planet, but Lynch would be forced to take on production design duties himself, sketching out the sets and even hand-building them.

31

The Warner Bros. Building on the
AFI Campus, photographed in 2011

Several AFI alumni and staff members would, however, come to his aid, notably Alan Splet, whose sound design would define the mood of the film, and a pair of cinematographers: Herb Cardwell, who would leave midway through production, and Frederick Elmes, who would go on to shoot *Blue Velvet* and *Wild at Heart* for Lynch. (He also formed longstanding relationships with directors including John Cassavetes, Ang Lee and Jim Jarmusch.)

But equally central to the creation of *Eraserhead* were two women, both in seemingly minor roles but whose determination and support – emotional, financial and technical – would give Lynch the space he needed to complete the film. Credited as Production Manager, Doreen Small would end up doing everything from casting to sourcing costumes and props, including finding a litter of puppies and scouring hospitals for real umbilical cords. Whether she also helped to craft the film's key prop remains unclear, because to the end of his days, Lynch refused to explain how he – or even *if* he – went about building the shockingly lifelike mutant baby.

Affectionately nicknamed Spike by lead actor Jack Nance, the baby would be the source of much discussion over the years, with materials including rabbit livers and lamb foetuses posited as possible elements in its construction. But Lynch and his fellow crew members always refused to comment; legend states that the director went so far as to blindfold the projectionist who screened the unedited rushes, so he couldn't see how it was done. 'The world in the film is a created one,' Lynch would write later. 'And if people find out certain things about how something was done … these things enter into their experience. I think it's so precious and important to maintain that world and not say certain things that could break the experience.'[4]

Credited as Director's Assistant, Catherine Coulson's remit would also prove wildly diverse, from make-up and camera assistance to making dinner for the cast and crew. Coulson would go on to have a close, lifelong friendship with Lynch, appearing as the iconic Log Lady in *Twin Peaks*; her scenes for

'My best friend': Jack Fisk with wife Sissy Spacek on the set of 1981's *Raggedy Man* (left) and as The Man in the Planet in *Eraserhead* (right)

Hair piece: Jack Nance's distinctive 'do,
as featured on a promotional poster for
a re-release of *Eraserhead*

the show's belated reboot were filmed just days before her death in 2015. But her first acting role would be in a memorable short film that Lynch directed during the shooting of *Eraserhead*. Co-starring Lynch as an anonymous doctor, *The Amputee* (1974) came about when Frederick Elmes was asked to test a pair of new video cameras for the AFI, and rather than just going out and shooting anonymous street scenes, Lynch asked if he could script something. Elmes agreed, so Lynch 'wrote this thing and we stayed up all night, me and Catherine, and made *The Amputee* the next afternoon'.[5] Almost Pythonesque in its use of spurting blood and fluids, the film might be Lynch's first attempt at comedy, as a woman with amputated limbs blithely composes a letter to a friend while Lynch's scalpel-wielding doctor amateurishly trims her stumps.

Meanwhile, in her role as hair stylist, Coulson would unintentionally provide *Eraserhead* with its most indelible image. Having cast Coulson's husband Jack Nance in the lead role of Henry, Lynch was keen to give the actor a unique look, something unforgettable. It was Coulson who teased Nance's hair into that towering bouffant, inadvertently providing stylistic inspiration for awkward loners worldwide.

Nance's casting would, of course, lead to yet another close collaboration, one that would only end with the actor's death under mysterious circumstances in 1996, following an altercation outside a donut shop. In the intervening years Nance would appear in every single Lynch production except *The Elephant Man*, essentially playing variations on the role of Henry: from carrot-topped sidekick Nefud in *Dune* to fusty, adorable Pete Martell in *Twin Peaks*, Nance would be a quiet, perplexed and strangely ordinary presence – a stand-in, perhaps, for the audience.

34

The trials of fatherhood: the mutant baby nicknamed
'Spike' (above); and his long-suffering Dad,
Henry (opposite) in *Eraserhead*

Jack Nance, Catherine Coulson, Alan Splet, Jack Fisk, Frederick Elmes – here, on his very first major project, are names that would be associated with Lynch throughout his career. 'I've been very lucky,' he would write later, with typical understatement. 'Along the way, there are people who help us. I've had plenty of those people in my life who've helped me go on to the next step.' Many more would join them – composer Angelo Badalamenti, casting agent Johanna Ray, designer Patricia Norris, actors Laura Dern, Sheryl Lee and Kyle MacLachlan – but it's testament to Lynch's loyalty, and his unerring talent for finding the right people, that so many of his creative relationships were forged so early, and endured for so long.

—

'The word "harmony" would make me want to puke'

Originally envisioned to take a few months, principal photography on *Eraserhead* ground to a halt after twelve. 'We shot for a year straight,' Lynch would recall, 'then we ran out of money.'[6] This was the most challenging time of all: Lynch's support network was crumbling, the cast and crew were starting to look for other jobs, and while his brother John may initially have been a positive presence, turning up regularly to build sets and source props, eventually he joined forces with their father to try and persuade David to set the film aside. 'It almost broke my heart,' Lynch would write, 'because they said I should ... forget *Eraserhead*. I had a little girl, and I should be responsible and get a job.'[7]

36

Breeding nightmares: David Lynch with Jack Nance
on the set of *Eraserhead* (opposite) and the monstrous
child they made together (above)

Lynch responded in typical fashion: he took the least time-consuming employment he could find, delivering the *Wall Street Journal* for $50 a week and ploughing every spare penny back into the film. Accepting freelance gigs as a house-builder, decorator and plumber ('it's a very satisfying thing to direct water successfully'),[8] he was able to save even more money by eating leftovers from Catherine Coulson's job as a waitress, and after the breakdown of his marriage by living rent-free in the AFI stables, a move that also gave him the opportunity to immerse himself in Henry's world. 'When you go slow and you're living in the set and in that world, it just becomes part of you, it's a beautiful experience and more ideas come out of that.'[9]

But the sets weren't his only source of inspiration. It was during the first hiatus in shooting that Lynch made a discovery which would quite literally transform his world, on every conceivable level. It was his sister Martha who, in the summer of 1973, first took Lynch to LA's Spiritual Regeneration Movement Center to learn the practice of Transcendental Meditation (TM). While he was initially sceptical – 'I had zero interest in it. I wasn't even curious. It sounded like a waste of time'[10] – Lynch would soon come around, and before long he was meditating twice a day, a practice he kept up without fail for the rest of his life.

A secular form of contemplation developed in the 1950s by the Indian mystic Maharishi Mahesh Yogi, Transcendental Meditation would become familiar to Western audiences through its association with The Beatles, a band Lynch had loved since he attended their very first American concert at the Washington Coliseum in 1964 (60 years later he would appear in the documentary *Beatles '64* to recall 'girls shuddering, crying, screaming their hearts out. It was phenomenal!').[11] Centred around the silent, internal repetition of a unique sound or *mantra*, by the time of Lynch's involvement TM had many thousands of practitioners worldwide, and its influence has only grown in the years since.

For many years, Lynch would be reluctant to discuss this aspect of his life: 'I don't really talk about meditation,' he said in 1990. 'A lot of people are against it. It's just something I like.' The fear, perhaps, was that his words would be mocked, taken out of context, and used as further proof of his quirky eccentricity. But around the turn of the century he decided to go public, since when it's been extremely rare to read an interview with Lynch that doesn't include an enthusiastic plug for TM and its life-enhancing properties. 'When you transcend, negativity recedes, tension and anxiety get less and less,' he told me in 2011. 'If I wasn't meditating, some of the things I've gone through

The giggling guru: The Beatles, their partners and entourage
with the Maharishi Mahesh Yogi in Rishikesh, India, 1968

in this business could've killed me. I'm not kidding. A lot of artists think they want anger. But a real, strong, bitter anger occupies the mind, leaving no room for creativity. Negativity is the enemy of creativity.'[12]

Indeed, the effects of TM on Lynch's work and his personal life cannot be overstated. By 1973, Lynch's marriage to Peggy was coming apart under the stress of shooting *Eraserhead*, and a burgeoning if ultimately short-lived romance with Doreen Small didn't help matters. Transcendental Meditation couldn't save his marriage, but it would make Lynch's separation from Peggy more amicable. 'I would make life miserable for Peggy,' he admitted in *Room to Dream*. 'I was not happy in those days and I took it out on her … When I started meditating, the anger went away.'[13]

Almost immediately, TM would begin to influence his work, too. In its original conception, *Eraserhead* was unremittingly bleak right up to the end, lacking one vital character: the compassionate Lady in the Radiator, whose childlike, Lynch-penned rhyme 'In Heaven' lulls Henry in his darkest moments. Under the influence of TM, the director would craft what he called 'a very happy ending',[14] as the Lady's arms enfold Henry and the screen fades to a celestial white. Not for nothing would he go on to describe *Eraserhead* as 'my most spiritual movie'.[15]

And this idea of blissful transcendence – of physical death and spiritual rebirth – would echo throughout Lynch's filmography, from the sublime final moments of both *The Elephant Man* and *Twin Peaks: Fire Walk With Me* (1992) to memorable scenes like Sandy's speech in *Blue Velvet* ('all of a sudden, thousands of robins were set free, and they flew down and brought this blinding light of love').[16] Indeed, if the central theme of Lynch's work is the struggle between darkness and light, then the most powerful form of light is the bliss achieved through meditation.

Saving grace: Laurel Near as The Lady in the Radiator (left);
and with Jack Nance on the set of *Eraserhead* (right)

Utilizing money put aside from his newspaper job alongside funds donated by, among others, Fisk and Spacek, photography on *Eraserhead* was finally completed in 1976 – but even then, Lynch's problems weren't over. First there was the sound mix to attend to, an epic process that saw Lynch and Splet create literally hundreds of unique sound effects and layer them into the film, reel upon reel. 'At some points we maybe had fifteen sounds going at one time ... Every single thing was added in, and none of it was real, at all.'[17] All their hard work was worth it: *Eraserhead*'s soundscape is as vital to the film's spectral mood as the visuals, and following a vinyl release in 1982 the soundtrack would be hailed as a classic of abstract noise.

Finally, in 1977, following a muted festival debut and an extended editing process which included the removal of almost 30 minutes of footage, *Eraserhead* was unleashed on the world via Libra Films, an independent outfit run by producer Ben Barenholz, who had worked to make John Waters' similarly DIY *Pink Flamingoes* (1972) a huge word-of-mouth success on the midnight movie circuit. The same would happen for *Eraserhead*: while initial reviews were scathing – *Variety*'s writeup ran beneath the almost wilfully wrongheaded headline 'Dismal American Film Institute Exercise in Gore; Commercial Prospects Nil'[18] – the film would ultimately find its audience: freaks, late-night thrillseekers and fellow creatives.

Eventually, *Eraserhead* would even filter through to something approaching the mainstream, selling thousands of copies on VHS and DVD and being reissued into cinemas multiple times. In 2004, the film was deemed 'culturally, historically, or aesthetically significant' enough to be preserved in the US National Film Registry, while in 2010 it was named the second-best debut of all time by the Online Film Critics Society, behind *Citizen Kane*. If, as has been suggested, The Beatles' abstract soundscape *Revolution 9* is the most widely distributed piece of avant-garde art in existence, then *Eraserhead* can't be too far behind.

But even in the early days, the film received some major endorsements. To Lynch's astonishment, his filmmaking hero Stanley Kubrick named it among his favourite films ('right then, I could have passed away peaceful and happy')[19] and allegedly drew on its sense of dread and unease while creating *The Shining*, while in a 1980 interview, future Lynch collaborator David Bowie claimed that among his great hopes for the new decade was 'to own a personal copy of *Eraserhead*'.[20]

For cineastes like Kubrick and Bowie, however, *Eraserhead* wasn't some outré transmission from the netherworld, but just the latest example of a

A match made at midnight: DIY classics *Eraserhead* and *Pink Flamingos* share a bill at LA's Nuart Theater, 1978

'A dream of dark and troubling things'

tradition of abstract and surrealist film stretching back to the very earliest days of cinema. And while Lynch has tended to be circumspect about any such 'highbrow' influences on his work – 'I don't even know that much about surrealism,' he insisted in 1990; 'I wasn't exposed to too many sophisticated things'[21] – when the BBC asked him in the mid-1980s to front a TV documentary about avant-garde cinema, the director agreed wholeheartedly.

Screened as part of the *Arena* strand, *'Ruth, Roses and Revolver'* (1987) is named for a Man Ray short and features Lynch on uncharacteristically forthcoming form, divulging his love for the game of snooker, screening clips from seven of his favourite surrealist films and waxing lyrical about a group of filmmakers who, in his words, 'discovered that cinema was the perfect medium for them, because it allowed the subconscious to speak How exciting it must've been to be a filmmaker in the early days of cinema, because not only was it so magical to see paintings begin to move, but they could start altering time.'[22]

41

Early adopters: Celebrity *Eraserhead* fans
Stanley Kubrick (left) and David Bowie (right)

The artist that Lynch names 'the heavyweight of surrealism'[23] is Jean Cocteau, a clip of whose 1930 film *Le sang d'un poete* (*Blood of a Poet*) plays in the documentary. The very embodiment of the 'art life' that Lynch longed for, Cocteau was a Renaissance man who turned his talents to literature, design and the visual arts as well as filmmaking, describing all of them as forms of *poésie,* or poetry. Born in 1889 and best known today for his magical fairytale *La Belle et La Bete* (*Beauty and the Beast*, 1946) and his mythic, self-reflective *Orphee* (*Orpheus*, 1950) and *Le testament d'Orphee* (*The Testament of Orpheus*, 1960), Cocteau's films resemble Lynch's work in the way they mine the artist's subconscious and personal life for poetic images. Specific sequences, too, seem to prefigure Lynch: in *Le sang d'un poete* a guardian angel descends to save the soul of a murdered boy much as the Lady in the Radiator comes to Henry's rescue in the closing moments of *Eraserhead,* while in Orphee the characters pass from our world into another through a liquid mirror very like the one that marks the entrance to the Black Lodge in *Twin Peaks*.

Indeed, as we watch the seven clips chosen by the director all the way back in 1987, the pre-echoes of one specific Lynch work become almost uncanny. Directed by the Dadaist master Max Ernst and included by surrealist artist Hans Richter in his 1947 compilation film *Dreams That Money Can Buy*, the short film *Desire* is described by Lynch as 'one of my favourites ... It really gets in there and portrays a dreamlike feeling.'[24] Among many indelible images is one of a young woman lying on a bed while a golden ball balances on her lips, and a frog sits beside her on the pillow. In 2017, Lynch's 18-hour odyssey *Twin Peaks: The Return*[25] would see characters transformed into floating golden spheres, while in the unforgettable eighth instalment a sleeping girl consumes a mutant creature that seems to be part frog, part moth. The influence of painter and photographer Man Ray's wild 1926 film *Emak Bakia* is also detectable in the same episode, specifically the experimental sequence following the explosion of the first atom bomb, which triggers a series of jarring, animated blurs very like those in the earlier film.

'I'm very happy to be a fellow traveller with any one of these guys,'[26] Lynch enthuses in the *Arena* film, and of course the influence of surrealist cinema on his work is inescapable. But Lynch differs from the early surrealists in one important respect: while artists like Cocteau would successfully marry surrealism with narrative, the latter would rarely be straightforward and the surrealist elements would, to a large extent, take precedence. For Lynch, however, surrealism would be just one colour in his filmmaking palette, brought to the fore in early films like *The Grandmother* and *Eraserhead* – and again in later works like *INLAND EMPIRE* (2006) and *Twin Peaks: The Return* – but for the majority of his career, subsumed within a relatively straightforward filmmaking framework.

And it would all start with his next project, an extraordinary leap forward that would give Lynch the opportunity to bring an avant-garde edge to that stuffiest and most old-fashioned of film genres: the English period drama.

'Surrealism is the subconscious speaking'

45

'With this ring ...' A still from Man Ray's 1926 dream-film
Emak Bakia, which seems to have influenced Lynch's *Twin Peaks*

The Elephant Man
1978-1980

'The face of an angel'

The fact that David Lynch was able to move directly from a handmade work of abstract cinema to a major prestige picture filled with respected screen actors remains one of the most miraculous sequences of events in modern cinema. Yes, *Eraserhead* had won favour with celebrities and cineastes, but it was still a midnight movie, playing in the same fleapits as *I Spit on Your Grave* (1978) and *Women in Cages* (1971) and on double bills with *The Rocky Horror Picture Show* (1975). And while the film may have been beautifully fashioned, lovingly detailed and tonally flawless, there's little in *Eraserhead* to suggest that its director could be trusted with a multi-million-dollar budget. But that is precisely the position in which Lynch found himself – and it was entirely down to the faith and confidence of three men.

As *Eraserhead* gradually found its audience, Lynch was back in LA working with his father to renovate an old house, rekindling his relationship with Jack Fisk's sister Mary, whom he'd marry in 1977, and putting the finishing touches to his first full-length screenplay, *Ronnie Rocket*. A gleefully bizarre spiritual odyssey about diminutive rock 'n' roll stars, rogue CIA agents, 'coal, oil and electricity',[1] the film was never likely to secure the kind of budget Lynch

'I am not an animal...' John Hurt and David Lynch at London's
Liverpool Street Station, shooting *The Elephant Man*

would've needed to bring it to the screen. But that didn't stop him trying, approaching Hollywood studios with the aid of fellow American Film Institute alumnus Stuart Cornfeld, who adored the script, loved *Eraserhead* and was desperate to work with Lynch. When these efforts came to nothing, it was Cornfeld who encouraged Lynch to consider working as a director for hire, suggesting four scripts that he might like to take a look at. 'The first thing he said was *The Elephant Man*,' Lynch told me in 2011. 'And an explosion went off in my brain. Very strange! I said immediately, that's it. That's what I want to do.'[2]

The story of Joseph Merrick (renamed John for the film), the severely malformed Victorian Englishman who had been exhibited as part of a freak show before being 'rescued' for the purposes of study by prominent London doctor Frederick Treves, was having something of a moment in the late 1970s. American playwright Bernard Pomerance's stage production *The Elephant Man* had opened in 1977 and within two years had landed on Broadway, where the title character would be played for a period by none other than David Bowie.

Meanwhile, an entirely unrelated film script had been doing the rounds; written by film students Eric Bergren and Christopher De Vore, the script would ultimately make its way via the family babysitter to producer Jonathan Sanger, a friend of Cornfeld's who had recently struck up a working relationship with writer-director Mel Brooks, the comic mastermind behind *The Producers* (1967), *Blazing Saddles* and *Young Frankenstein* (both 1974). Eager to foster new talent – 'he was given breaks in life and he wanted to help out some people who were young and getting going'[3] – and keen to create art of an altogether different stripe than the absurd comedies that had made him famous, Brooks was in the process of setting up his own production company when Sanger handed him the script, suggesting himself as producer and Lynch as director.

Cornfeld and Sanger had both played vital roles in bringing Lynch this far, but it was Brooks who took the extraordinary decision to hand *The Elephant Man* – along with five million dollars of his own and other people's money – over to Lynch. He would also work alongside Lynch on rewrites of the script intended to enhance the inherent drama of the story, and when during shooting certain actors began to question their director's grip on the material – with Anthony Hopkins demanding, according to Lynch, that he be fired – it was Brooks who came to Lynch's defence.

'You know they say forest fires are around 2,000 degrees Fahrenheit?' Lynch would recall. 'This was a baptism by fire far hotter than that … But I had total support from Mel, and it all came right in the end.' Indeed, without Brooks's faith and foresight – and ongoing support from both Cornfeld and Sanger – it seems entirely likely that David Lynch's film career may have sputtered to a halt, and that he might be known today as an interesting visual artist who once made that crazy movie with the mutant baby. Instead, he was about to score his first Academy Award nomination – and he'd do it without compromising his artistic vision.

49

'... I am a human being!' The real Joseph Carey Merrick
photographed in 1889 (right), and David Bowie
as Merrick on Broadway in 1980 (left)

From the first, however, the *Elephant Man* shoot was hard going for Lynch. Brimming with confidence, he had intended to design and fashion Merrick's make-up himself, just as he had crafted the physical effects for *Eraserhead*. Early tests, however, were catastrophic, limiting actor John Hurt's movement and proving impossible to work with. An expert was called in, but this was Lynch's first serious failure and it shocked him to the core, robbing him of sleep for three nights straight. 'I thought it would be better to kill myself, because I could hardly stand to be in my body,' he would write in *Room to Dream*. 'I was a fuckin' basket case.'[4]

Then, as photography got underway, Lynch found himself rubbing up against recalcitrant actors, art department workers who felt that the footage was too dark, and British crews who questioned both his experience and his very specific ideas for the film. The sheer scale of the production daunted him, as did the international pedigree of the cast: he would recall 'putting on my underwear thinking, today I'm going to direct John Gielgud. It was a traumatic thing.'[5]

There was hardship in his personal life, too. Lynch and Mary Fisk would find living in London difficult; they didn't know the culture, and the weather must've been disheartening to a couple accustomed to the temperate charms of LA. Having become pregnant with twins during pre-production, Fisk would be hospitalized for three weeks during their stay in London. Lynch would sit at her bedside every other night, after shooting had ended. She would miscarry some weeks later.

Still Lynch soldiered on, taking joy where he could find it: 'I would go to the local Peking Chinese restaurants,' he would tell *Time Out London* in 2014. 'I was in seventh heaven every time I had the crispy-fried seaweed: one bite of that and you leave your body!'[6] He would also, over time, begin to forge supportive relationships with many members of the cast and crew, including legendary cinematographer Freddie Francis, who would go on to shoot both *Dune* and *The Straight Story* (1999), and actors Freddie Jones, John Hurt and screen legend Wendy Hiller. 'She turned out to be another one who supported me beyond the beyond,' Lynch would tell me. 'I love Dame Wendy Hiller!'[7]

But his confidence hit bottom again during post-production, when he was persuaded to show the cast and crew an unfinished print of the film. 'Some of them wrote me letters saying how much they didn't like it … and how disappointed they were.'[8] It's not hard to understand why they were nonplussed: with Lynch as director *The Elephant Man* was never going to be a straightforward costume picture, and his unprecedented use of avant-garde techniques in the imagery, editing and especially the sound – from distorted elephant calls to sudden, deafening bursts of flame – must have wrongfooted anyone expecting a frilly-frocked Victorian melodrama.

Happily, Mel Brooks's faith in Lynch – and in Alan Splet, who was responsible for the film's dense sonic world – never faltered. 'I didn't have final cut (in my contract), but he in effect gave me final cut,' Lynch would

Everything to prove: David Lynch on the set of *The Elephant Man*, with Anne Bancroft and Anthony Hopkins (opposite, top) and with John Hurt (bottom left)

'People are frightened by what they don't understand'

51

Lynch alone with the camera (bottom right)

recall. 'When (studio executives) wanted to alter things, he became the most powerful lion and just devoured these enemies.'[9] Leaving London under a cloud, Lynch wouldn't even attend the film's American premiere, preferring to stay at home while his sister Martha chaperoned their parents.

—

'You see this thing through the lens and you just get filled with euphoria'

His time in the UK would, however, prove to be another turning point in Lynch's artistic life, and not just because of *The Elephant Man*. For Lynch, an interest in still photography had grown naturally from his filmmaking in the same way film grew organically from his art. But it was only when scouting potential locations in London that he first began to take the artform seriously. In the late 1970s, before the regeneration of London's docklands and their adjacent industrial zones, the city was filled with derelict buildings: factories, warehouses, houses and hospitals.

'I grew up in the north-west of America where there are no factories at all – just woods and farms,' Lynch would say later. 'But my mother was from Brooklyn, so ... I got a taste for a certain kind of architecture and a feeling for machines and smoke and fear.'[10] This fascination with industry – sparked in New York, nurtured in Philadelphia and revived in London – would not only feed directly into the film Lynch was making, with its grinding pistons and soot-smeared Victorian streets, but would lend a new sense of purpose to his photographic work, which from then on would centre almost exclusively on two things: naked human bodies and crumbling industrial spaces. This stark contrast between vulnerability and hardness would seem to mirror the dualities found elsewhere in his work, between light and dark, good and evil, outward perfection and internal decay.

'A new factory is a beautiful thing,' Lynch would say, 'but an aged factory ... the work (that has been done there) makes so many stains and disturbances and all this stuff, then nature on top of that ... the way nature goes to work on the steel, the bricks, the concrete, it's just unbelievably beautiful.'[11] Eager to find more industrial sites to photograph, Lynch would accompany Freddie Francis on a tour of the North of England, and the image of bright young Lynch gee-whizzing his way through the dark Satanic murk of late 1970s Yorkshire is one to savour.

The voyage north would prove disappointing – 'everywhere we went, the factories had been torn down',[12] Lynch would lament – but his fascination with industrial spaces would endure: he would shoot extensively in LA and New York, tracking down abandoned spaces wherever he went. Then, several decades later, Lynch would finally locate his industrial mecca: the city of Lodz

Flesh and industry: the lips of Isabella Rossellini
in *Blue Velvet* (opposite top) ...

53

... and the streets and factories of Victorian England
as depicted in *The Elephant Man* (centre & below)

in Poland, home to the Camerimage Film Festival, a celebration of film and photography whose organizers had invited Lynch to appear, and who would become part of his inner circle. 'I really liked them,' Lynch would recall later, 'and I asked them, do you have old factories? And they said yes, we've got many, many old factories. And I said, do you have nude women? And they said, yes, yes, yes. So I went over to Poland.'[13] Thanks to this winning combination, in the twenty-first century Lodz would become something of a second home for Lynch: in 2007 he would purchase a plot of land near the city, having shot much of *INLAND EMPIRE* there.

'Time disappears when I'm shooting in a factory,' Lynch would tell *Time Out* in 2014, on the eve of a major photography exhibition. 'It's really beautiful.'[14] The same interview would find him listing some of his favourite photographers, namely William Eggleston, Joel-Peter Witkin and Diane Arbus. Eggleston would later meet with Lynch for a photo session, resulting in a beautiful portrait of the director – '(it's) out of focus, but good!'[15] Lynch would say admiringly – while Arbus, with her sympathetic portraits of strippers, sideshow performers and other marginalized folk, would be an obvious influence on his film work from *The Elephant Man* forwards.

But it's Witkin whose impact is perhaps the most intriguing, particularly with reference to one of Lynch's later photographic series, Distorted Nudes. Born in Brooklyn in 1939, Witkin would be deeply affected by an incident in childhood when he witnessed the decapitation of a girl in an automobile accident, and the constructed photographs he has taken in the years since reflect a fascination with the grotesque, macabre and disturbing. Utilizing religious imagery and, like Arbus, often depicting human figures considered to be outside the norm – hermaphrodites, trans people and those with dwarfism – Witkin's photographic subjects also controversially include dead bodies and severed human parts, arranged into patterns and shot in Mexico for legal reasons. Like Lynch, his work has also been accused of being tasteless, exploitative and unnecessarily gruesome.

For his Distorted Nudes, Lynch didn't require the use of severed limbs, or even real models – instead, he ransacked the pages of a Taschen compendium entitled *1000 Nudes: A History of Erotic Photography from 1839–1939*. 'I would scan them in and distort them,' Lynch would explain later. 'Because so many of them are old ... they come from another time, another place, a whole other world.'[16] The results might not be quite as disturbing as Witkin's work, but that may simply be because we know that they're digitally manipulated photographs rather than real tableau. And Lynch's nudes are still shocking, depicting decapitated women holding their own heads, twisted bodies with looping, connected limbs, explicit images remoulded into monstrous shapes.

In the years following, Lynch's nudes would become more straightforward, using light and shadow to dreamlike effect, and often photographed in such extreme close-up that the images became almost abstract.

They would, however, always depict women, usually young and traditionally attractive. 'Both forms are beautiful,' Lynch would insist. 'But I haven't gotten into men.'[17]

—

'Luck, my friend, luck.
Who needs it more than we?'

Released in the US on 3 October 1980, *The Elephant Man* was an immediate success, earning $26 million at the domestic box office and ranking 25th in a list of the year's highest grossing films, below *The Shining* and *Flash Gordon* but ahead of *Raging Bull* and *Xanadu*. More notably, it would also be nominated for eight Academy Awards including Best Picture, Best Actor for Hurt and Best Director for Lynch, a stunning achievement for an untried filmmaker on his first studio picture. The film wouldn't end up collecting a single award – Robert Redford's stagey drama *Ordinary People* would clean up, leaving both Lynch and Martin Scorsese empty-handed – however, a letter of protest from industry insiders suggesting that *The Elephant Man* be granted a special Oscar for its make-up effects would lead the following year to the first Academy Award for Best Makeup.

But for all its mainstream success, *The Elephant Man* was, and remains, wholly a David Lynch film. Opening with a sequence of pure, abstract horror in which Merrick's mother is seemingly trampled, violated and impregnated by a herd of thundering elephants, the film seamlessly marries straight narrative drama with moments of jarring, abstract intensity, all underpinned by Alan Splet's dissonant industrial soundscape. Beautifully photographed by Freddie Francis, the film is as aesthetically immersive as *Eraserhead*.

A childlike figure fascinated by fairy tales and the theatre, Merrick is every bit as much of a naïf as Henry Spencer, and his recapture and descent into the brutal world of the freak shows is one of the most upsetting sequences in Lynch's filmography. Indeed, with the arguable exception of *Twin Peaks: Fire Walk with Me*, *The Elephant Man* is perhaps the most emotionally forceful film in Lynch's canon, its avant-garde elements serving not to distract from the resonance of Merrick's story but rather to enhance it, creating a uniquely intimate and overpowering sense of empathy that culminates in the final scene, another of Lynch's climactic moments of death and transcendence. The fact that he was able to make such a film within the confines of the studio system (albeit with independent financing) – and to make it a huge commercial and critical hit – remains a staggering achievement.

It wasn't a trick he could pull off twice.

'You're a Romeo!': The prosthetic make-up designed by Christopher Tucker for *The Elephant Man* would result in the creation of a new Academy Award

Dune
1981-1984

Chapter Four
'It is by will alone I set my mind in motion'

David Lynch's relationship with Hollywood was a complicated one. His respect and affection for its rich history and the work it produced was never in doubt – nods to classic movies recur throughout his work, as we'll explore in more detail later. He was nominated three times for Best Director at the Academy Awards – for *The Elephant Man*, *Blue Velvet* and *Mulholland Drive* – and in 2019 was belatedly awarded an honorary Oscar, which he received in person only to deliver a three-sentence acceptance speech ('To the Academy and everyone who helped me along the way, thanks.' Then to the statuette itself: 'You have a very nice face. Good night.').

Lynch lived and worked in Los Angeles almost exclusively from the early 1970s onwards: 'because of the light, and a feeling in the air that we can do anything here'.[1] And throughout his career he flirted with the major studios, approaching them with his projects only to be, in almost every instance, turned down – one notable exception being *The Straight Story*, which opens with the unlikely credit: 'Walt Disney Pictures Presents A Film By David Lynch'.

59

But Lynch clearly mistrusted Hollywood, too: when asked about his favourite movies he would often cite Billy Wilder's *Sunset Boulevard* (1950), an acid tale of self-destruction in which a screenwriter attempts to exploit the comeback fantasies of an ageing actress only to end up floating face-down in her swimming pool. 'I love *Sunset Boulevard* with all my being,' Lynch enthused. 'Just a magical, beautiful, incredible film.'[2] It would go on to be a key influence on Lynch's *Mulholland Drive*, in which the creative ambitions of directors and actors are repeatedly thwarted by shadowy money-men and vested interests; a reflection of Lynch's own miserable experiences in the so-called City of Dreams. And it would all begin with his first (and last) blockbuster production, his most technically ambitious film and his greatest failure: *Dune*.

—

As *The Elephant Man* broke hearts around the world, David Lynch was once more in limbo, unsure of his next move. 'Successes are complicated things, psychologically,' he would say. 'These things ... are thrilling, but they can also get in the way of the next project. They make you second guess things.'[3] Again, efforts were made to launch *Ronnie Rocket*, potentially starring young *Elephant Man* bit-player Dexter Fletcher in the title role, but the project failed to attain

Building worlds: An Atreides Heighliner approaches
the city of Arrakeen in Lynch's *Dune* (top)

'I'm ready for my close-up': Gloria Swanson as ageing
star Norma Desmond in *Sunset Boulevard* (bottom)

'By the time you learn the game, you've
already been hurt bad'

escape velocity: Hollywood producers may have been keen to develop a new film by the respected auteur behind *The Elephant Man*, but no one wanted to chuck millions at that lunatic who made *Eraserhead*. Another potential project for Lynch was a crime story he'd begun writing called *Blue Velvet*, but again it was deemed too weird and gruesome, with even Lynch later admitting that the draft he shopped around at the time wasn't worth the effort.

Further attempts would be mounted to pair Lynch with a script by someone else, re-teaming him initially with Eric Bergren and Christopher De Vore on a project that might have been tailor-made for Lynch at the time: a biopic of Seattle-born starlet Frances Farmer, whose meteoric rise in 1930s Hollywood was cruelly cut short when she was arrested for disorderly conduct and committed to a mental institution, where she underwent shock therapy. Even Lynch isn't sure why he didn't end up making *Frances*, which was ultimately released in 1982 under the direction of first-timer Graeme Clifford, and earned star Jessica Lange an Academy Award nomination.

Other potential projects would include the mournful, intimate country music tale *Tender Mercies* (1983) – a wonderful script, but a dreadful fit for

A lost opportunity: Hollywood actress Frances Farmer
in a glamorous 1935 headshot (right), and during
her arrest for parole violations in 1943 (left)

Lynch – and an adaptation of Thomas Harris's novel *Red Dragon*, the book that introduced the world to Hannibal Lecter. After briefly flirting with the project, Lynch departed, later dismissing it as 'real violent ... completely degenerate'[4]. He also reportedly met with writer Cameron Crowe to discuss directing teen comedy *Fast Times at Ridgemont High* (1982), a seemingly odd fit until one considers how central the teenage characters would be to both *Blue Velvet* and *Twin Peaks*, and how successfully those high school scenes fuse adolescent angst with moments of oddball humour.

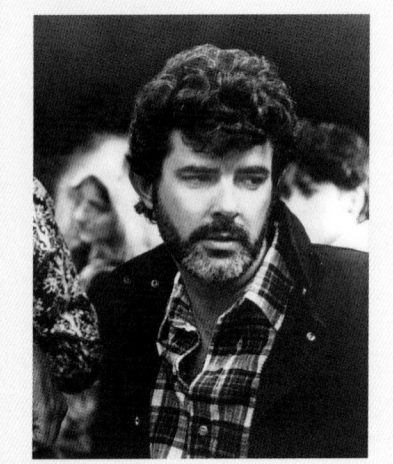

Famously, in late 1980 Lynch would sit down with director-producer George Lucas to discuss directing the third episode in the *Star Wars* saga. This may seem a curious match on paper, but as writer Max Evry points out in his book *A Masterpiece in Disarray: An Oral History of David Lynch's Dune*, the two filmmakers had, up to that point, had remarkably similar trajectories: both were middle-class suburban kids who cut their teeth on avant-garde shorts before graduating to features; both their first films were somewhat oblique (though Lucas's *THX 1138* (1971) is almost mainstream compared to *Eraserhead*); and both scored an unexpected critical and commercial hit with their second movie. Lynch has always said that he turned Lucas down the day after their meeting, urging him to direct the film himself, but Evry's book tells a different story: according to Lucas's producer Howard Kazanjian, Lynch remained Lucas's first choice as late as February 1981, and upon being offered the job replied to say that he was 'thrilled'[5] – only to turn it down some days afterwards.

Imagining what *Return of the Jedi* (1983) might have become under Lynch's direction is a troubling prospect: the opening act, set in the dank, tentacle-infested dungeons of Jabba the Hutt's palace, are already daunting for younger viewers; Lynch might've made them unwatchable. What seems most likely is that, had Lynch gone ahead and accepted Lucas's offer, the pair would have parted ways before shooting even began: Lucas was already having misgivings about Lynch's stated desire to bring in regular collaborators including Alan Splet to replace members of the regular *Star Wars* team, while Lynch would inevitably have resented the fact that Lucas insisted on having final say on almost every aspect of production.

Instead, Lynch decided to sign up to another project that had come his way around the same time: another mystical space saga, drawn from a novel that Lucas had extensively mined when creating his *Star Wars* movies. Lynch wasn't the first filmmaker to attempt to bring Frank Herbert's *Dune* to the screen: the mad, quixotic efforts of Chilean director Alejandro Jodorowsky have been explored extensively elsewhere, not least in the excellent documentary *Jodorowsky's Dune*, while a project headed by Ridley Scott had only recently collapsed when Lynch came on board. But he was the first to be successful – at least, by some metrics.

Wookiee break: *Star Wars* creator George Lucas offered Lynch the job of directing the third instalment in the sci-fi saga

'Cinema can create another world.
That's what's so beautiful about it'

—

American author Frank Herbert's epic science fiction novel *Dune* had first been serialized in *Analog* magazine in the early 1960s, before being published in a standalone volume in 1965. Set in the year 10,191, the story follows young nobleman Paul Atreides who travels with his family and their retinue to the desert world of Arrakis, known colloquially as Dune, where they've been sent to oversee production of the most valuable substance in the universe: a hallucinogenic spice, melange, which gives its users power of prescience. Joining forces with a tribal people known as the Fremen, Paul leads a campaign to free Arrakis from the clutches of the powerful Padishah Emperor and his lackeys, the monstrous Harkonnens.

Though it may have initially arrived without much fanfare, by the end of the 1960s *Dune* was a sensation, second only to *The Lord of the Rings* on campus nightstands, thanks in large part to its extraordinary, if largely unplanned cultural resonance. Incorporating themes of first nations rebellion, colonial exploitation, religious manipulation, hallucinogenic drugs, Zen mysticism and Eastern spirituality, *Dune* told precisely the right story at precisely the right time.

Unfinished business: Director Alejandro Jodorowsky
and artist Jean Giraud test out a Sardaukar warrior costume
for their never-completed *Dune* adaptation

'A beginning is a very delicate time': The first edition cover
of Frank Herbert's *Dune*, published in 1965

It's easy to see why Lynch was intrigued. Still deeply absorbed in the practice of meditation, he must have thrilled to the idea of a future where such things are not just accepted but have been developed to the point where Zen-like techniques give characters the ability to place themselves in trance-like states, control others with the power of their voice and determine the sex of an unborn child. Filled with hallucinatory and transcendental imagery, Herbert's book is also – at least on the surface – powerfully Lynchian in the way it deals with ideas of good and evil, pitting the imperfect but essentially decent Atreides family against the grotesque, deformed Harkonnens.

Executive producer Dino De Laurentiis must also have been a draw. A ruthless Italian businessman who had produced a number of early works by Federico Fellini including Lynch favourite *La Strada* (1954), he would later introduce the young director to his hero over a lavish Italian supper. With his daughter Raffaella as day-to-day producer on *Dune*, De Laurentiis essentially adopted Lynch, introducing him to a world of big-budget, high-stakes filmmaking that must have seemed a thrilling echo of old Hollywood, when producers took risks and directors had vision.

Of course, vision had never been Lynch's problem – and with a budget of some $40 million and a huge team of special effects technicians, miniatures builders and set designers, *Dune* offered him the chance to indulge that vision like never before. If both *Eraserhead* and *The Elephant Man* had, to some extent, been exercises in world-building, then *Dune* offered Lynch the chance to create not just one but four entirely distinct worlds, each with their own cultures, costumes and architectural style: oceanic Caladan, industrial Giedi Prime, gilded Kaitain and windswept Arrakis. Again, Lynch would take

The men who made *Dune*: Executive producer
Dino De Laurentiis (pictured left, with Federico Fellini) (top left);
director David Lynch and author Frank Herbert (top right)

Fallen icon: Hollywood legend Aldo Ray pictured in the 1960s with his wife Johanna, who would go on to become Lynch's go-to casting director (their son, Eric Da Re, would also appear in *Twin Peaks*) (top right)

Lost in the desert: A sandswept Lynch with producer Raffaella De Laurentiis on the Mexico set of *Dune*, 1983 (top left) and Jack Nance (left) as Nefud, opposite Brad Dourif as Piter De Vries (bottom)

direct inspiration from the world around him, letting the smokestack darkness of Philadelphia feed the hissing cityscapes of Giedi Prime, while the palaces of Kaitain and Caladan were informed by the old-world opulence of Venice. 'I went for a boat ride … and these strange mansions were coming out of the black water,' he would recall. 'It was just like another world.'[6]

Given the film's high profile he was also able to take his pick of actors, meeting up-and-comers including Tom Cruise, Rob Lowe, Kevin Costner and Val Kilmer, the latter of whom very nearly landed the lead role before Lynch met Kyle MacLachlan and recognized a kindred spirit (Kilmer was later given the first-draft script for *Blue Velvet* with a view to playing Jeffrey, only to dismiss it as 'straight-up, hard-core pornography').[7] *Dune* also offered Lynch the chance to work with some of his favourite screen stars, including Bergman stalwart Max Von Sydow and Hollywood legend Aldo Ray, and to reunite with *Elephant Man* alumni John Hurt and Freddie Jones, plus of course his old *Eraserhead* cohort Jack Nance.

Indeed, Nance's involvement was only possible because Lynch was also given the responsibility of penning the script, allowing him to write an entire part – scowling henchman Nefud – specifically for his old friend. Working again with De Vore and Bergren, Lynch crafted a vast, 200-page adaptation that it was initially assumed would be released in two parts. But Dino De Laurentiis refused to consider it, convinced that the book could be squeezed into a single film.

Bergren and De Vore disagreed and left the project, but Lynch chose to accede to De Laurentiis's wishes, working alone on several progressively shorter drafts before the final shooting script was agreed shortly before the start of production. In retrospect, it was this decision to compress the novel that would lie at the root of all the film's problems. 'You know the expression, "Well begun, half done"?' Lynch would say ruefully, years later. 'It wasn't well begun. From the beginning, it was a slippery slope that kept going downwards. I was two people: One that put one foot in front of the other and does the work, while the other one is right above it, going insane.'[8]

—

'I will never be yours to control'

On the night of 7 September 1982, Mary Fisk gave birth to David Lynch's second child and first son, Austin. Still in LA to work on the *Dune* script, Lynch was able to be at Fisk's side throughout her 36-hour labour. But once shooting commenced early the following year, Lynch would leave, spending much of 1983 in Guadalajara, Mexico, where Raffaella De Laurentiis had found a studio that seemed to meet the production's needs: huge soundstages, cheap labour and easy access to the nearby desert.

A project four long years in the making, Lynch's *Dune* is often over-shadowed by tales of everything that went wrong. Shooting had barely begun when Aldo Ray was fired after turning up drunk on set; he was replaced by Patrick Stewart. Dean Stockwell was also rushed in when scheduling conflicts forced John Hurt to leave the production. Shooting in Mexico meant that cast and crew were regularly afflicted with stomach ailments, while customs problems meant that shipments of food, costumes and vital camera equipment were regularly delayed. And while everyone on the project admired Lynch for his positivity, his directorial vision and his work ethic, many also recognized that he was increasingly out of his depth, particularly when it came to the film's multiple, complex special effects sequences.

But it was in post-production that the problems began in earnest. Envisioning an approximately three-hour cut, Lynch was told in no uncertain terms by both Dino De Laurentiis and the bosses at Universal Pictures that the film had to be trimmed. Initially the director tried to fulfil that brief, shooting last-minute drop-ins like the 'water of life' sequence in the desert, which alone was able to replace some six or seven existing scenes. But as the cuts piled up, as scenes were removed or pared back to the absolute basics of storytelling – often with the addition of clunky passages of narration – Lynch felt himself losing control. It didn't help that the special effects were also in crisis, with shots that were initially intended to be temporary, like the ropey images of Paul's hand in the 'box of pain', making it into the final edit.

Ultimately Lynch simply stepped back, allowing Raffaella, her father and the editors to complete a 137-minute cut for release. The experience would colour his career for years to come, and would transform his approach to filmmaking. 'If a painter finishes a painting, there's no bunch of people that come in and say they don't like this blue or they don't like that and you've got to change this,' he would say later. 'Filmmaking should, in my opinion, be

Out of his depth? David Lynch with the cast of *Dune*: Dean Stockwell
and Francesca Annis (left); Sting and Kyle MacLachlan (right);
and the 'floating fat man', Kenneth McMillan (opposite)

exactly that ... you've got to stay true to yourself, you've got to stay true to your voice, and then you have at least a chance of being able to live with yourself.'[9]

By the time *Dune* was ready for release, no one believed that it would be a hit, and certainly not the '*Star Wars* for grown-ups' that Universal had envisioned. The marketing campaign for the film has to be among the most desperate and misguided in Hollywood history, with colouring books aimed at kids depicting dead bodies and knife fights, and plastic figurines of phallic worms and Sardaukar warriors along with every child's favourite pustulent, genocidal rapist, Baron Vladimir Harkonnen.

But while it's easy to point the finger of blame at Dino De Laurentiis and Universal, perhaps *Dune* was simply misguided from the start. Many of Lynch's visual ideas are magnificent – the bulbous, grasshopper-like Third Stage Guild Navigator, the industrial hellscape of Giedi Prime – while his talent for casting is once again evident: MacLachlan may be a little old for Paul, but with players like Stockwell, Stewart, Jones, Brad Dourif and the extraordinary Kenneth McMillan each giving their all, the cast are much more lively and memorable than in the recent *Dune* movies (the one notable exception, nappy-clad pop star Sting, was studio mandated).

Lynch's initial cut of *Dune* was screened just once for cast and crew, the majority of whom – with the rose-tinted benefit of hindsight – recall it as an incomplete masterpiece. The two notable standouts were Raffaella De Laurentiis and Lynch himself, who insisted in 1986 that 'the rough cut ... wouldn't have worked ... I think what we ended up with is the best that could be done with it ... There's something wrong with the movie ... and I'm not certain you could "fix" it.'[10]

It is of course impossible to judge exactly how the film might have turned out if Lynch had been given the chance to complete his vision. However, many of *Dune*'s flaws are absolutely present in his shooting script, notably some awkward expositionary dialogue and a slavish adherence to Herbert's book. Perhaps Lynch was simply the wrong director for the project, too inexperienced to tackle a movie of this size, and fundamentally incapable of delivering the kind of audience-friendly entertainment that the De Laurentiises and their studio backers wanted. Either way, *Dune* remains a fascinating curio: beautiful and horrifying, murky and strange, and absolutely a David Lynch film.

—

Fed up with living alone and encouraged by her brother Jack and his wife Sissy Spacek, in late 1983 Mary Fisk moved with baby Austin to a rural home near Charlottesville, Virginia. But although he would eventually join them, by 1984 Lynch was still in LA, struggling to complete *Dune* and embarking on an affair with an LA producer named Eve Brandstein. He was also hard at work on a new screenplay, though not one he'd ever finish. His *Dune* contract required Lynch to write and direct any potential sequel, so during gaps in production

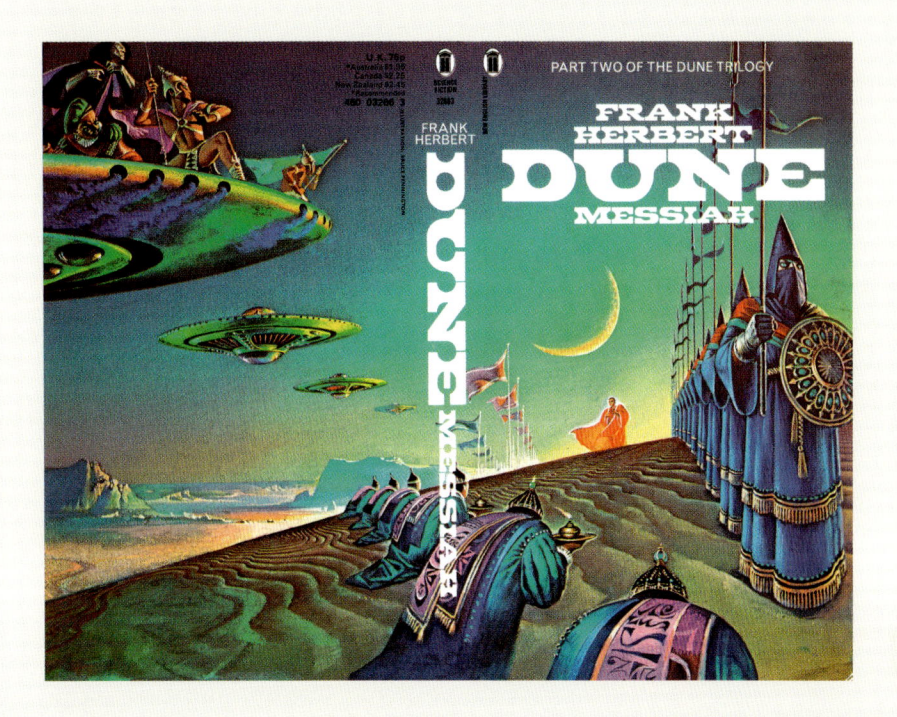

he'd been hard at work on an adaptation of the second book in Herbert's series, *Dune Messiah*. Though he completed less than half of the first draft, Lynch was full of enthusiasm about the script, enjoying the scaled-down nature of the novel, which is far shorter than *Dune* and much more manageable. 'It wasn't a big story,' he would enthuse afterwards. 'More like a neighborhood story. It had some really cool things in it.'[11]

Believed lost for decades, in 2024 the incomplete, 56-page Lynch script was discovered in the Frank Herbert archives by Max Evry, who wrote a fascinating breakdown for *Wired* magazine detailing the script's richly Lynchian touches, from 'a dark metal world with canals of steaming chemicals and acids' to characters with 18 heads, exploding dogs, oceans of blood and a naked knife-fight between a teenage girl and a training robot.[12] Comparing the script favourably to Herbert's rather dry source material, Evry offers a fascinating insight into what might have been: 'a glimpse into an alternate ... movie landscape where a visionary oddball conjured Herbert's sci-fi works onscreen as a dark, sophisticated, and eye-poppingly weird cinematic odyssey'.[13]

Perhaps it was for the best, however, that *Dune* failed: if it had been a hit, Lynch might have been trapped for years, adapting Herbert's progressively murkier and more idiosyncratic novels. Instead, *Dune* showed Lynch exactly the kind of filmmaker he didn't want to be, and the kind of relationship to the industry he didn't want to have. 'They call it a film business but money is the last thing a person should be thinking about,' he'd say later. 'It just nailed this idea – never, never do a film without final cut.'[14]

It was a rule he'd never break again.

71

Bruce Pennington's 1972 cover of first sequel *Dune Messiah*,
a book that Lynch had already begun adapting

Blue Velvet
1985-1987

Chapter Five
'You're a mystery. I like you very much'

In the wake of *Dune*, David Lynch was shattered, heading for Virginia to be with his family and promptly collapsing with serious back pain. 'That experience could have finished me,' he said later. 'It was so horrible. I identify so much with my films – and I knew I sold out.'[1] As before, it was Lynch's spiritual beliefs that came to his rescue – 'meditation kept me from jumping off the cliff'[2] – along with a more earthbound, and rather more unlikely saviour: Dino De Laurentiis.

It's been said that De Laurentiis agreed to finance *Blue Velvet* out of pity, as a kind of apology for the way things turned out on *Dune* (though as we've seen, conversations about the film actually go back to an earlier time). It's even been suggested that Lynch's *Dune* contract may have stipulated the funding of a smaller feature to follow, just as Francis Ford Coppola's deal for *The Godfather* (1972) included an agreement that Paramount stump up the budget for *The Conversation* (1974). Whatever the reality, De Laurentiis's willingness to fund *Blue Velvet* – and to give Lynch final cut, provided the director agreed to slash both his initial budget and his own salary – probably saved Lynch's career. Without De Laurentiis's backing it's hard to see how a film as transgressive as *Blue Velvet* could have been made at all, and if Lynch had been forced into another director-for-hire gig the experience might have turned him off cinema altogether.

Big trouble in small-town America: J. Michael Hunter,
Isabella Rossellini, Dennis Hopper, Kyle MacLachlan
and Jack Nance in *Blue Velvet*

Extensively revised in the wake of *Dune*, the screenplay for *Blue Velvet* would be a test case for a method of screenwriting that Lynch had picked up from his American Film Institute tutor, the Czech writer and filmmaker Frantisek 'Frank' Daniel. 'He taught a way to do it,' Lynch recalled. 'You get yourself a pack of 3 x 5 [inch] cards, and you write a scene on each card. And when you have 70 scenes, you have a feature film.'[3] Drawing on ideas and images that had been floating around in his subconscious since at least the early 1970s – 'red lips, green lawns and blue velvet ... someone finding an ear in a field'[4] – the script follows university student Jeffrey Beaumont, played by Kyle MacLachlan, who is forced to return to his small-town home when his father falls ill, only to find himself caught up in a mystery involving lounge singer Dorothy Vallens, played by Isabella Rossellini, and her captor and rapist, the terrifying Frank Booth, played by Dennis Hopper. A less directly personal story than his last original project, *Eraserhead*, the film is nonetheless filled with nods to Lynch's own history, most obviously the green lawns, white fences and forested surroundings of Boise, Idaho, that pristine surface under which darker things moved.

A budding detective fascinated by good and evil, light and dark, and the reality beneath the veneer of everyday life, Jeffrey is another clear stand-in for Lynch. And while the film has often been read as reflecting a pre-pubescent child's horrified discovery of sexuality, with disturbed Dorothy and controlling Frank as 'parents' to curious innocent Jeffrey, there are numerous adolescent concerns in the film, too – part of the initial inspiration came from Lynch's own teenage desire to sneak into a girl's bedroom at night, while the achingly pure love story between Jeffrey and Laura Dern's bubbly high-schooler Sandy could have been ripped straight from a 1950s romance novel (or, indeed, from Lynch's own pursuit of Mary Fisk). There are nods to Philadelphia in Lumberton's clanking, industrial downtown, and while a character like Frank may not have been inspired by a specific person, he was nonetheless drawn from real life: 'Frank ... is a guy Americans know very well. I'm sure most everybody growing up has met someone like Frank ... All you've got to do is exchange eye contact with someone like that and you know you've met him.'[5]

But despite the dark, distressing nature of the material, the first draft script for *Blue Velvet* had actually been written in one of the brightest, least threatening places imaginable: Bob's Big Boy Diner on Riverside Drive in Burbank, where Lynch would famously go after lunch every day for several years. 'There's a safety in thinking in a diner,' he would explain. 'You can have your coffee or your milkshake, and you can go off into strange dark areas, and always come back to the safety of the diner.'[6]

To the meticulous Lynch, the timing of these visits was all-important: half past two on the dot. 'If you go earlier, at lunchtime, they're making a lot of chocolate milkshakes,' he

74

would tell the *LA Times*. 'The mixture has to cool in a machine, but if it doesn't sit in there long enough, when they're serving a lot of them, it's runny ... At 2.30, the milkshake mixture hasn't been sitting there too long, but you've got a chance for it to be just great.'[7] The shakes also provided Lynch with another vital creative tool: sugar. 'I'm heavily into sugar,' he'd tell TV host Jonathan Ross. 'I call it granulated happiness. It's a friend.'[8] Thus fortified, Lynch would grab a pencil and let his imagination run riot. 'The coffee and the sugar would really get me going. And I would try to catch ideas.'[9]

—

'It's like a dream of strange desires wrapped inside a mystery story'

Given the level of creative freedom Lynch was granted, it's perhaps surprising that *Blue Velvet* is as narratively direct as it is. Yes, there are surreal touches and outrageous characters, but this isn't *Eraserhead* or even *The Elephant Man*: this is a coming-of-age story set in a familiar world, albeit a twisted one. Filmed in Wilmington, North Carolina, the self-styled 'East Coast Hollywood' where De Laurentiis Entertainment Group (DEG) had recently established a new filmmaking complex, *Blue Velvet* would share studio space with everything from punchy Arnold Schwarzenegger vehicle *Raw Deal* (1986) to the long-delayed adaptation of *Red Dragon*, which had finally got off the ground with Michael Mann as director and would be released in 1986 under the title *Manhunter.* By some distance the smallest film on the DEG slate, *Blue Velvet* would sail largely under the radar, allowing Lynch the space he needed to make the film he wanted. 'There were 13 films Dino was making, and we were the lowest budget, the least regarded (which led to) a really good sense of freedom throughout.'[10]

And that freedom didn't just extend to the director. Despite – or perhaps because of – the intense nature of the project, behind-the-scenes photographs invariably show cast and crew in high spirits, clowning around between takes and clearly having a whale of a time, leading to some equally joyous moments on-screen, like Kyle MacLachlan's hilarious 'chicken walk'. Harking back to the atmosphere of *esprit de corps* that had kept *Eraserhead* on the rails – and in stark contrast to the studio-mandated work ethic that had dominated both *The Elephant Man* and *Dune* – the *Blue Velvet* set would possess a spirit of optimism and unity that Lynch would seek to recapture on every project from then on.

'I feel like a set should be like a happy family,' he would insist later, 'happily going down the road together, getting along.'[11] For Lynch, this kind of supportive environment allows everyone on the team, and particularly the actors, to operate without fear of humiliation. 'It's to let actors know ... that

75

'A happy family': Lynch on the *Blue Velvet* set with Kyle MacLachlan (top);
Dean Stockwell and Dennis Hopper performing for the camera (centre);
and MacLachlan enjoying a glass of Heineken (bottom)

they're in a safe zone, that it is safe to say goodbye to themselves and take on this new character and make it real from their depths. And it's safe to make a fool of themselves if they have to go through that to get to where it's gotta be.'[12]

Indeed, while on-set footage may occasionally show Lynch losing his patience – 'fuckin' morons, everywhere!'[13] he grumbles in the behind-the-scenes documentary *Lynch (One)* – it's clear from those who've worked with him that, in contrast to many other directors, a Lynch set was an unusually calm and protective environment. 'People who run a set on fear ... are really stupid,' he has said. 'When you have a fear-based thing, people don't want to go the extra mile ... they want to say "fuck you, man!"'[14]

—

'It's a strange world'

Once again, *Blue Velvet* would rely to a large extent on the strength of its casting, and once again Lynch displayed an unerring talent for picking the right people, working for the first time with casting director Johanna Ray, who – entirely coincidentally – had been married in the 1960s to the same Aldo Ray that Lynch had been forced to fire from *Dune*; she would go on to cast (and in some cases produce) every Lynch project from then on. From the start, Lynch wanted Dennis Hopper to play Frank, but after repeated warnings he agreed to see other actors (including Robert Loggia, who would go on to play the Frank-alike Mr Eddy in *Lost Highway*). Notorious for his excessive behaviour both on and off set, in 1983 Hopper had spent time in a drug rehab programme, so the possibility of a Ray-like departure seemed high. Still, in the end Lynch took the chance, and he never regretted it: Hopper's now-famous statement that 'I *am* Frank Booth!' was the only thing that gave him pause.

The second gamble Lynch and Ray took was casting a relative unknown in the female lead. An experienced model, Isabella Rossellini had for years received offers from filmmakers eager to capitalize on her physical similarity to her mother, Ingrid Bergman. But it was only after Bergman's death in 1982 that Rossellini began to seriously consider acting; she was 32 when she accepted the role in *Blue Velvet*, and it was only her second major part. Inexperienced but utterly fearless, Rossellini would bear as much responsibility for the bewitching power of *Blue Velvet* as Hopper, MacLachlan or even Lynch himself. It was a spell that the director would prove unable – and indeed unwilling – to resist: Lynch and Rossellini began seeing one another during the *Blue Velvet* shoot, a fact that his wife Mary would only become aware of following the end of their marriage, a year after the film's release.

With Kyle MacLachlan on board as Jeffrey, the last key casting decision would introduce Lynch to the next of his great collaborators. Another child of 'movie people' – namely *Silent Running* (1972) actor Bruce Dern and film

and TV supporting player Diane Ladd – Laura Dern had grown up on film sets, and by the age of 18 was already a screen veteran, bringing a much-needed lightness to *Blue Velvet* that allows the film's shadows to stand out the clearer. Earning the affectionate nickname of 'Peanut', she would forge a close creative bond with Lynch, ultimately resulting in some of the finest work either of them would achieve.

Other newcomers joining the Lynch family for *Blue Velvet* would include set designer Patricia Norris, with whom he'd collaborate regularly right up to 2017, and editor Duwayne Dunham, who had cut *Return of the Jedi* for George Lucas and who would be involved in every stage of the *Twin Peaks* project, from directing episodes of the original series to editing the reams of footage Lynch shot for *The Return*. But there was room for former collaborators too, from supporting players Jack Nance, Brad Dourif and Dean Stockwell to sound designer Alan Splet and cinematographer Frederick Elmes.

—

'I like to sing "Blue Velvet"'

But one *Blue Velvet* newbie looms above all others. Struggling to find a suitable backing track for Rossellini's on-screen rendition of the title song – a problem compounded by the fact that she was no singer – Lynch agreed to let producer Fred Caruso invite his friend, composer Angelo Badalamenti, to assist. Gratified with the results, Lynch tapped Badalamenti for a larger favour: to write an entirely new song to soundtrack the first dance between Jeffrey and Sandy.

Initially, Lynch had been keen to use the 1983 version of Tim Buckley's oceanic ballad 'Song to the Siren', recorded by producer and record label exec Ivo Watts-Russell and musicians Robin Guthrie and Elizabeth Fraser under the name This Mortal Coil, only to have his advances rebuffed (a decision Watts-Russell presumably regretted, as he later allowed Lynch to use the track in *Lost Highway*). Unable to find another piece of music with the same ethereal tone, Lynch was surprised when Caruso suggested he pen some lyrics himself for Badalamenti to set to music. Entirely unconvinced that whatever they came up with could begin to rival the song in his head, Lynch was astounded when, after only two attempts, Badalamenti came back with the cosmic tone-poem 'Mysteries of Love', sung by Julee Cruise, with whom Badalamenti had worked before.

What often gets overlooked in this story, however, is the fact that, on the strength of these two relatively small-scale collaborations, Lynch then went ahead and commissioned Badalamenti to score the entirety of *Blue Velvet*. It had been a full decade since Badalamenti had scored a film, and even then he only had two minor exploitation pictures and a single episode of television to his credit. But Lynch was determined, and his trust would be rewarded in spectacular fashion.

79

New arrivals: Angelo Badalamenti at the piano
with Isabella Rossellini (top); and David Lynch with
Laura Dern on the set of *Blue Velvet* (bottom)

With Badalamenti on board, *Blue Velvet* was the first time that Lynch was able to develop a distinctive musical identity for his films ('I never got into music really until I met Angelo,'[15] he would say later). Early works like *The Grandmother* and *Eraserhead* may have made radical use of sound, but music was just one element in a tightly packed sonic landscape. Both *The Elephant Man* and *Dune* do have memorable scores – the former by Mel Brooks's regular collaborator (and co-writer of 'Springtime For Hitler') John Morris, the latter by rock band Toto – and in both cases Lynch kept the music intentionally high in the sound mix, particularly at moments of high emotion. In both these films, however, the relatively straightforward soundtrack is among the least 'Lynchian' elements in the production.

This isn't the case for *Blue Velvet*. Blending ominous, Stravinsky-inspired orchestral swells, floating synthesizer drones and finger-snapping 'cool' jazz, *Blue Velvet* created a new and indelible musical world, one that Lynch and Badalamenti would develop further in *Twin Peaks*, *Wild at Heart* and *Mulholland Drive*. And the film's contemporary setting also gave Lynch licence to use popular songs for the first time, notably Roy Orbison's 'In Dreams', which would supplant the title track as the piece of music most associated with *Blue Velvet* (Orbison, who also wrote the song, was reportedly unhappy at first, though he later recanted and would even collaborate with Lynch on a new version).

New wave meets old school: David Lynch with
Julee Cruise and Angelo Badalamenti in 1989 (left); and a
1963 cover of Roy Orbison's *In Dreams* LP (right)

'I love you, love me!'

Badalamenti's lush orchestral score highlights another noteworthy aspect of *Blue Velvet,* namely its debt to other films, specifically Hollywood cinema of the 1940s and 1950s. As noted previously, Lynch tended to be guarded about his debt to other movies, or even the kind of movies he preferred. 'I like all different kinds of cinema,' he said in 2024. 'There are no rules. Some abstract things don't move me at all and some move me like crazy. Some straight-ahead movies don't do anything for me, whereas others really light my fire. It's cinema, it's billions of elements.'[16]

When pressed, however, he would list some of his favourites, often citing films by Hollywood masters Alfred Hitchcock, Billy Wilder and Stanley Kubrick alongside European heavy hitters like Ingmar Bergman, Jacques Tati and Federico Fellini. But he would refuse to go into the specifics of how those films might have influenced his work, conceding only that: 'There have been 110 or more years of cinema, and it's impossible for any one of us to make a film that can't be compared to something that has come before. To me *Blue Velvet* is *Blue Velvet* and *Rear Window* is *Rear Window.* You could say that *Sunset Boulevard* or *Rear Window* has conjured an idea for me, but even though I love them or am inspired by them, life is a 24/7 movie. Ideas come out of that all the time.'[17]

And yet, *Blue Velvet* is self-evidently a movie about movies and the power they have to make us dream, drawing many of its ideas and characters from *film noir*, a loose, retrospectively defined wave of hard-nosed crime thrillers released from approximately 1940 until the late 1950s. Incorporating titles such as *The Maltese Falcon* (John Huston, 1941), *Double Indemnity* (Wilder, 1944), *Out of the Past* (Jacques Tourneur, 1947) and *Touch of Evil* (Orson Welles, 1958), *films noir* are identified with a number of thematic and stylistic motifs, many of which appear in *Blue Velvet,* namely naive, inquisitive heroes; dangerous, seductive women; remorseless, charismatic killers; upstanding policemen; criminal underworlds; richly textured shadows; and inevitable gunplay. In an early scene, we even see Jeffrey's mother (Priscilla Pointer) watching a *noir*-style drama on TV, in which an unseen gunman creeps up a shadowy flight of stairs. '*Film noir* has a mood that everyone can feel,' Lynch told an interviewer in 1997, following the release of his equally noir-inflected *Lost Highway.* 'It's people in trouble, at night, with a little bit of wind and the right kind of music. It's a beautiful thing.'[18]

But the single filmmaker whose shadow looms longest over *Blue Velvet* has to be Alfred Hitchcock: when Sandy asks Jeffrey if he is 'a detective or a pervert', it's hard not to recall Hitchcock's classic riposte to an accusing interviewer: 'everything's perverted in a different way'.[19] Hitchcock's films were, like Lynch's, often critiqued for their furtive fascination with sex and violence, and as Lynch admitted, the master's 1954 thriller *Rear Window* – another film about voyeurism and murder – was at least a partial inspiration

on his work, as may have been the earlier *Shadow of a Doubt* (1943), in which a quiet suburban home is invaded by a dark presence: a long-lost uncle, who may or may not be a Nazi spy. A film about trust and manipulation within the family, *Shadow of a Doubt* can be read as a parable about child abuse, a theme Lynch would explore explicitly in *Twin Peaks: Fire Walk With Me*.

It's Hitchcock's 1958 film *Vertigo*, however, that would seem to have left the deepest impression on Lynch. The dreamlike story of a traumatized detective who witnesses a woman's apparent suicide only to later encounter another, seemingly identical woman, the film most obviously prefigures Lynch's *Lost Highway,* in which Patricia Arquette plays two women, one blonde and one brunette, who may or may not be sisters, or even the same person. Arquette isn't alone, however: almost every Lynch film features variations on a similar theme, contrasting innocent or victimized light-haired women – *Eraserhead*'s Lady in the Radiator, *Blue Velvet*'s Sandy, *Twin Peaks*' Laura Palmer and *Mulholland Drive*'s Betty Elms – with dangerous and/or seductive dark-haired women like the unnamed Beautiful Woman Across the Hall, Dorothy Vallens, Audrey Horne and Rita/Camilla Rhodes. Things are rarely as straightforward as they seem, of course: Sandy in *Blue Velvet* may be a true innocent, but the same cannot be said of Laura Palmer; conversely, Dorothy is as much a victim as a seductress, while Audrey's bad-girl act is quickly revealed to be just that. For Lynch, this idea of duality was clearly fascinating – but it was always just a starting point for something deeper.

83

The same, but different: James Stewart with Kim Novak
and Kim Novak in a publicity shot for Hitchcock's *Vertigo*

Light and dark: Like Hitchcock, Lynch often contrasted blonde and brunette female characters, such as Renee and Alice (both Patricia Arquette in *Lost Highway* (bottom left and right) ...

... and Sandy (Laura Dern) and Dorothy (Isabella Rossellini) in *Blue Velvet* (top)

85

Other examples include Audrey (Sherilyn Fenn) (top left)
and Laura (Sheryl Lee) (top right) in *Twin Peaks*; and Betty (Naomi Watts)
and Rita (Laura Elena Harring) in *Mulholland Drive* (bottom)

And as much as it borrowed from classic cinema, *Blue Velvet* would give back in spades, becoming one of the most influential films of the decade. Indeed, 1986 would be a boom year for American movies, with films as diverse as the Coen brothers' debut *Blood Simple*, Spike Lee's first feature *She's Gotta Have It*, Jim Jarmusch's *Down By Law*, Gus Van Sant's *Mala Noche* and Lynch's old AFI classmate (and future *Twin Peaks* director) Tim Hunter's *River's Edge* serving to revitalize homegrown cinema. Imaginative, low budget and often independently produced, like *Blue Velvet* these films fused the personal with the generic, playing with film history and technique and often shifting abruptly between tones, from comedy and romance to violence and back again. *Blood Simple* and *River's Edge*, in particular, share DNA with Lynch's film, notably their small-town settings and focus on crime; the latter even stars Dennis Hopper, albeit in a more sympathetic role.

Of all these films, however, *Blue Velvet* would prove the most popular and enduring, securing Lynch his second Best Director nomination – a surprisingly bold decision for the Academy, given the film's wildly divided reception. The fusion of extreme violence, unalloyed romanticism and deadpan comedy dismayed many viewers, notably critic Roger Ebert, who was among many to assume that Lynch was standing at an ironic distance from his characters, 'pretending it's all part of a campy in-joke'.[20] But others were more willing to give themselves over, among them Ebert's reviewing partner Gene Siskel, director Martin Scorsese and the writer David Foster Wallace, who would rave about the film for years afterwards: 'What the really great artists do is they're entirely themselves,' Foster Wallace would tell Charlie Rose in 1997. 'They're entirely themselves. They've got their own vision, their own way of fracturing reality, and that if it's authentic and true, you will feel it in your nerve endings. And this is what *Blue Velvet* did for me.'[21]

New American cinema: Crispin Glover and Dennis Hopper
in *River's Edge* (top left); Frances McDormand in *Blood Simple* (top right);
Isabella Rossellini in *Blue Velvet* (opposite)

89

Suburban bliss: Blue skies, a white picket fence and red roses,
as depicted in the opening moments of *Blue Velvet*

90

'A woman in trouble': Lynch's plots often turn on acts of sexual violence,
as seen in *Blue Velvet* (top) and *Wild at Heart* (bottom)

'He put his disease in me'

Viewed today, many of the things that were most shocking about *Blue Velvet* – that teetering balance between the darkly comic and the shockingly depraved, the constant, repetitive use of harsh language and the jarring, decontextualized deployment of popular songs – have all become normalized, at least in part thanks to the films of Quentin Tarantino, whose *Reservoir Dogs* (1992) and *Pulp Fiction* (1994) – not to mention his screenplay for lovers-on-the-run road movie *True Romance* (1993) – all draw heavily on Lynch (though, as Foster Wallace wryly noted, 'Quentin Tarantino is interested in watching somebody's ear getting cut off; David Lynch is interested in the ear.').[22]

One element of *Blue Velvet* that hasn't been softened over time, however, is its depiction of violence, and particularly violence against women. The film's central scene – in which Jeffrey hides in the closet and witnesses Frank's brutal rape of Dorothy – remains deeply upsetting, and if one assumes, as Ebert and many others did, that Lynch is in any way mocking or looking down on his characters, it could be viewed as deeply offensive. At the time, Lynch seemed surprised by the reaction from women's groups, some of whom organized boycotts of the film or protested outside screenings. 'The only thing to say about all the controversy,' he said, 'is did I make all that up, or are there examples like that in real life? And there are countless examples like that in real life. So why do they get so upset when you put something like that in a film? ... People get into all sorts of strange situations ... and they could get out of it, but they don't. And there are lots of reasons for it.'[23]

As Lynch's career unfolded, however, it would become increasingly difficult to ignore the fact that violence against women – very often sexual violence – had become a regular feature of his work. Scenes of sexual assault would appear in both *Wild at Heart* and *Twin Peaks: Fire Walk With Me*, while the plots of *Twin Peaks*, *Lost Highway* and *Mulholland Drive* are all kickstarted by the murder – or attempted murder – of women. Lynch has consistently refused to be drawn on the issue, saying only that 'it's dangerous, I think, to say that a woman in a film represents all women, or a man in a film represents all men ... It's *that* particular character in this particular story, going down *that* particular road.'[24] This may seem a naive defence, particularly in the current cultural landscape, but it may also be a valid one: just as Lynch's films exist in a kind of nebulous, netherworldly version of America, so his characters should not have been mistaken for 'real' people.

Some critics would point not just to the violence but to the general depiction of women in Lynch's work, arguing that his use of archetypes – the wicked seductress, the virginal romantic, the insane mother – was further evidence of his misogyny. But defenders would counter that Lynch's male characters were every bit as archetypal, from stand-up guys like Jeffrey Beaumont and FBI Agent Dale Cooper to slavering villains like Frank Booth and *Wild at Heart*'s Bobby Peru, and that in fact they tended to have far less

92

Butterfly effect: *Apollo Pap's Nose* (1953)
by Lynch favourite Jean Dubuffet

developed inner lives than female characters such as Laura Palmer, Betty Elms or Nikki Grace in *INLAND EMPIRE*. At its core, the debate over misogyny is one of intention: was Lynch using sexual violence as a shock tactic, or even worse, as titillation? Or was he right there with his characters, feeling what they felt, suffering with them? It can only be for the viewer to decide.

—

'Stay alive, baby. Do it for Van Gogh.'

A year after *Blue Velvet*'s release, the James Corcoran Gallery in Los Angeles hosted David Lynch's first major American art show – and thanks to the notoriety surrounding the film, it would be a hot ticket. For Lynch, the connections between creating art and making movies were there, but painting was a much more organic, less intellectual process. 'Many of the things that you subconsciously use in art you use in film, but I don't think about it so much as feel it.'[25]

In the two decades since art school Lynch had continued to create constantly, utilizing whatever materials came to hand, or that he could afford. According to Jack Fisk, Lynch would fashion artworks using 'house paint, roofing tar, anything he could find',[26] while illustrations from the era can be found on anything from sticky notes and matchbooks to business cards and pages torn from a calendar: 'Big canvases cost a lot of money, so I was working small.'[27] Much more than mere doodles, these might depict abstract geometric shapes, figures, interiors, landscapes or strange machines, displaying a diversity of styles that suggests a restless creative spirit.

Lynch hadn't lost his fascination with dead creatures, either, creating pieces like his darkly humorous Bee Board, in which deceased bees were nailed to a piece of wood above a series of labels giving each one a different, determinedly 'ordinary' name (many of which would become familiar to fans of his work – there are bees named Bob, Harry, Dougie, Ed and even Riley, the name of Lynch's second son). 'Isabella Rossellini has the original bee board,' he would lament later, 'but the bees all came apart.'[28] During post-production on *The Elephant Man* he had also created the infamous 'Fish Kit', fixing portions of a dead fish to a piece of board with instructions on how to reassemble it. 'It's based on a model airplane kit ... So if you're successful at putting your fish together, it'll swim.'[29] It would be followed by a 'Chicken Kit', a 'Duck Kit' ('but it didn't turn out too well'),[30] and as late as 1986 he was still planning to create a 'Mouse Kit': 'I've got six mice in the deep freeze right now ... but I haven't had time.'[31]

During production on *Dune*, Lynch had also embarked on another project that would remain in his life for many years. Initially published in the *L.A. Reader*, *The Angriest Dog in the World* was a cartoon strip consisting of four panels that remained identical each week, depicting a dog in a yard, straining against his leash. The only thing that ever altered was a small speech balloon

emanating from the house, with text that Lynch phoned in weekly to the magazine. Essentially a single joke taken to extreme lengths – an approach that Lynch fans are, by now, very familiar with – the strip would run for almost a decade before its creator threw in the towel.

As the years passed and his resources increased, Lynch's artworks began to grow larger and more personal. 1988 would find him working on a series of dark paintings, shadowy canvases created using oils and bearing lengthy, often drily amusing titles that seemed to nod back to Lynch's childhood: 'That's Me in Front of My House', 'Oww, God, Mom, the Dog He Bited Me!', 'The Shadow of a Twisted Hand Over My House' and 'Boise, Idaho', which despite the artwork's all-embracing darkness actually depicts a place where Lynch was at his happiest. 'One of the reasons I prefer painting in black and white,' he would explain, 'or almost in black and white, is that if you have some shadow or darkness in the frame, then your mind can travel in there and dream. In general, colour is a little too real.'[32]

Lynch's paintings tended to be instinctive, rather than thought out. 'What I'm trying to do with each canvas is create a situation in which the paint can be itself,' he would say, 'which means letting go of any rationalization. It's important to let ideas blossom without too much judging or interference.'[33] And yet, as with his films and photography, a number of specific influences could be detected. Just as Lynch's early films were influenced by surrealist filmmakers like Renoir and Cocteau, so his artwork bore the fingerprints of artists like Max Ernst and Rene Magritte, alongside expressionists Edvard Munch, Lynch's beloved Oskar Kokoschka and Vincent Van Gogh, whom Lynch missed no opportunity to praise ('I love how driven he was!').[34] Meanwhile, the distorted, almost childlike figures that populate his work recall the 'childish, bad painting'[35] of French Art-brut painter and sculptor Jean Dubuffet, while among the other artists he admired were 'Julian Schnabel, Anselm Kiefer, Edward and Nancy Kienholz, and Georg Baselitz',[36] the latter of whom also created rough, textured paintings ('I really like to paint thick!'[37] Lynch admitted in 1990).

Like a number of artists including Kiefer, Lynch would often enhance his artworks with scrawled words, the better to engage with the viewer and let them into the story that the artwork is attempting to express. 'If it wasn't for words,' Lynch would say, 'it just wouldn't be complete.'[38] Indeed, over the years more and more of Lynch's paintings would begin to involve storytelling, further blurring the lines between his art and his films. 'I love a narrative,' he told *ARTnews* in 2018. 'A little story ... I like to have something going on with the characters Sometimes the story comes first, but sometimes the narrative comes out of the work later. It depends how it goes.'[39]

But while his paintings may have restricted Lynch to these 'little stories', in his day job he was ready to take the opposite approach. With assistance from a new collaborator, David Lynch was about to start crafting a narrative project on a far grander scale than anything he had attempted before – albeit on a smaller screen.

95

The expressionistic *Self-Portrait with Burning Cigarette* (1895)
by Edvard Munch

Twin Peaks
1988-1990

Chapter Six
'It looks like we're 100 per cent certain that we're not sure'

If David Lynch's feelings towards Hollywood were complex, his relationship with the small screen appeared equally conflicted. 'Television seemed like a horrible thing to me,' he would write in *Room to Dream*. 'All the commercial interruptions.'[1] And yet, two of his most highly regarded projects – *Twin Peaks* and *Mulholland Drive* – would both have their roots in television, though each of them would suffer badly at the hands of executives, from scheduling changes and eventual cancellation on the former to editorial interference and ultimate refusal on the latter. Perhaps it was only in 2017 that Lynch was able to make his peace with the format, when the Showtime network finally gave him the budget and the freedom to fully indulge his creative fantasies.

The man who would introduce Lynch to the world of network television had entered his orbit in 1986. As *Blue Velvet* sent shockwaves through the culture – and as Lynch's relationship with Rossellini made him an unlikely tabloid star – the director nonetheless found himself in a familiar position, trying and failing to launch *Ronnie Rocket*, and fishing around for new projects. No one seems to remember exactly who introduced Lynch to Mark Frost – who

This changes everything: David Lynch
and Mark Frost hold a press conference on the
Twin Peaks studio set in Culver City, 1990

at the time was best known for writing the hit cop drama *Hill Street Blues* – only the project they were brought together to work on: a film about the final months of Marilyn Monroe, to be entitled *Venus Descending*. United in their vision for the project, which would have combined a realistic depiction of Monroe's life with more fantastical elements, Lynch and Frost soon discovered that they enjoyed each other's company, and worked well as a creative team.

Despite the completion of a first-draft script in late 1986, *Venus Descending* would never reach the screen; both Lynch and Frost would blame shadowy interference from the Kennedy estate. But its influence would echo throughout Lynch's career: 'You could say that Laura Palmer is Marilyn Monroe,' he would write in *Room to Dream*, 'and that *Mulholland Drive* is about Marilyn Monroe, too. Everything is about Marilyn Monroe.'[2]

Either way, Lynch and Frost would continue their collaboration with a script for an original project, an absurdist romp entitled *One Saliva Bubble* about a town where an accident at a weapons research facility causes people to begin switching identities. Described by Lynch as 'an out-and-out wacko dumb comedy',[3] the film had secured funding from Dino De Laurentiis and was set to star Steve Martin and Martin Short when De Laurentiis Entertainment Group folded and the budget collapsed.

—

Given the violent and troubling nature of so much of his output, it may be hard to imagine Lynch directing a mainstream comedy. But in fact, there's a broad streak of goofy humour running through almost every one of his major projects: *Eraserhead* is as much nightmare farce as horror movie (think of Mr X bellowing 'look at my knees!'); villains like Frank Booth in *Blue Velvet* and Mr Eddy in *Lost Highway* are so extreme as to verge on the hilarious; *Wild at Heart* is peppered with gruesome jokes culminating in the sight of a dog running off with a human hand; the first act of *Twin Peaks: Fire Walk With Me* is essentially a drily humorous rerun of the original TV show; and *Twin Peaks: The Return* pushes a single joke further than had ever been attempted before, as Agent Cooper aka Dougie Jones spends literally hours of screen time shuffling aimlessly through a baffling world.

And although he never got to make a straight-up comedy for the big screen, Lynch would direct several comic shorts, TV episodes and web features, from his dry, DIY oddity *The Amputee* in 1974 to his last widely released short film, *What Did Jack Do?*, in 2017. In 1988, Lynch would join a group of five

98

renowned directors including Werner Herzog and Jean-Luc Godard to craft a segment for *The French as Seen by* ..., a portmanteau project produced for French television and overseen by the iconic *Le Figaro Magazine*. By some distance the least serious entry, Lynch's *The Cowboy and the Frenchman* combines 'two cliches in one',[4] as three taciturn, gun-toting cowpokes – played by Harry Dean Stanton, Jack Nance and the great Tracey Walter – encounter a beret-wearing, baguette-wielding stranger, played by producer Frederic Golchan. With frequent musical interludes, a time-frame that appears to span decades and Michael Horse as the film's third cliche, a Native American brave named Broken Feather, the film is goofy, sweet and genuinely funny.

Lynch's next foray into comedy would seem even more unlikely. In the wake of *Twin Peaks'* initial success, he and Frost would inexplicably be given a not insignificant budget to produce an original series of half-hour comedy episodes entitled *On the Air* (1992). Starring Ian Buchanan, a former soap star who brought an oily smarm to his role as clothing salesman Dick Tremayne in *Twin Peaks*, alongside Tracey Walter as 'Blinky' Watts, a technician who suffers from 'Bozeman's Simplex, a disease that causes him to see 25.62 times more than everyone else',[5] the show would take place backstage at a 1950s variety show. Loopy, self-conscious and gleefully dumb, *On the Air* would only run for three, appallingly reviewed and deeply unpopular episodes on ABC, though all seven shows would play in the UK and other territories. It's easy to see why it flopped: every joke is intentionally idiotic, every character is larger than life, and the tone of frantic, upbeat mayhem can prove exhausting. And yet, *On the Air* is one of the most purely joyful Lynch projects, and viewed in the right context – preferably with an audience – it's frequently hilarious.

99

Make 'em laugh: David Lynch on the set of his short-lived sitcom *On the Air* in 1992

And the show's failure didn't deter Lynch from attempting to make audiences laugh. Following the release of *Twin Peaks: Fire Walk With Me* in 1993 he would re-team with that film's co-writer, Robert Engels, for a script entitled *Dream of the Bovine*, an LA-set comedy about three men who used to be cows, and are trying to assimilate into human society. Described by Lynch as 'sort of in the same realm as *One Saliva Bubble*',[6] the film was set to star Harry Dean Stanton and – in Lynch's dreams – Marlon Brando. Unfortunately when Lynch and Stanton visited Brando to offer him a role, he declined. 'He looked me in the eye and said, "it's pretentious bullshit",'[7] Lynch would later admit. Brando did, however, become an occasional visitor to Lynch's home, helping himself to whatever was in the fridge and making the director, as he admits in *Room to Dream*, 'a little nervous'.[8]

In the early 2000s – around the same time that he took to the pages of *Empire* magazine to praise *There's Something About Mary* (1998), particularly 'all the dog bits ... And I like the guy with the crutches who tried to get his keys'[9] – Lynch would regularly turn to comedy when creating shorts for his website, notably the gleefully foul-mouthed *Dumbland* (2002), a web series animated on Flash and voiced by the director. Perhaps influenced by the work of independent filmmaker Don Hertzfeldt, whose line-drawn visual style and penchant for gruesome humour would see him Oscar-nominated for the 2000 short *Rejected,* the series also has overtones of TV's *South Park* (1997–present) as we follow the exploits of Randy, a moronic suburban father whose son Sparky is named after Lynch's dog and whose neighbour is, as he grudgingly admits, 'a one-armed duck fucker'. Initially commissioned by the video portal Shockwave before the dotcom bubble burst, Lynch would be paid in shares which swiftly became worthless – one final, dark joke at the expense of the show's creator.

—

Both *Venus Descending* and *One Saliva Bubble* may have stalled, but the Lynch-Frost partnership was a happy one. Their next project, another comedy and another deeply unusual proposition, would be pitched for television. *The Lemurians* would have followed the survivors of the ancient, Atlantis-like civilization of Lemuria, who are being hunted down and murdered by crooked, Geiger-counter-wielding FBI agents. But while the NBC network actually liked the idea and were willing to pick it up as a TV movie, Lynch was convinced it deserved to be a series.

Around the same time, however, another idea began to surface, starting with the image of a body washing up on the shores of a lake. Initially titled *Northwest Passage*, the concept would take shape as a mystery-box series set in a small, forested town just south of the Canadian border – the sort of old-fashioned settlement where, as one character observes, 'a yellow light still means slow down and not speed up'.[10]

Opening with that striking first image, the series would follow the hunt for the killer of Laura Palmer, a high-school girl whose picture-perfect exterior masked a secret life filled with drugs, sex work and abuse. Led by FBI Agent Dale Cooper – whose razor-keen powers of observation, dogged work ethic, boyish enthusiasm and reliance on intuition make him the most explicitly Lynch-like of all the director's leading men – and wide-eyed local Sheriff Harry S Truman, the investigation would expand outwards to expose the network of deceit, exploitation and lies that underpin this seemingly idyllic community.

'I have no idea where this will lead us, but I have a definite feeling it will be a place both wonderful and strange'

Lynch and Frost can't have held out much hope for their fourth pitch in two years, so they must've been pleasantly surprised when executives at the ABC network jumped at the show, commissioning a pilot script on the spot. Borrowing the small-town setting, 1950s stylings and array of unusual supporting characters from *Blue Velvet,* and adding Frost's knack for concise, audience-friendly storytelling, the pilot was written in a month, and the first draft was the one Lynch shot. 'We got together and strangely the ideas started flowing,' he would recall. 'Sometimes things just unfold in a really beautiful way.'[11]

A handful of network executives may have attempted to offer notes, but with Frost running defence, Lynch was able to proceed largely unencumbered. He was also free to bring a number of former collaborators back into the

101

Wrapped in plastic: Michael Ontkean,
Warren Frost and Sheryl Lee in the
early moments of the *Twin Peaks* pilot

fold, notably editor Duwayne Dunham – who was lured with the offer of directing an episode himself – and production designer Patricia Norris. But perhaps the biggest task fell to Johanna Ray, who had to find the perfect fit for each of the pilot's 30-plus speaking parts. While a handful – lead actor Kyle MacLachlan, *West Side Story* alumnus Russ Tamblyn and Lynch's old *Eraserhead* compadres Jack Nance and Catherine Coulson – would be hand-picked by the director, much of the cast list would be made up of newcomers scouted by Ray and her team.

Filmed largely in Washington State, with the entire cast and crew sharing a single hotel, the pilot for the show that would ultimately be titled *Twin Peaks* took just twenty-two-and-a-half days to shoot: a minor miracle, given the number of locations and setups required. Viewed today, the result is remarkable not so much for its lightly surreal touches – the one-armed man, the flickering lights in the autopsy room, the first appearance of the Log Lady – but for its mournful realism: the episode's long opening stretch is mostly comprised of characters reacting to the death of someone they loved, and some of those scenes, particularly the phone call between Laura Palmer's parents, are truly harrowing. The fact that Lynch is also able to weave in scenes of romance, eroticism and bone-dry comedy only makes the overall atmosphere of grief more palpable.

Another element of the pilot that would set it apart from the vast majority of contemporary small-screen entertainment is its visual richness. Photographed in autumnal shades of copper and green by experienced cinematographer Ron Garcia – who had shot the dazzling neon-lit musical *One From the Heart* (1981) for Francis Ford Coppola – the pilot even moves like a film: take the interrogation scene in the Twin Peaks High School library, as Garcia's camera glides around Bobby, Sheriff Truman and Hawk, shifting their positions in the frame, a technique redolent of a similar sequence in Orson Welles's late-noir masterpiece *Touch of Evil*.

And the references to classic Hollywood – and particularly *film noir* – don't end there. Not only is the murder victim's name a direct nod to Otto Preminger's dreamy, necromantic 1944 thriller *Laura*, about a detective who falls in love with the woman whose murder he is investigating, but the villain of that film, Waldo Lydecker, lends his name both to the mynah bird who witnesses Laura's slaying and the veterinary clinic where the bird was treated. *Noir* fans would also spot direct references to *Double Indemnity* – whose hapless insurance-agent hero, Walter Neff, gives his name

102

It was *Laura*: A poster for the dreamlike 1944 *film noir* that gave names to several characters in *Twin Peaks* (bottom)

Pocket rocket: Newcomers Dana Ashbrook and Mädchen Amick with David Lynch on the set of the *Twin Peaks* pilot (top)

Memories of *Twin Peaks*: Phoebe Augustine as sole survivor
Ronette Pulaski in the pilot episode (above) ...

... Agent Cooper (Kyle MacLachlan) joins mourners
at the funeral of Laura Palmer (bottom left) ...

... while 'Big' Ed Hurley (Everett McGill) consoles
his nephew James (James Marshall; bottom right)

to the character who comes to discuss Catherine Martell's life insurance claim – and to *Sunset Boulevard*, from where Lynch took the name of his very own character, Gordon Cole.

The central conceit of the seemingly perfect town filled with dark secrets had been inspired in part by the 1957 drama *Peyton Place* and its small-screen spinoff; Lynch may have hated the film, but he and Frost were still willing to draw on it for ideas (and to lampoon it, and the entire genre of daytime soaps, in *Twin Peaks*'s show-within-a-show, *Invitation to Love*). And although neither Lynch nor Frost ever discussed it, it's hard not to draw parallels between *Twin Peaks* and a curious 1962 thriller titled *Experiment in Terror*, directed by Blake Edwards between *Breakfast at Tiffany's* and *The Pink Panther*. Starring Lee Remick as a woman whose home is invaded by a masked man, the film not only possesses a powerful mood of suburban disquiet and barely suppressed sexual violence, it also features a villain named Garland Lynch, whose unusual first name would also be given to a major character in *Twin Peaks*. The opening moments even feature a close-up shot of a road sign reading, in block capitals, TWIN PEAKS – a reference to the LA suburb of the same name, but a startling coincidence nonetheless.

—

Though some at the ABC network expressed misgivings, on the strength of the pilot *Twin Peaks* was picked up in the spring of 1989 with an order for seven

The face of fear: Stefanie Powers in the unusual
1962 thriller *Experiment in Terror*

more episodes. With Lynch already in pre-production on his next feature, *Wild at Heart*, and only able to commit to directing a single instalment, it was left to Frost to pull together the team who would complete the series, including directors Tim Hunter, Duwayne Dunham, Tina Rathborne and Frost himself, and writers Harley Peyton and Robert Engels. Nevertheless, the first season of *Twin Peaks* shares a remarkably consistent tone, a pitch-perfect balance of mystery, humour, nostalgia and violence that would strike an immediate chord with the viewing public.

Following a long run-up and a lot of advance publicity, the pilot episode of *Twin Peaks* aired on 8 April 1990, scoring huge audiences. Reviews had been overwhelmingly positive: 'Troubling, transcendent,'[12] was *The Washington Post*'s verdict, while *Time* called the show 'Like nothing you've seen in prime time – or on God's earth ... It may be the most hauntingly original work ever done for American TV.'[13] *The Hollywood Reporter* called the show 'television at its best – climax, building, and climaxing again, ever drawing the viewer into its intrigue'[14] – though they did, rather patronizingly, express doubt that TV viewers would possess the patience for the show's steady reveal of information.

Thanks to raves like these – and cover stories in magazines including *Time, Rolling Stone* and *Entertainment Weekly* – *Twin Peaks* was an immediate cultural sensation, scoring strong viewer ratings despite going up against TV's most popular show, *Cheers*. For a time, Lynch and Frost's creation was inescapable: pretty young cast members like Sherilyn Fenn, Mädchen Amick, Dana Ashbrook and James Marshall became overnight stars, while

A night to remember: Cast members Wendy Robie and James Marshall (left); and Lara Flynn Boyle with Kyle MacLachlan (right) at the 1990 Emmy awards

the water-cooler debate around who killed Laura Palmer was a staple of the late-night talk shows, and even became a bumper sticker. After the first season finale aired – directed by Frost, who was determined to pack as many cliffhangers as possible into 43 minutes of television – the hunger for more *Twin Peaks* was palpable.

At September's Emmy awards, *Twin Peaks* received 14 nominations including Outstanding Drama Series, Outstanding Lead Actor in a Drama Series and Outstanding Directing in a Drama Series for Lynch – he would lose to a now entirely forgotten ABC series called *Equal Justice*. Indeed, the only Emmies the show collected were for costume design and editing – both well deserved, but not much consolation. They would fare better at the 1991 Golden Globes, however, where *Twin Peaks* picked up Best Drama, Best Actor for MacLachlan and Best Supporting Actress for screen legend Piper Laurie as the scheming Catherine Martell.

Twin Peaks also effortlessly achieved what *Dune* had so spectacularly failed to: a successful merchandizing campaign. In September 1990, Angelo Badalamenti's soundtrack landed in the top ten in several countries, while the single 'Falling' – the show's opening theme, with vocals by Julee Cruise – would prove equally successful. T-shirts, keyrings and coffee mugs followed, while a tie-in novel, Jennifer Lynch's speedily written but nonetheless heartfelt *The Secret Diary of Laura Palmer*, reached No. 4 on the *New York Times* best seller list.

—

But it couldn't last. A second spin-off book, *The Autobiography of FBI Special Agent Dale Cooper* by Mark Frost's brother Scott, would struggle in 1991, during the much longer second season. While reviews for the show would remain strong, notably for Lynch's magnificent, thread-tying season opener, the ratings would soon start to slide, thanks in part to the breakout of the Gulf War, which forced ABC to rework their schedule to make way for unplanned news announcements. But even after the conflict ended *Twin Peaks* continued to lose viewers, sparking panic at the network.

The blame for the decline of *Twin Peaks* has been laid at many doors. For Lynch, it would always be the fault of those ABC hatchet-men who forced him to reveal the identity of Laura's killer half-way through the second season, thereby robbing the series of its driving force. According to the director, the idea had always been that the investigation into Laura's murder would be just a hook on which to hang the rest of the show's interweaving plotlines and mysteries. 'It was not supposed to get solved,' he'd say. 'The idea was

'The only thing Columbus discovered was that he was lost'

An ill-starred romance: Sherilyn Fenn as Audrey Horne
and Kyle MacLachlan as her unrequited crush, FBI Agent
Dale Cooper in *Twin Peaks*

for it to recede a bit into the background, and the foreground would be that week's show ... As soon as that was over, it was basically the end. There were a couple of moments later when a wind of that mystery – a wind from that other world – would come blowing back in, but it just wasn't the same ... I loved *Twin Peaks*, but after that, it kind of drifted for me.'[15]

Others would blame Lynch himself for stepping away to focus on other projects, allowing lesser writers and directors to pollute the show's purity, while Frost has even insinuated that actor Lara Flynn Boyle was the guilty party, accusing her of vetoing a planned romance between Sherilyn Fenn's character Audrey and Agent Cooper, played by Boyle's then-boyfriend Kyle MacLachlan, which would've been one of Season 2's key storylines. Leaving aside the unlikely idea that a cast member like Boyle would have sufficient clout to shut down a major plotline, it seems far more likely that MacLachlan and others realized that depicting a sexual relationship between a high school girl and an FBI agent might not be entirely appropriate, and nixed the idea. Mercifully, Audrey's crush on Cooper would remain unrequited.

Whatever the reason, ABC's disinterest would become increasingly evident, as *Twin Peaks* was shuffled through various time slots only to be dumped into the unpopular Saturday night schedule. And yet, in all honesty, it's hard to blame them. With 22 hours of screen time to fill and no overarching narrative beyond the hunt for Laura's killer, Frost and his team were forced to make the show up as they went along, leading to half-baked plotlines like the arrival of 'satanic' orphan Little Nicky or the Miss Twin Peaks contest, which appears to be planned, advertised and staged within the space of a few days. While never less than entertaining, the drop-off in quality following the arrest of Laura's killer is inescapable, as that carefully modulated balance of humour and mystery tips into high camp, crude slapstick and wackiness.

—

So, with cancellation looming and nothing to lose, it was left to Lynch to retrieve as much as he could from the wreckage with his Season 2 closer. Titled 'Beyond Life and Death', the episode is credited to writers Frost, Peyton and Engels, but one glance at their original screenplay shows how far Lynch wandered off-book. 'He did not like the script that had been written,' production coordinator Sabrina Sutherland would later admit. 'He was so upset, So he rewrote it and took out stuff that he didn't like, and made new scenes to make it more like his and Mark's original vision.'[16]

Set almost entirely within the crimson-curtained confines of the Red Room – the threshold to a realm of ultimate evil known as the Black Lodge – the episode would be the most willfully abstract 43 minutes of film that Lynch had shot since *Eraserhead,* and one of the most extreme things ever broadcast on network television. It's also, perhaps, one of the angriest pieces of work he ever produced, his frustration at the way *Twin Peaks* had been treated

seeping through at every turn. Not only does the episode leave the fate of numerous fan-favourite characters hanging – while dispatching latecomers like cartoon villain Windom Earle with barely a backwards glance – it even has the temerity to undermine the show's most iconic and upright character, Agent Cooper, who, when faced with his 'shadow self', flees in terror, allowing his evil doppelgänger to escape into the 'real' world.

Screened on 10 June 1991, this unrepentantly downbeat finale would seem to signal the end of *Twin Peaks*, at least on television. The show's influence, however, had only just begun to percolate. It was *Connoisseur* magazine that, in September 1989, a full eight months before the pilot even aired, was the first to refer to *Twin Peaks* as 'the series that will change TV',[17] but it wouldn't be the last. From the beginning, reviewers and audiences recognized that the series would have a lasting impact on what had become an increasingly staid and risk-averse medium, and not only for its violence, sexuality and flashes of surrealism. At a time when television was seen as a step down for any seasoned movie actor, let alone a two-time Oscar nominated director, Lynch recognized the potential for telling an ongoing story within an intricately detailed world, and for building characters beyond the limits of the two-hour movie format. At the same time, *Twin Peaks* proved that a TV show needn't just be one thing – here was a murder mystery that was also a small-town soap, a character-based comedy and, increasingly, a sci-fi drama,

109

A shattering finale: Kyle MacLachlan as Bad Cooper in the climactic moments of the original *Twin Peaks* closer

'Wonderful and strange': Shows like *Wild Palms* (above left);
Eerie Indiana (below right) and *The X-Files* (top right)
were hugely influenced by *Twin Peaks*

with references to shadowy government agencies, extraterrestrial signals and worlds beyond this one.

It was in the autumn of 1991, just a few months after cancellation, that the first unmistakable 'child of *Twin Peaks*' would hit the small screen. Though aimed at kids, *Eerie, Indiana* is another small-town story of uncanny goings-on, blending goofy comedy with tales of the supernatural. 1993 would see the premiere not just of *Wild Palms* – a short-lived sci-fi satire executive produced by Oliver Stone, which quickly earned the critical epithet 'Twin Palms' – but another show that would take core elements of *Twin Peaks* and spin nine hugely successful seasons out of them. Starring *Twin Peaks* bit-player David Duchovny as an FBI agent investigating unexplained mysteries, *The X-Files* (1993–2018) is far more traditional than its forerunner, but the influence of Lynch and Frost is evident in its dry humour, its frequent visits to creepy small towns and its general air of pregnant mystery (the show also mirrors *Twin Peaks* in the fact that its core mythology was clearly cobbled together on the fly).

It may have taken time to filter through, but the success of *Twin Peaks* would ultimately lead in a direct line to the twenty-first-century's ongoing 'golden age of television', and to off-beat crime shows like *True Detective* (2014–present), *The Killing* (2011–2014) and *Hannibal* (2013–2015), not to mention mystery-box sci-fi series from *Lost* (2004–2010) to *Stranger Things* (2016–2025). As *Sopranos* (1999–2007) creator David Chase told *Time* magazine in 2017: 'Anybody making one-hour drama today who says he wasn't influenced by David Lynch is lying.'[18]

—

But if the tone, story elements and style of *Twin Peaks* would prove influential, so too would the show's most enduring single element: its music. Much of the soundtrack of *Twin Peaks* was actually written before the show, as part of the sessions for an album, *Floating Into the Night*, that Lynch and Badalamenti had begun making with singer Julee Cruise, and which would be released in September 1989. But while the album sleeve may credit Badalamenti as composer and Lynch as lyricist, in fact Lynch had been as much creative director as songwriter, dreaming up moods and tones for Badalamenti to spin into melodies. 'I would sit next to Angelo on the piano bench ... I would talk to Angelo with words, and he would play my words. And if I didn't like what he was playing, I would change my words ... Many times I'd start crying, it was so beautiful.'[19]

Inspired equally by 1980s dream-pop groups like Cocteau Twins, whose lead singer Elizabeth Fraser had provided lead vocals on Lynch's beloved 'Song to the Siren', and by mid-century jazz artists including Charles Mingus, Miles Davis and Dizzy Gillespie, *Floating Into the Night* is an album that still sounds like no other. At once driftingly ethereal and breezily cool, these 10 tracks would form the bedrock of the show's instrumental score.

It was while Lynch and Badalamenti were in New York mixing the soundtrack for *Wild at Heart* that the director was made an offer he couldn't refuse. Staged as part of the New Music America Festival at the Brooklyn Academy of Music, *Industrial Symphony No. 1: The Dream of the Brokenhearted* would be Lynch's first attempt at a live production. Drawing heavily on *Floating Into the Night*, this abstract performance piece opens with a filmed phone call between two unnamed former lovers played by Laura Dern and Nicolas Cage, then proceeds to depict the dream-life of the 'heartbroken woman', as personified by Cruise.

Later released on home video – where it was credited as A Film By David Lynch and Angelo Badalamenti – *Industrial Symphony* abounds with Lynchian touches: a half-naked woman writhes through the windshield of a rusted car, Cruise hangs suspended above the audience wearing an angelic white dress, and at one point diminutive *Twin Peaks* star Michael J. Anderson starts vigorously sawing a three-foot log – a reminder that, with Lynch, not every accusation of self-parody was entirely unfounded. But the film is interesting not just for its dreamy tone and imaginative set design, but because it was perhaps Lynch's most music-driven project thus far – with the exception of the film he was already working on.

'A policeman's dream': Kyle MacLachlan,
Michael Ontkean and a smorgasbord of sugary treats
in a publicity still for *Twin Peaks*

113

Dream pop: Julee Cruise on the Roadhouse stage
in *Twin Peaks* (top); and Cocteau Twins frontwoman
Elizabeth Fraser in the studio, 1989 (below)

Wild at Heart
1990-1991

Chapter Seven
'Stab it and steer'

The early 1990s would be the busiest period of David Lynch's life. No more fishing around for new projects: with the ink barely dry on the *Twin Peaks* deal, he was already flying down to New Orleans to shoot his next movie. The novel *Wild at Heart: The Story of Sailor and Lula* had come to Lynch via Monty Montgomery, who had produced the *Twin Peaks* pilot and would later – despite zero acting experience – play the pivotal role of the Cowboy in *Mulholland Drive.* The manuscript was handed to Montgomery by author Barry Gifford, a Chicago-born poet, essayist and writer who at the time was working as an editor on a series of rediscovered 1950s pulp novels. Initially keen to direct the adaptation, Montgomery asked Lynch to read the book and, if he liked it, to step in as executive producer. Instead, Lynch announced that he wanted to adapt it himself. 'I saw a love story in a violent and insane world,' Lynch would reflect later. 'And I saw a love story where the man and the woman were equal.'[1]

A lurid but highly entertaining pastiche of pulp-era lovers-on-the-run stories, Gifford's book would act more as a springboard for Lynch's screenplay, providing a pair of characters who, through his suburban lens, Lynch clearly viewed as the epitome of outsider cool. Part Elvis, part Kerouac, part violent

Be-bop-a-Lula: Laura Dern as the heroine
of David Lynch's 1990 road movie *Wild at Heart*

small-time crook, Sailor Ripley is outclassed only by the love of his life, Lula Pace Fortune, a joyseeking, emotionally driven firecracker who dreams of finding a safe place for her and Sailor to lie low, far from the violence and abuse that have marked her childhood.

Perhaps his least personal project to date, the film would take Lynch far from the wooded suburban enclaves of *Blue Velvet* and *Twin Peaks*, offering a garish, intentionally cliche-ridden take on the American South complete with drawling crooks, shit-kicking creeps, guitar-picking Bluesmen and wide open skies; a knowing exercise in pulp which rockets along on a cocktail of violence, gasoline, extreme language and very loud music. Boiling down the bones of Gifford's book, Lynch would stuff the script with his own unique fascinations, throwing in seemingly random scenes of extreme horror, deviance and dread, and the blackest comedy.

But perhaps the most Lynchian element in the film is its bizarre, cockeyed optimism: describing *Wild at Heart* as a story about 'finding love in hell',[2] Lynch's genuine affection for Sailor and Lula – and their enduring commitment to one another – lends heart and soul to what could easily have been a remote exercise in shock and strangeness. And while he may initially have considered keeping Gifford's downbeat ending because he didn't want to be accused of trying to be too commercial – 'in those days a happy ending made people puke – they thought it was a fuckin' sellout'[3] – ultimately Lynch decided to follow his gut and give these two disturbed but essentially admirable characters the finale they deserved. 'That can happen in life,' he would write in *Room to Dream*. 'Everything is possible and sometimes something just appears out of nowhere and makes everything right.'[4]

—

'Don't turn away from love, Sailor. Don't turn away from love.'

In *Wild at Heart*, the character who 'makes everything right', appearing to Sailor in a blaze of heavenly light and setting him back on the path of righteousness, is one that neither Lynch nor Gifford could take credit for. Played here by Lynch's current angel, Sheryl Lee, Glinda the Good Witch was of course 'borrowed' from the 1939 film *The Wizard of Oz*, based on the novel by L. Frank Baum, directed by Victor Fleming and King Vidor, and starring Judy Garland as Dorothy (a name Lynch had previously lifted for *Blue Velvet*), the little girl from Kansas who travels 'over the rainbow' to the mythical land of Oz.

For Lynch, the intrusion of characters from this most childlike of fantasies into his violent road movie was entirely organic. 'It just started creeping in that they (Sailor and Lula) love *The Wizard of Oz*,' he would recall. 'It made sense to the characters and in my mind it honours this great film ... that's caused people to dream for decades. There's something about *The Wizard of Oz* that's cosmic, and it talks to human beings in a deep way.'[5]

116

Over the rainbow: Nicolas Cage and Laura Dern
in *Wild at Heart* (opposite, top) ...

117

... and the movie they both adore,
The Wizard of Oz starring Judy Garland (bottom)

Weird on top: David Lynch on the set with
cinematographer Fred Elmes at the camera (top)

118

Lynch shoots the final scene with Cage and Dern (bottom left)

Nicolas Cage with the monstrous Bobby Peru,
played by Willem Dafoe (bottom right)

That 'uncool' happy ending (top left)

Lynch takes a moment alone
(top right)

119

Lynch with Laura Dern (bottom)

Structurally, the two are loosely similar: both are road movies in which good-hearted characters flee danger into strange lands, encountering both help and hardship along the way. Both are, essentially, musicals, featuring scenes where characters burst inexplicably into song. Both feature monstrous female villains: Diane Ladd's grotesque, controlling Marietta is explicitly paired with Margaret Hamilton's Wicked Witch of the West. Jack Nance even gets to cement the comparison, referring in a queasy speech about pet dogs to 'Toto, from *The Wizard of Oz*'.[6]

In fact, the links between *The Wizard of Oz* and Lynch's work are so explicit that in 2022 they would become the subject of an entire feature-length documentary, *Lynch/Oz*. With an impressive list of contributors including longtime fellow traveller John Waters and *A Ghost Story* (2017) director David Lowery, each essentially narrating their own 'visual essay' under the guidance of director Alexandre O. Philippe, the film makes a persuasive argument that *The Wizard of Oz* is among Lynch's most vital influences. Not just for its impact on *Wild at Heart* but for all the other references that crop up throughout his work, from the little dog in the opening scene of *Blue Velvet* (actually Lynch's own pet, Sparky) to Audrey Horne's ruby-red shoes in *Twin Peaks*, and from the hidden 'wizard' pulling the strings in *Mulholland Drive* to Agent Cooper's whirlwind re-entry into reality in *Twin Peaks: The Return*. Exactly when Lynch first encountered the film is unclear, but it seems certain that he caught it young, and it affected him deeply.

Friends reunited: Lynch compadre Jack Nance
makes a memorable cameo in *Wild at Heart* (left);
as does *Twin Peaks* alumnus Sheryl Lee (right)

The speed at which *Wild at Heart* came together was dizzying. With only two months between signing the rights and the start of shooting, Lynch powered through two drafts of the script, throwing everything he had at the project. Casting took place while the screenplay was still being written, with both Cage and Dern locked in for the lead roles. A number of parts also went to *Twin Peaks* alumni, notably small-screen mother–daughter pairing Grace Zabriskie and Sheryl Lee, and Sherilyn Fenn in an unforgettable one-scene cameo as a road accident victim. Other Lynch favourites included Harry Dean Stanton as browbeaten detective Jonny Farragut, *Dune*'s Freddie Jones making a brief cameo as a quacking lunatic in a bar, and Isabella Rossellini in immense, Frida Kahlo-inspired eyebrow make-up as the mysterious outlaw Perdita Durango.

But Lynch and Rossellini's relationship wouldn't survive the making of *Wild at Heart*. Though they had been together for around three years by this point, during the production their relationship began to fray. Lynch broke things off shortly after the film played in Cannes, leaving Rossellini shocked, angry and heartbroken. It was only later that she realized Lynch had fallen for an assistant editor, Mary Sweeney, who would later become his producer, his screenwriter, the mother of his third child, and very briefly his wife.

Shot fast and loose on a budget of $10 million and edited at breakneck speed, *Wild at Heart* scored early success at the Cannes Film Festival, where it won the film world's highest accolade, the Palme d'Or. It was a controversial win, however, particularly for those turned off by the film's excessive violence – little did they know that Lynch had actually trimmed some of the more extreme material, following walkouts at early screenings. 'I did cross the line in my first cuts,' he would admit later. 'I was kind of pushing it to this place I felt was real, but it was very sick and insane.'[7]

Despite this act of self-censorship, however, *Wild at Heart* would find itself caught up in a debate around movie violence that would see the film placed alongside the likes of *Henry: Portrait of a Serial Killer* (shot in 1986, but only distributed in 1990), *Reservoir Dogs* (1992), *Bad Lieutenant* (1992) and Oliver Stone's clearly Lynch-influenced *Natural Born Killers* (1994) as part of a new wave of screen savagery. Lynch was typically nonplussed by all the furore. 'I'm not sure what these people are saying,' he'd complain to *Rolling Stone* some years later. 'Is it that if you depicted no graphic violence, the world would calm down and there would be less violence? Or is it that if you sense certain things about violence and then portray those things in a film, does that make the violence go to another level?'[8] For Lynch, violence was just another tool, another way to impact his audience. 'I believe that films should have power, the power of good and the power of darkness,' he insisted. 'so that you can get some thrills and shake things up. And if you back off from that stuff you're shooting down into lukewarm junk.'[9]

Wild at Heart would go on to mediocre box office and middling reviews, many of which accused Lynch of self-parody: the new film had all the extreme violence and challenging eroticism of *Blue Velvet*, but with a much giddier,

122

The end of the affair: Lynch shooting *Wild at Heart*
with Isabella Rossellini (top); and accepting the Palme d'Or
at the 1990 Cannes Film Festival (bottom)

more cartoonish flavour. Putting aside the fact that *Wild at Heart* is tonally very different from anything Lynch had attempted before – it's fast, aggressive, raw and hysterical, a million miles from the ominous sensuality of *Blue Velvet* or the gentle nostalgia of *Twin Peaks* – the truth is that as an artist Lynch had a certain style and set of fascinations, so if there were parallels to be drawn between his films, that's only to be expected. 'All artists have a particular machinery and specific likes and dislikes,' he wrote, 'and the ideas they fall in love with are going to be certain kinds of ideas.'[10]

And while the film may have underperformed at the box office, fellow filmmakers were clearly taking notes: the influence of *Wild at Heart* is all over violent road movies like *Kalifornia* (1993), *The Living End* (1992) and *The Doom Generation* (1995) – the latter two both directed by DIY filmmaker and lifelong Lynch enthusiast Gregg Araki – while Quentin Tarantino's screenplays for a pair of ultra-violent lovers-on-the-run pictures, Tony Scott's gleeful *True Romance* and Oliver Stone's *Natural Born Killers*, are essentially shallower riffs on Lynch's film.

Wild at Heart also allowed Lynch to fully indulge his passion for popular music for the first time, from the dizzying speed metal of Powermad to the ominous strings of Schubert's '*Im Abendrot*', via Gene Vincent, Glenn Miller, African Head Charge, Elvis Presley and Chris Isaak, whose 'Wicked Game' would become as indelible as the movie itself. The resulting soundtrack is as thrillingly eclectic as any music geek's mixtape, reflecting the film's own mix-and-match aesthetic as it leaps from scene to scene and mood to mood like a playlist on shuffle. By contrast, Lynch's next film would pare everything back, zeroing in on a single character and tracking her journey into the blackest imaginable nightmare.

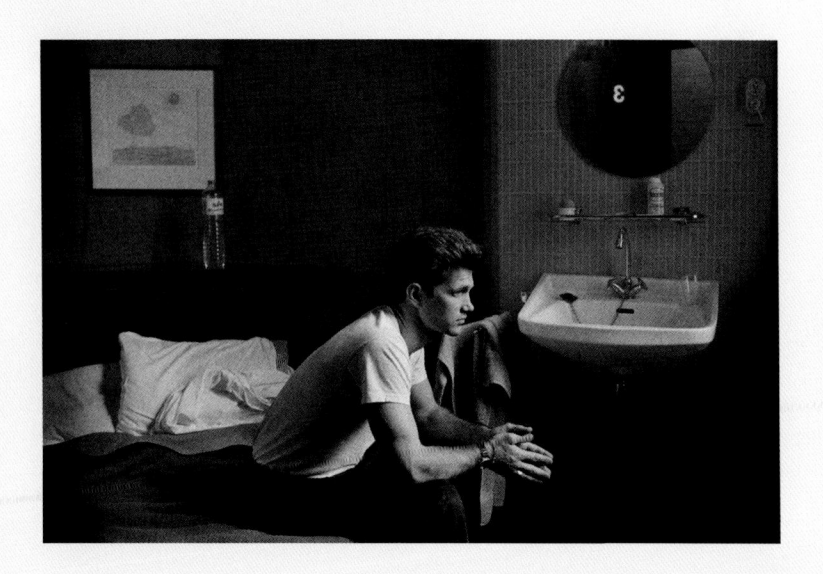

123

'The same power E had': Chris Isaak's 'Wicked Game'
provided *Wild at Heart* with an unlikely hit single

124

Quentin Tarantino's bloody heist flick *Reservoir Dogs* (top) Lynch fanatic Gregg Araki's *Doom Generation* (bottom)

Tarantino-scripted road movie *True Romance* (top)

Scattergun satire *Natural Born Killers* (bottom left) David Duchovny with Brad Pitt in *Kalifornia* (bottom right)

Twin Peaks: Fire Walk With Me
1991-1993

'The angels wouldn't help you, because they've all gone away'

David Lynch never thought of himself as a writer. 'I don't know how to spell, I don't know how to type. To me, writing is just a way to remember ideas.'[1] From the beginning he seemed uncomfortable with words: his earliest print interviews are filled with hesitations and obfuscations ('That I … I don't … I … I don't wanna, uh … talk about that'),[2] while even in his celebrity prime, watching him being interviewed could be a tortuous experience: he would shift in his seat and leave long pauses, staring into space as he attempted to find the right words to express himself. Utilizing a relatively limited vocabulary – often peppered with corny 1950s slang – he would repeat entire sentences verbatim from one interview to another, often years apart.

For Lynch, writing a screenplay was just a means to an end: like 'a blueprint for a house … it helps you find the structure and organize things'.[3] There would often be major differences between his initial scripts and the finished films, as the process of shooting sparked new ideas and fresh connections. He would never call himself an improviser: 'I don't really believe in improvisation – like say "let's just wing it and whatever goes." That is total bullshit to me.'[4] But his willingness to wander off the script, to experiment and explore, would become legendary.

Boys from the Bureau: Miguel Ferrer, Kyle MacLachlan,
David Lynch and David Bowie as unconventional FBI agents
in *Twin Peaks: Fire Walk With Me*

And yet, for all his reluctance, there was genuine poetry in the way Lynch wrote. From Duke Leto's speech to his son in *Dune*, a passage that appears nowhere in Frank Herbert's book – 'I'll miss the sea, but a person needs new experiences. They jar something deep inside, allowing him to grow. Without change something sleeps inside us, and seldom awakens. The sleeper must awaken'[5] – via Sandy's dream of the robins in *Blue Velvet*, all the way through to the words of the dying Log Lady in *Twin Peaks: The Return* – 'Electricity is humming. You hear it in the mountains and rivers. You see it dance among the seas and stars and glowing around the moon. But in these days the glow is dying. What will be in the darkness that remains?'[6] – his dialogue was always memorable, always elegant and often deeply moving.

And Lynch's lyrics could be equally expressive. The words he wrote for artists like Julee Cruise and Chrystabell – not to mention the songs he would later sing himself – possess the same enchanting directness as his dialogue, from old-fashioned romantic declarations redolent of those 1950s ballads he grew up on to story-songs influenced by the likes of Tom Waits or Bob Dylan, often set in LA and echoing those 'little stories' that one also finds in many of his artworks. And while they could look clumsy on paper – upon receiving the words Lynch had written for their first collaboration, 'Mysteries of Love', composer Angelo Badalamenti reportedly exclaimed that 'These are the worst fuckin' lyrics!'[7] – they always sounded perfect in context, voiced by Cruise and drenched in Badalamenti's synthesized strings.

—

Like a dog with a bone, David Lynch had carried his first self-penned script, *Ronnie Rocket*, around with him for more than a decade. But when he was finally offered the chance to make it – on a decent budget, with total creative control – he turned it down. 'When it comes down to it, I've always been afraid to make that film,' he would write much later. 'Something isn't right with the script and I don't know what it is; plus, I started thinking about Laura Palmer.'[8]

The ABC network – and the American TV audience – may have been finished with *Twin Peaks*, but David Lynch wasn't. The character of Laura still held enormous resonance for him: when Lynch told Chris Rodley in 2005 that he was 'in love ... with Laura Palmer, and her contradictions,'[9] he seems to have meant it in quite a literal sense, an almost Pygmalion-like devotion by an artist for his creation. It's also possible that the world of *Twin Peaks* had become something of a safe space for Lynch at a time of personal upheaval, as his relationship with Rossellini collapsed and his name suddenly became a household one – the term 'Lynchian' may not have been coined at this time, but by 1991, everyone knew what it meant. Returning to *Twin Peaks* would also offer the chance to correct some of the missteps that had been taken towards the end of the series, to ditch the weasel-worrying weirdness and remind viewers why they'd loved the show in the first place.

129

Hearts of flame: The original promotional poster
for *Twin Peaks: Fire Walk With Me*

FBI agents Kiefer Sutherland and Chris Isaak (top)

Sheryl Lee as tortured heroine Laura Palmer,
with (l-r) Eric DaRe, Phoebe Augustine and Walter Olkewicz (bottom)

131

'Now it's dark': Laura with her secret lover James Hurley
played by James Marshall in *Twin Peaks: Fire Walk With Me* (top & bottom)

And so, when French producer Pierre Bouygues and his production company Ciby 2000 offered Lynch a three-picture deal with essentially no strings, the director opted not to make his lifelong passion project – or at least, not right away. Instead he decided to go back to the source, to explore the lead-up to the events depicted in the pilot episode of *Twin Peaks*: the murder of Teresa Banks, and the slow descent of Laura Palmer. Why Lynch chose not to invite his co-creator Mark Frost on this journey remains a subject of debate: *Room to Dream* suggests that Lynch blamed Frost for the tone of later *Twin Peaks* episodes, but if that's the case, why would he choose to collaborate with Robert Engels, a screenwriter who may have written some of *Twin Peaks'* best moments, like Deputy Hawk's 'one woman can make you fly like an eagle'[10] speech, but had also been responsible for some of its very worst, from Ben Horne's re-enactment of the Civil War to Windom Earle in a horse costume?

Mercifully, pantomime ponies would not be required in the film version, for which a first draft screenplay had been completed within a month of *Twin Peaks*'s cancellation in June 1991. Instead, this would be a story of serial murder, familial decay and, as Lynch himself eloquently put it, 'the loneliness, shame, guilt, confusion and devastation of the victim of incest.'[11] It would be the most intimate and single-minded story Lynch had told since *Eraserhead*, and the most tragic since *The Elephant Man:* an unflinching portrait of innocence corrupted, and a headlong downward spiral into the darkest despair. There wouldn't be a pine weasel in sight.

Initially intending to include a full complement of characters from the TV show, Lynch was stung when several cast members – notably Lara Flynn Boyle, Sherilyn Fenn and Kyle MacLachlan – declined to take part, citing their unwillingness to become over-identified with their small-screen roles (Fenn had also been romantically linked with Lynch in the press, which may have affected her decision). Boyle would be recast and Fenn written out, and while MacLachlan did ultimately change his mind, by then it was too late: the majority of the scenes written for Cooper would instead be handed to Chris Isaak as fellow agent Chester Desmond, a situation that doesn't particularly improve the film, but doesn't really damage it either.

Like *Wild at Heart*, the film that would come to be titled *Twin Peaks: Fire Walk With Me* came together remarkably swiftly: by 8 August 1991, Lynch and Engels had completed their shooting script, and with the cast already in place, filming was able to begin on 5 September and finish by 31 October. Again, this schedule seems almost miraculous given the number of characters involved, many of whom would have to be edited out in order to get the film to a releasable length: Lynch may have been guaranteed final cut, but that didn't mean he was going to saddle Ciby 2000 with a three-and-a-half hour picture. Working with his pregnant partner Sweeney as editor, Lynch pared the film down to a lean and uncompromising 134 minutes, in time for a debut screening at the Cannes Film Festival on 16 May 1992, where just two years previously *Wild at Heart* had taken the top prize. Lightning would not strike twice.

'I was standing right behind you, but you're too dumb to turn around'

Famously, it was at Cannes that the trouble began for *Fire Walk With Me*. Though reports that the film was roundly booed may have been exaggerated – footage from the event clearly depicts an applauding crowd – there were a significant number of naysayers, and the press conference that followed the screening was decidedly prickly, with Lynch batting away questions about the film's 'perverse' nature. The overall critical reception was perhaps best summed up by Cannes attendee Quentin Tarantino, who said in an interview that 'David Lynch had disappeared so far up his own ass that I have no desire to see another David Lynch movie':[12] big words from a filmmaker who would go on to make a two-part, four-hour revenge thriller built entirely from movie references and in-jokes.

Looking back, the critical hammering meted out to *Fire Walk With Me* is borderline disturbing, an almost gleeful mob-murder of a film that most commentators simply refused to meet on its own terms. For the *New York Times'* Vincent Canby, it 'wasn't the worst movie ever made; it just feels like it',[13] while in *Variety*, Todd McCarthy claimed that 'Laura Palmer, after all the talk, is not a very interesting or compelling character and long before the climax has become a tiresome teenager.'[14]

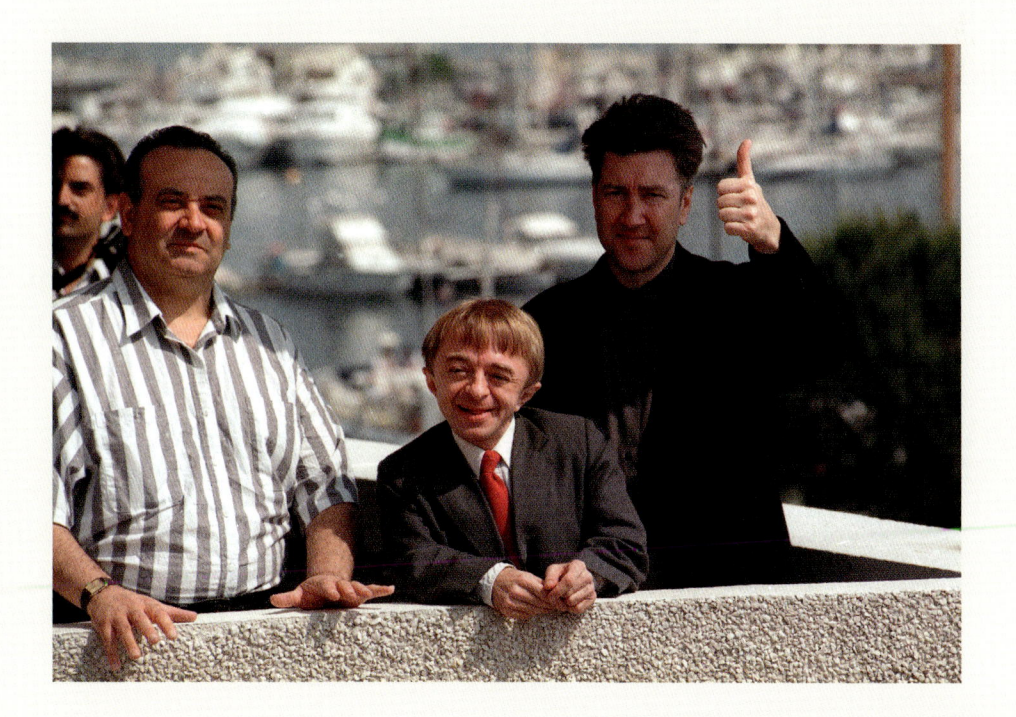

Trouble on the Croisette: Lynch returns to the Cannes
Film Festival, accompanied by Angelo Badalamenti (left)
and Michael J. Anderson (centre)

And the critics didn't reserve their loathing for reviews. *Time Out London* film editor Geoff Andrew used an interview with Lynch – presumably conducted by the director in good faith – to continue attacking the film, calling it 'a deeply cynical exercise, a blatant attempt to cash in on the success of the TV series'[15] – never mind that the show had just been cancelled for lack of audience figures – before going on to insinuate that Lynch is being intentionally obtuse, and even 'lazy ... boring and dumb'[16] for refusing to discuss the meaning of his film with someone who openly despised it.

For those faithful *Twin Peaks* fans who flocked to the film on first release, comments like these seemed to emanate from another planet. *Fire Walk With Me* was and remains a masterpiece: violent, yes, and deeply upsetting, absent some of the charm and sweetness of the show along with many of its quirkiest characters – an intention wittily signalled in the opening image of an axe slamming into a television set. But the film is also heartbreaking, intimate and profoundly resonant, anchored by a startling, courageous performance from Sheryl Lee, who as Laura switches from ecstasy to fear, from power to submission in a heartbeat, ably supported by Ray Wise as her self-loathing, demonically possessed father Leland.

In depicting Laura's humiliation, rape and eventual murder, Lynch would again be accused of misogyny, but in many ways his decision to go back and tell this story was a deeply responsible one. For the first time, Laura is able to become more than just a victim, a statistic, the metaphorical reflection of an entire town's transgressions. Instead we are allowed to witness her strengths as well as her weaknesses, her loyalty and bravery even after all the years of abuse have twisted her into something she knows to be wrong and corrupt. The sheer horror of her situation is never avoided, never sanitized, the complexity of her inner struggle never simplified. She is shown to be cold and self-serving, promiscuous and uncaring, and eventually suicidal. But we are with her every step of the way, drawn into her nightmare world, sharing her fear, her desperation, her need to dominate others and drag them down to her level. We understand at each moment why she behaves the way she does; we know that she never had a choice. And therein lies the film's power: Lynch never looks away, and never, ever does he trivialize his subject.

Reuniting Lynch with cinematographer Ron Garcia, the film would also be one of the best-looking of the director's career, moving out of the studio interiors that had increasingly come to dominate the TV show into sunlit streets and mist-shrouded forests, illuminating sets and faces with strobes and spotlights until the experience becomes almost overpowering. From the crimson of Laura's lipstick and the curtains of the Red Room to the glaring neon pink and blue of The Power and the Glory nightclub, *Fire Walk With Me* is saturated with colour, a stark contrast to its moments of almost total blackness.

But again, the most celebrated element in the film, both on release and in the decades since, would be its score. Consisting entirely of original music – excepting a handful of pieces originally written for the TV series – the soundtrack

A role to die for. Sheryl Lee gives the performance of a lifetime, accompanied by Kyle MacLachlan (top) and Ray Wise (bottom) in *Twin Peaks: Fire Walk With Me*

would balance Angelo Badalamenti's lush instrumentals with a brace of semi-improvised drone-rock workouts written by Lynch himself. The pair would also collaborate on a heartbreaking ballad, 'Questions in a World of Blue', to be sung by Julee Cruise, and on a raw, experimental spoken word project they named Thought Gang, who contributed two tracks to the soundtrack and belatedly released a full album in 2018. It was while recording one of these – the driving, rumbling 'A Real Indication', with shrieking vocals by Badalamenti himself – that Lynch laughed so hard he gave himself a hernia and ended up in hospital. His agony was worth it: the score would go on to win several awards, and in 2011 was named the Best Soundtrack of All Time by London's *New Musical Express*.

—

'Goddamn, these people are confusing'

Unsurprisingly, *Twin Peaks: Fire Walk With Me* would be a failure at the box office, earning back less than half of its production budget. A pair of planned sequels, which would have centred on the discovery of Laura's diary pages and the search for the 'real' Agent Cooper, were never even scripted, and despite having initially expressed an interest in returning to a world he clearly loved deeply, by 2001 Lynch was telling *Empire* magazine that *Twin Peaks* was 'as dead as a doornail'.[17]

But while its mainstream fanbase may have dwindled, the true *Twin Peaks* devotees never faltered in their love for the show – and over the years, that dedication would only deepen. 1993 would see the launch both of the first *Twin Peaks* fan publication, *Wrapped in Plastic*, which would run for 12 years and 75 issues, and of the first Twin Peaks Festival, a for-fans event held in Snoqualmie, Washington, which would continue successfully for more than two decades, hosting countless cast members and creatives.

The success of the US Festival would ultimately lead to an international edition, the Twin Peaks UK Festival in London, launched in 2009 by Julee Cruise herself, descending a flight of steps to perform 'Falling' to a breathless crowd. Over the next decade the TPUK would host appearances from cast members including Sheryl Lee, Catherine Coulson, Al Strobel and Mädchen Amick – among many others – alongside live music, screenings, cosplay, donut-eating competitions, games, quizzes and eye-opening stage performances from local Lynchian cabaret outfit The Double R Club.

Regrettably, both the US and UK Festivals would fall victim to their own success: while the return of *Twin Peaks* in 2017 should have offered up a whole new ticket-buying fanbase, wily TV executives had also been paying attention. In 2019, rights to the show would be withdrawn from both the US and UK festivals, and in their place, an officially sanctioned 30th anniversary celebration was planned for the summer of 2020. Scheduled to be held, for unexplained reasons,

136

Images from the Twin Peaks UK Festival:
An attendee cosplays as Pete Martell (opposite, top left), Michael Horse
greets cabaret performer Heavy Metal Pete (opposite, top right)

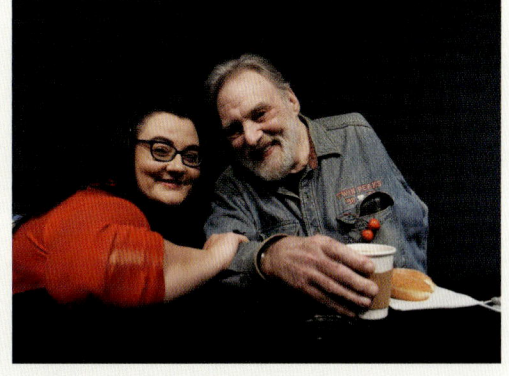

137

Double R Club mastermind Rose Thorne
performs as The Elephant Man (bottom left);
festival organiser Lindsey Bowden cosies up to
Al Strobel (bottom right)

in a convention centre across the street from Elvis Presley's home of Graceland, the event was cancelled due to the COVID-19 pandemic, and has yet to be revived.

Twin Peaks fans would also be instrumental in persuading Lynch to make a slight return to the series in 2014, as a years-long email campaign led to the release of *The Missing Pieces*, a 91-minute compilation of deleted and extended scenes from *Fire Walk With Me,* edited by Lynch and scored by Badalamenti. And while some of the footage would prove superfluous – nobody was dying to know what Jack at Hap's Diner really thought of Teresa Banks – the majority of these scenes bear comparison with anything in the released film, from Agent Desmond's knock-down drag-out fisticuffs with the lumbering Sheriff Cable to a series of illuminating flashbacks to Leland Palmer's time with Teresa.

Lynch may have made the decision not to edit these deleted scenes back into the film, but it was only a matter of time before fans took on the job themselves: several 'fan edits' of *Fire Walk With Me* can be found online, and are a must for any enthusiast. In this longer version Laura's downward spiral is, if anything, even more heartbreaking, echoing Bobby's words at Laura's graveside in the Lynch-directed third episode of *Twin Peaks*: 'Everybody knew she was in trouble, but we didn't do anything.'[18] From Doc Hayward to Sarah Palmer to Bobby himself, the deleted scenes hammer home the idea that Laura in her final days was utterly isolated, even from her closest friends and family.

And these recuts of *Fire Walk With Me* are not the only Lynch 'fan edits' in existence. While he may have removed his name from the notorious extended TV cut of *Dune* – that version is credited to director Alan Smithee and writer Judas Booth, a reference presumably to Frank, John Wilkes, or both – 2021 would see the unveiling of an excellent 3-hour cut put together by an editor known only as 'spicediver', and based on the original Lynch script. In 2023, this version even received the unexpected honour of being officially released, as part of a six-disc German Blu-ray package.

Meanwhile, also in 2014, the arrival of a 51-minute selection of deleted scenes from *Blue Velvet* – compiled, again, by Lynch – has led to several extended cuts of that film, featuring scenes like Jeffrey's forced departure from university, more of his dotty Aunt Barbara, and the long-rumoured scene where Dorothy attempts to throw herself off the roof of her building, only to be prevented by Jeffrey. However, while interesting, these scenes are by no means as crucial as *The Missing Pieces*

—

'Your Laura disappeared. It's just me now'

In the years following the release of *Fire Walk With Me*, Lynch would be philosophical about the film's reception: 'It was what it was supposed to be,' he told *Empire* in 2001, 'but it wasn`t what people wanted.'[19] Repeatedly, he

would stress that the experience was different from *Dune*, because in this instance he was happy with the work he'd done. 'With *Dune*, I sold out ... because I didn't have final cut, and it was a commercial failure, so I died two times with that,' he told *Deadline* in 2017. 'With *Fire Walk With Me*, it didn't go over well at the time, but I loved it so I only died once.' In *Room to Dream*, he insists that he didn't take the experience to heart, admitting 'that was a horrible, horrible stressful time', but insisting that he 'recovered quickly ... and bounced back and got to work'.[20]

Others, however, tell a rather different story. In an interview with *The Guardian*, Angelo Badalamenti would say that, 'for David, it was like somebody had taken away his kid and was murdering the child',[21] while in *Room to Dream* Lynch's biographer Kristine McKenna observes that 'Lynch began turning inward at that point.'[22] The total critical and commercial failure of his and Frost's second series *On the Air* (see page 99) around the same time can only have deepened Lynch's sense of despondency. 'When the black cloud comes over, there's nothing you can do about it,' he would tell *LA Weekly* in 2001. 'And then you wonder, "how long will the cloud be there?"'[23] It cannot be a coincidence that 1992 was the year he took up smoking again after a break of several years (the birth of his third child and second son, Riley, just six days after the Cannes premiere, may also have been a contributing factor).

David Lynch would step away from filmmaking for half a decade, and when he returned it would be with a much more controlled and impersonal piece of work, lacking the emotional abandon of *Fire Walk With Me*, *Blue Velvet* or *The Elephant Man*. Indeed, viewed in hindsight, the failure of *Fire Walk With Me* seems to mark something of a turning point in Lynch's filmography – it would be the last to feel so raw and personal, the last to mine his own inner life in such an unguarded fashion. Perhaps he felt that he had exposed a little too much of his soul with *Fire Walk With Me* – and the world had taken a vicious glee in ripping it to shreds.

—

There's a peculiar footnote to all this, however, because in fact, *Fire Walk With Me* would not prove to be David Lynch's final visit to *Twin Peaks* in the twentieth century. One country where the audience for the show had never dwindled – and where the release of the movie had audiences queueing round the block – was Japan, and in 1993 Lynch agreed to shoot a series of four commercials for Georgia, a popular brand of canned coffee owned by the Coca-Cola Company. Reuniting much of the *Twin Peaks* cast, including Kyle MacLachlan, Michael Horse, Kimmy Robertson, Michael Goaz and Catherine Coulson, who pops up in each instalment to repeat the words 'It's true!', the ads offer precisely the kind of upbeat goofiness that was absent from *Fire Walk With Me*, as Cooper hunts for a missing Japanese girl, following the clues to the Red Room only to escape with his personality – and love of coffee – intact.

The Georgia coffee ads were not David Lynch's first flirtation with the world of commercials, nor would they be his last. Indeed, the director's singular visual style and love of unexpected imagery might have been tailor-made for advertising, and it's no surprise that his first high-profile campaign, launched in 1988, was for the major lifestyle brand Obsession by Calvin Klein. Over the years Lynch has repeatedly been courted by perfume companies, directing ads for Gio by Armani (1992) and Opium by Yves St Laurent (1992 and 1999), alongside other big brands like Adidas (1993), PlayStation (2000), Nissan (2002), L'Oréal (2004) and Gucci (2007). Slick, sumptuous and almost invariably featuring beautiful people in sexy locations, these ads would not just provide Lynch with a steady income stream, but allow him to flex his filmmaking muscles in the lull between projects. 'Obviously, it's got to be partly about the money,' he would say. 'But, these commercials. I liked the idea of them. And ... I've got kind of a thing now about keeping busy.'[24]

Along the way this sideline has thrown up a handful of genuinely inter-esting projects, notably a grim, rat-infested Public Service Announcement produced by the New York Department of Sani-tation, aimed at terrifying citizens into disposing of their rubbish more carefully (the impact of Lynch's childhood trips to the city is evident in every frame). He also appears to have tested out ideas in his advertising work that he'd later develop in his filmmaking: the weird, hand-made special effects in his 1993 Adidas ad, *The Wall*, look uncannily similar to some of the intentionally outmoded digital tricks employed in his 2017 *Twin Peaks* reboot, while an entirely backwards-shot 1998 ad for Parisienne cigarettes takes place outside a tumbledown gas station almost identical to the convenience store visited in that series.

By the mid-2000s, Lynch's commercial work would begin to tail off: he'd never say why, but it seems likely that his comfortable financial situation – and the fact that he was busy making short films for his own website – must have played a part. In 2012, the launch of David Lynch Signature Brand coffee drew him briefly back to the commercial world, albeit in the loosest sense: one clip is just seven minutes of the director conversing with a detached Barbie doll head. As ever, Lynch's money-making instincts would appear to be just a little skewed.

Cup of joe? In 2012, David Lynch unleashed
his very own 'signature brand' coffee beans

142

'Black as midnight on a moonless night': David Lynch
enjoys a French blend at Cannes in 2001 (above)

Coffee lovers Audrey Horne (Sherilyn Fenn)
and Agent Cooper (Kyle MacLachlan) in *Twin Peaks* (opposite)

Lost Highway
1993-1997

'I'm ready to work'

Following the release of his next feature film, *Lost Highway*, David Lynch would tell interviewers that the reason it took him so long to follow *Twin Peaks: Fire Walk With Me* was that he'd been biding his time, waiting for the right idea to swim out. 'It's a matter of finding something that you fall in love with,' he'd tell Chris Rodley. 'You can't make a movie for money or any other reason than that you just fall in love with the material, and you're excited about it.'[1] In fact, Lynch had attempted to launch several feature films during this period, from oddball comedy *Dream of the Bovine* (see page 100) to an experimental biopic of Bluesman Robert Johnson entitled *Love in Vain* – an intriguing proposition, not least because it would have seen Lynch working with a majority Black cast.

But perhaps the most ambitious of these unrealized projects was a feature-length adaptation of Lynch's favourite novel, *Metamorphosis*, by the Prague-born Jewish novelist Franz Kafka – another idiosyncratic artist whose name has become an adjective, meaning anything labyrinthine, inescapable and perplexing. The story of a man who wakes up one morning to find that he has transformed into a giant insect, *Metamorphosis* was completed as a screenplay but the project never went anywhere, perhaps because it's such

Drifting apart: Patricia Arquette and Bill Pullman
as the unhappily married Madisons in *Lost Highway*

an obvious meeting of material and director that it's possible to imagine the film in detail without it having to actually exist at all.

Kafka would, however, continue to be a source of inspiration: as Lynch said in 1986: 'the one artist that I feel could be my brother – and I almost don't like saying it because the reaction is always, "yeah, you and everybody else" – is Franz Kafka. I really dig him a lot ... If Kafka wrote a crime picture ... I'd like to direct that, for sure.'[2] Kafka's influence is detectable throughout Lynch's work, from the fruitless search for meaning embarked upon by Henry Spencer in *Eraserhead* to the labyrinthine nature of the Red Room in *Twin Peaks*, while in *Twin Peaks: The Return*, Lynch's character Gordon Cole even has a portrait of the author on the wall of his FBI office: a nod, perhaps, to the impenetrable, Kafkaesque nature of that entire series.

One project that did go somewhere was *Hotel Room* (1993), an anthology series for HBO comprising three half-hour episodes, of which Lynch directed the first and last from scripts by *Wild at Heart* author Barry Gifford. Co-created with producer Monty Montgomery, the show took place across different time periods in the same New York hotel, with each episode telling a standalone story with unique characters. But despite solid scripts, a Badalamenti score and an excellent cast of Lynch regulars including Freddie Jones, Harry Dean Stanton, Alicia Witt and Crispin Glover, the series failed to find its audience, and a proposal for further instalments was never followed up.

Hotel Room would be released as an anthology film on VHS, with the director's name prominent on the cover. But revisiting the show today, it's hard not to blame Lynch for its failure. The idea of telling an entire story in one room is not, by definition, a bad one: the majority of *Eraserhead* had taken place in a single apartment, a space that Lynch managed to make simultaneously eerie

'My brother': This 1923 portrait of author Franz Kafka (top) can be glimpsed on the wall of Gordon Cole's office in *Twin Peaks: The Return* (bottom)

and familiar. By contrast, *Hotel Room* tends towards the stagey, and indeed Gifford would later convert his scripts into plays for the theatre. The fact that the series was shot in the wake of *Fire Walk With Me* can't have helped: Lynch doesn't seem fully engaged with the material, shooting in an uncommonly workmanlike fashion.

—

The same cannot be said of the second notable project that Lynch would put his name to during this period. Released in 1995 to mark the 100th anniversary of *L'Arrivée d'un train en gare de La Ciotat*, commonly agreed to be the first moving picture ever screened for the public, the portmanteau film *Lumiere and Company* was intended as a tribute to the French brothers who invented the first cinematograph, collecting 41 short pieces by renowned directors each shot with an original Lumiere camera, and working with similar restrictions to the brothers themselves. 'The deal was you had three takes,' Lynch would recall. 'And each take was about 55 seconds, in a beautiful little wooden magazine, hand-cranked camera ... You had to use natural light, you could not edit but you could put on sound or music.'[3]

The results would be intriguing and diverse, ranging from the personal – Spike Lee would film his daughter learning to speak – to the bluntly practical, as Michael Haneke simply shot 52 seconds of TV news. But it would be Lynch whose film would be most widely celebrated – indeed, for all its cultural promise, just about the only reason anyone mentions *Lumiere and Company* today is because of Lynch's *Premonition Following an Evil Deed*, which remains one of the most brutally effective and downright unsettling films of the director's entire career, despite lasting less than a minute. Shot in a single take, the short utilized a complex set built in the front yard of a property belonging to practical effects technician Gary d'Amico, a Hollywood veteran who had worked on everything from *Tron* (1982) to *Waterworld* (1995), and would go on to oversee the effects on each of Lynch's future projects.

In classic Lynch fashion, *Premonition ...* is built up of disparate images that somehow combine to become more than the sum of their parts. As a group of policemen approach a suburban home where a child's body lies in the yard, the occupant seems to suffer a series of disturbing hallucinations: visions of sadistic torture, of monstrous men with melting faces, of roaring flames. It may be brief, but the film engenders a sense of dread as clammy and palpable as anything in *The Grandmother* or *Eraserhead*, those early works that *Premonition ...* most resembles. And it was this very sense of dread that would infiltrate every frame of Lynch's next big-screen project.

147

A century of cinema: the Lumiere brothers,
Auguste and Louis, photographed in 1895

HERTS-LION INTERNATIONAL CORP.
PRESENTS

A "NEW WAVE" PICTURE
YOU CANNOT FORGET!

A SENSATION ABOUT
A NEW DIMENSION!!

'Captain, this is some spooky shit we got here'

Dread is a very Lynchian emotion, and a weapon he employed more effectively than perhaps any other filmmaker. None of his films could be straightforwardly classed as horror – though with its themes of demonic possession and murder, *Twin Peaks: Fire Walk With Me* comes closest – but Lynch utilized the techniques of horror cinema throughout his career, from the splattering gore of the dissected baby in *Eraserhead* to the hacked-up victims of ice-pick killer Ike 'The Spike' in *Twin Peaks: The Return,* via the merciless 'jump-scares' of Frank's sudden appearance in *Blue Velvet* and Laura's discovery of Bob behind her closet in *Fire Walk With Me,* still perhaps the most jarring moment in the director's filmography.

Again, Lynch would be close-mouthed when it came to his debt to horror; however, one movie that is regularly cited as a likely influence is also, perhaps, the single most Lynchian film ever made by anyone other than the director himself: 1962's *Carnival of Souls,* directed by Kansas-born commercial film-maker Herk Harvey. Shot in black and white and completed guerilla-style when the budget ran out, *Carnival of Souls* was the *Eraserhead* of its day; an eerie daylight ghost story influenced, like Lynch, by the work of Jean Cocteau and his fellow surrealists.

DIY dread: An original 1962 pressbook for *Carnival of Souls* (above),
starring director Herk Harvey as 'The Man' (opposite, top)

149

Party crasher: Robert Blake as the terrifying
Mystery Man in *Lost Highway* (bottom)

150

Night people: Patricia Arquette as Alice Wakefield (top);
Balthazar Getty as Pete Dayton (bottom)

Exactly when (or even if) Lynch saw the film remains unclear; however, *Carnival of Souls* screenwriter John Clifford would go on to work as a song-writing partner with Angelo Badalamenti, so there is a direct connection. And while the similarities between *Carnival* and *Eraserhead* are almost certainly coincidental, they are worth noting, not just the hand-to-mouth nature of the films' creation or their atmosphere of slightly stilted otherworldliness, but key details, too, like the central presence of a blonde, confused young woman named Mary.

Throughout *Carnival of Souls*, Mary is haunted by visions of a figure known only as The Man – a white-faced, smirking phantom played by Harvey himself. In Lynch's next project, his disturbed hero Fred Madison would be visited by an eerily similar figure: the pale and smiling Mystery Man, played by Robert Blake, whose nocturnal visitations send Fred into a spiral of madness and psychological breakdown. 'The character came out of a feeling,' Lynch would tell *Cinefantastique*, 'of a man who, whether real or not, gave the impression that he was supernatural.'[4] Again, *Lost Highway* may not be a horror movie – but at least for the first half-hour, it sure feels like one.

—

The roots of *Lost Highway* are as fractured as the film itself. On the last night of shooting *Fire Walk With Me*, Lynch conceived the idea of a couple whose marriage is falling apart finding video tapes on their doorstep. Some time later, he read the novel *Night People* by Barry Gifford and was intrigued by a single line: 'We're just a couple of Apaches riding wild on the lost highway.'

151

Robert Loggia as Mr Eddy in *Lost Highway*

Following that, at his home in Los Angeles, Lynch answered the telecom one morning to hear a voice telling him that 'Dick Laurent is dead' – a sentence that meant nothing to him.

Then in June 1994, the fatal stabbing of Nicole Brown and Ronald Goldman led to the arrest of Brown's husband O.J. Simpson, and a murder trial that would capture the imagination of every American, Lynch included. 'I was kind of obsessed,' he would say later. 'It struck me how someone could do murders, then go on living with themselves.'[5] The idea was fascinating to Lynch. 'Ask yourself: How can O.J. golf? How can he even hit the ball? How can he even go out of bed in the morning? How does the mind seal itself off from horror?'[6]

In 1995, Lynch would approach Gifford, not to acquire the rights to *Night People* but to propose that they work on an original screenplay together. Early efforts went nowhere, with the pair tossing out as many ideas as they kept, but gradually *Lost Highway* began to take shape. Later that year Lynch would take the script to Ciby 2000, with whom he still had a good relationship; the deal would be quickly finalized, and shooting would commence before the end of the year. But it would take a long time for *Lost Highway* to find its way into cinemas, debuting in France in January of 1997 following a lengthy post-production process and some extensive cuts.

Both literally and figuratively the darkest film of Lynch's career, *Lost Highway* begins with the character of Fred Madison (Bill Pullman), a saxophone player who becomes convinced that his wife Renee (Patricia Arquette) is cheating on him. After receiving a series of mysterious video tapes that appear to show events inside their home, Fred's paranoia increases until he snaps and apparently murders his wife – though he has no recollection of doing so. Confined to Death Row, Fred is awaiting execution when he inexplicably transforms into an entirely different person: Pete Dayton (Balthazar Getty), a young suburban mechanic whose life is about to intersect with that of local thug Mr Eddy (Robert Loggia) and his new squeeze Alice Wakefield, also played by Arquette.

Shot almost entirely within a house on the same street as Lynch's home – a property he actually purchased and refurbished specifically for the production, and would continue to own for the rest of his life – the opening act of *Lost Highway* is as hermetic and unnerving as *Eraserhead*, as Fred and Renee drift from darkened room to pitch-black corridor, watching in horror as their lives are recorded on tape, and finding it progressively harder to trust one another. Working with cinematographer Peter Deming – another Hollywood veteran whose work on mainstream comedies like *Drop Dead Fred* (1991) and *My Cousin Vinny* (1992) led him to *On the Air* (1992), where he established a good working relationship with Lynch – this first act is *film noir* in the most literal sense, the characters seeming to melt into the shadows as their lives steadily disintegrate.

But if the first act resembles Lynch's early work, the longer second section sits somewhere between *Blue Velvet* and *Wild at Heart*, as Pete tries

'People coming out of darkness visually is beautiful, but the idea
of coming out of darkness is really what life is about'

'At your house': A 2024 image of the residence on Senalda Road
purchased by Lynch for use in *Lost Highway*

to get his head around exactly how he ended up in that prison cell, all the while falling dangerously for Arquette's sultry Alice. Like those earlier films, *Lost Highway* wears its influences on its sleeve: the blonde-brunette pairing of Alice and Renee – who may or may not be sisters, or even the same person – is, as we've seen, a clear nod to Hitchcock's *Vertigo*, while the relationship between Pete and Alice comes straight from *Double Indemnity*, another story of a well-meaning doofus tricked into criminal acts by an alluring *femme fatale*. The snarling, vicious Mr Eddy, meanwhile, is a wholly Lynchian creation – a near-resurrection of Frank Booth, with a touch of Mr Reindeer.

–

'We've met before, haven't we?'

The issue is that by borrowing plot ideas and characters from well-known movies – and from Lynch's own back catalogue – *Lost Highway* not only opens itself up to familiar accusations of self-parody, but also comes close to becoming something that the director had never been before: predictable. And yet, *Lost Highway* is still a David Lynch movie, and one crammed with ideas, wit and visual splendour. The idea of someone so horrified by their actions that they literally transform into another person is fascinating; after the film was completed, Lynch even learned that there's a name for it: *psychogenic fugue*, a psychological illness whereby a traumatized person sheds their 'real' personality and becomes someone else. Deming's photography is extraordinary throughout; his use of white light and black shadows is almost hypnotic. Individual moments rival anything in the Lynch canon in terms of uncanny impact: the Mystery Man's first appearance, taunting Fred at a showbiz party; the shot of a corpse impaled on a glass table; and of course the flickering lines of the 'lost highway' itself, as David Bowie's jittery murder ballad 'I'm Deranged' rises on the soundtrack.

Indeed, pop music is once again a powerful force in *Lost Highway*: the use of tracks by 1990s electro-goth outfits like Smashing Pumpkins and Marilyn Manson – who also appears, mercifully briefly, in a pornographic movie-within-the-movie – may date the film slightly, but other pieces, like Lou Reed's fuzzily ecstatic cover of The Drifters' 'This Magic Moment', work brilliantly. And while Angelo Badalamenti was once again hired to pen an orchestral score, a large proportion of the music for *Lost Highway* was actually written by the great British multi-instrumentalist Barry Adamson, whose sleek, atmospheric lounge-pop suits the film perfectly. Disappointingly, however, the soundtrack would be attributed solely to Badalamenti, with Adamson listed as providing 'additional music'.

Somewhat predictably, *Lost Highway* was not a box-office success. Too moody and abstract for general audiences, the film met with a mixed response from critics, too, many of whom praised its sinister opening but felt that the film lost its way in the second half. Once again, America's premier film writer

Roger Ebert came out swinging, dismissing the film as 'not much fun, and kind of cold'[7] – though when Ebert and critical partner Gene Siskel treated the film to their dreaded Two Thumbs Down rating, Lynch's marketing team struck back with a poster describing the verdict as 'two more great reasons to see *Lost Highway*'.

Indeed, the critical and commercial failure of the film doesn't seem to have affected Lynch anything like as deeply as the punishment handed out to *Fire Walk With Me.* To some extent, this must have been because he was expecting it: a film like *Lost Highway* was never going to receive across-the-board praise. Perhaps he had grown a thicker skin, refusing to allow the opinions of non-creative people to affect him. Or maybe the film simply didn't have the same emotional resonance: while clearly a labour of love, it feels more impersonal than anything he'd made since *Dune.* This would seem doubly true for Lynch's next feature, a studio picture whose script – for the first time in his career – would be written entirely by someone else.

As always, however, appearances would be deceptive.

Gratuitous sax: Bill Pullman as jazz musician Fred Madison,
with David Lynch on the set of *Lost Highway*

The Straight Story
1997-1999

Chapter Ten
'Like we used to do, so long ago'

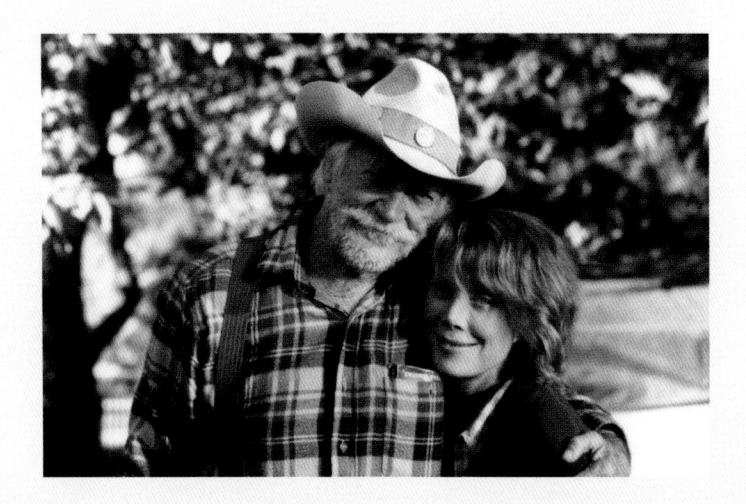

By the time *Lost Highway* premiered, Lynch was already back in his studio, preparing the artworks for a pair of exhibitions in Osaka and Paris, and getting ready for his first furniture showcase at the Salon de Mobile in Milan. Always something of a handyman, Lynch had been designing and building furniture since art school or even earlier, since the 'family projects' he used to work on as a kid. 'My father had a workshop in the house,' he would tell *Form* magazine in 1997, 'and I was taught how to use tools and spent a lot of time in the shop building things ... I love building. And building is as important as designing, because many times design grows as one is building.'[1]

This facility with carpentry and construction meant that, throughout his career, David Lynch would be a world-builder in the most literal sense: many of the props seen in *Eraserhead* were designed and built by Lynch, while during pre-production on both *The Elephant Man* and *Dune* he was deeply involved in the creation of everything from sets to make-up effects to creatures, with varying results. Behind-the-scenes footage from *Twin Peaks: The Return* found him still getting stuck in, mixing plaster, stirring gold paint and cracking eggs to use as mysterious slime.

157

A travelling man: Richard Farnsworth as Alvin Straight
with Sissy Spacek as his daughter Rose in *The Straight Story*

Influenced by mid-century designers like Ray and Charles Eames, whose furniture would become iconic in the 1940s and 1950s, as well as New York-based designer Vladimir Kagan and the French designer Charlotte Perriand, Lynch began taking furniture more seriously in the 1990s: *Lost Highway* was the first of his films to really showcase his designs, notably the opening scenes, where the Madison house features several of Lynch's own pieces. 'Sometimes I see a need for a certain piece of furniture, in a certain place,' he told *Form*. 'It'd take too much time to search for a specific piece. And it's more fun for me to build it on my own.'[2]

—

Also keeping himself busy with commercial work – including, rather bizarrely, an ad for Clearblue Easy home pregnancy tests (1997) – Lynch was in the same period starting to become fascinated with the possibilities of the internet, laying the groundwork for his own website, a project that wouldn't reach fruition until several years later. And he was once again fishing around for a new film project, reportedly turning down offers to direct scripts including *American Beauty* (1999) and the US remake of the Japanese horror movie *Ring* (1998), though he would later claim to have no memory of either.

The script he did agree to make would come from a place much closer to home. By then Lynch's partner for five years – as well as his editor on *Lost Highway* – Mary Sweeney had been working with her friend John Roach on a screenplay inspired by the unlikely odyssey of Alvin Straight, a septuagenarian Second World War veteran who, in 1994, had made the 240-mile (385-km) trip from his home in Laurens, Iowa to visit his brother in Blue River, Wisconsin. Denied a driving licence on account of his eyesight, Straight made the entire trip on a 1966 John Deere riding mower, travelling at 5mph (8km/h) and taking six weeks to complete the journey.

While she may not have been writing with Lynch in mind – the director would later admit that he 'had zero interest in a man on a lawnmower'[3] – Sweeney did ask him to take a look at the completed screenplay and offer his thoughts. To her surprise, Lynch took to the project wholeheartedly. 'What struck me was the simplicity,' he would tell *Positif*. 'The purity of the story ... It's about a man, all alone.'[4] The character of Alvin may also have reminded Lynch of his own Midwestern grandfather, another old-school American with a can-do attitude.

As mentioned, *The Straight Story* would be the first and only example of Lynch shooting from someone else's script, but that isn't the only unique aspect of the production: not for nothing would Lynch refer to it as 'my most experimental movie'.[5] For the first time he would shoot almost entirely in sequence, in real locations: there was no world-building required here, no furniture design or prop creation, though it's hard to imagine that Lynch didn't have a hand in crafting the rust-bucket appearance of Straight's mower

and its creaking, over-heaped trailer. Starting in Laurens, the cast and crew crawled like Straight across the Midwest, shooting on highways, in woodlands, in bars, homes and gas stations, locations Lynch had personally picked out on an earlier retracing of the route. 'The important thing for me was the vast extent of the countryside, and the feeling of floating in nature.'[6]

This very Lynchian sensation of floating is most evident in the film's opening and closing shots, a pair of drifting star-fields that hark back to the final image in *The Elephant Man*, and are equally transcendent. Indeed, comparisons between Lynch's first studio picture and *The Straight Story* run deep: like John Merrick, Alvin is a man out of time, searching for his place in the world and finding both help and hindrance along the way. And again, *The Straight Story* is clearly informed by Lynch's practice of meditation, with its slow, considerate pace and mindful fascination with simple, everyday objects: rusty machines, open skies, grain silos and tarmac roads.

'I long for a kind of quiet where I can
just drift and dream'

159

Power couple: David Lynch with his partner, screenwriter
and editor Mary Sweeney on the set of *The Straight Story*

But perhaps the most Lynchian element of *The Straight Story* is its focus on family: a consistent theme in his films, though this would be the last time he would address it so directly. Made up of just two people, Alvin Straight and his daughter Rose (a mother and other children have come and gone, we're told), the Straights are not a twisted, hateful family like the Palmers or the Madisons, but a loving, supportive unit like the Beaumonts in *Blue Velvet*, the Haywards in *Twin Peaks*, Sailor and Lula in *Wild at Heart* or Lynch's own parents. Indeed, the entire plot of the film rests on Alvin's desire to retrieve a wayward family member and return him to the fold – and in the real-life Straight story, Alvin's brother, whose name was Henry, ended up moving back to Laurens to be closer to his family.

For Lynch, the film was also a family affair in a more direct sense. Not only was it written, produced and edited by his longtime partner, it was also soundtracked – gorgeously – by Angelo Badalamenti, and shot by the 82-year-old Freddie Francis, in his first collaboration with Lynch since *Dune*, and his final film before retirement. Happily, *The Straight Story* would also reunite Lynch with his oldest and closest friend, Jack Fisk. Though the pair had never been out of touch – Fisk had even directed a pair of *On the Air* episodes – this would be their closest collaboration since art school, and along with his work on Terrence Malick's *The Thin Red Line* (1998) – another film concerned with spirituality, and ideas of 'floating in nature' – *The Straight Story* would mark the spectacular rebirth of Fisk's career as a production designer: he would work with Lynch again on *Mulholland Drive*, before going on to become perhaps the most respected designer in the business with projects like *There Will Be Blood* (2007), *The Tree of Life* (2011) and *Killers of the Flower Moon* (2023).

And Fisk didn't travel alone. For the part of Rose, Lynch was finally able to cast an actor who had been a part of his life since *Eraserhead*, but who had never appeared in one of his movies: Sissy Spacek, whose marriage to Fisk was still going strong – in fact, the pair celebrated their fiftieth wedding anniversary in 2024. A complex and potentially controversial role, Rose is neurodivergent, leading to a unique manner of speech and behaviour – an element of her character that both Lynch and Spacek were committed to getting right. 'Playing someone who is a little outside the norm is always a delicate thing,' Lynch would tell *Salon* at the time. 'And Sissy just dances along the high wire and makes it look simple.'[7]

While some smaller roles would be filled out by Lynch regulars, including Harry Dean Stanton as the wayward Lyle Straight and *Twin Peaks*' Everett McGill as an upstanding mower salesman, the part of Alvin would go to a stuntman turned actor who had been working in Hollywood for more than sixty years, making his screen debut alongside the Marx Brothers in 1937's *A Day at the Races*. 79 years old and afflicted with terminal prostate and bone cancer, Richard Farnsworth accepted the role of Alvin in the full knowledge that it would be his last, and in fact he would take his own life less than a year after the film was released. Present in almost every scene – and physically

The ties that bind: Richard Farnsworth and Sissy Spacek
as Alvin and Rose (opposite, top)

161

The real Alvin Straight with his brother Henry,
pictured in 1998 (bottom left); and Spacek with her
husband, Lynch's friend Jack Fisk, in 1970 (bottom right)

active for many of them – Farnsworth quite literally gives the performance of a lifetime, the years of hardship, struggle, joy and disappointment written in every line on his face. Frustratingly, while he was nominated for the Best Actor Oscar, Farnsworth would be passed over in favour of *American Beauty*'s Kevin Spacey – a decision the Academy may have had cause to regret in the years since.

—

'Did you ride that thing all the way out here to see me?'

The Straight Story would earn Lynch his best reviews since *Blue Velvet* – perhaps unsurprisingly, given that, at the time of its release, the average American movie critic occupied approximately the same demographic as Farnsworth's sympathetic hero. Lauding the film's naturalistic tone and absence of sentimentality, the reviews would inevitably single out Farnsworth for particular praise, but many would find space for Lynch, too, with Janet Maslin in the *New York Times* calling it 'a profoundly spiritual film that can hold an audience in absolute thrall … Lynch presents the flip side of *Blue Velvet* and turns it into a supremely improbable triumph.'[8]

Once again, however, the film would struggle at the box office, earning just over half its production budget on domestic release. And in the years since, it has become something of a lost Lynch film, viewed as a minor work beside the 'big beasts' of *Blue Velvet* and *Mulholland Drive*. Perhaps it's simply that, to some viewers, the film feels too direct, too effortless, too damn *straight* to slot neatly into Lynch's body of work. But such an attitude displays a shallow and reductive understanding of Lynch and his films, and indeed the very nature of what it means to make art. Though it may tell a simpler tale than the mystery-box narratives of *Lost Highway* and *INLAND EMPIRE*, *The Straight Story* contains countless threads linking it to Lynch projects before and after, not just its sense of meditative transcendence or its focus on the family but its depiction of a determined hero on an absurd, heartfelt but potentially impossible quest; its warm, goofy humour and moments of romanticism; and its love of American landscapes and American people, particularly those in small towns (the clerk in the hardware store where Alvin buys his all-important 'grabber' even wears the same red waistcoat as the employees of Beaumont's in *Blue Velvet*). Even the circumstances of the film's creation would prove oddly familiar: just as, in 1990, Lynch had to juggle production of another road movie, *Wild at Heart*, with writing and directing duties on his first TV show, *Twin Peaks*, so October 1998 would find him balancing post-production on *The Straight Story* with a commission to write the pilot script for another upcoming TV project, *Mulholland Drive*.

One notable aspect of *The Straight Story* that often gets overlooked, however, is the fact that it would prove to be, in some respects, the *last* David

Road movie: Richard Farnsworth with
David Lynch, shooting *The Straight Story* (opposite, top)

163

Alvin with the citizens of Laurens, Iowa (bottom left),
and aboard his (t)rusty lawnmower (bottom right)

Lynch movie. This would be the final time that Lynch would make and release a film in the time-honoured fashion, shooting from a completed script and releasing into cinemas via a distributor, as opposed to making the film in pieces and/or releasing it by himself, or onto TV. From here, his work would grow ever more fractured and experimental.

—

'Gotta light?'

One further Lynch project from this period is well worth exploring, though it would remain regrettably incomplete. In 1998, reportedly inspired by the retro-styled Japanese video game *Gadget: Invention, Travel, & Adventure* (1993), Lynch announced his intention to partner with developers Synergy to produce a game of his own. Details were hard to come by, aside from a wonderfully evocative title: *Woodcutters from Fiery Ships.*

According to *Straight Story* producer Neal Edelstein, 'the intent was for David Lynch to create an immersive video game',[9] and indeed Edelstein would make significant headway securing financing from Synergy and other companies, while Lynch put together a proposal booklet filled with visual ideas. Sadly, it wasn't to be: whether it was down to commercial disinterest or simply to Lynch's increased work rate as both *The Straight Story* and *Mulholland Drive* were greenlighted back-to-back, the project would never reach fruition.

But the game did sound extraordinary. In a 1998 interview, Lynch discussed the project at some length, revealing that it would've been a 'conundrum thing ... a beautiful kind of place to put yourself. You try to make a little bit of a mystery and a bit of a story, but you want it to be able to bend back upon itself and get lost – really get lost.'[10] He was even happy to discuss key elements of the narrative, which may have seemed baffling at the time but in a modern context sound eerily familiar. 'Certain events have happened ... in a bungalow which is behind another house in Los Angeles,' he told writer Jonathan Romney. 'And then suddenly the woodcutters arrive and they take the man who we think has witnessed these events, and their ship is ... uh, silver, like a 30s sort of ship, and the fuel is logs. And they smoke pipes.'[11]

The name 'Woodcutters from Fiery Ships' would resurface as the title of a track on Lynch and Badalamenti's 2018 *Thought Gang* album, while the woodcutters themselves would, of course, find themselves terrifyingly reincarnated in *Twin Peaks: The Return*, their pipes replaced by cigarettes and their LA house with a tumbledown convenience store: yet another reminder that, with David Lynch, no idea was ever left to waste.

Holy smoke: Lynch with actors Russ Reed (left) and Richard Farnsworth
(right) shooting *The Straight Story* (top); and Robert Broski as the
Woodsman in *Twin Peaks: The Return* (bottom)

Mulholland Drive
1999-2001

Chapter Eleven
'I had a dream about this place'

Opened in 1924 and winding for 34km (21 miles) along the ridgeline of the Santa Monica mountains, the scenic highway known as Mulholland Drive offers sensational views over both the movie studios of the San Fernando Valley and of downtown LA, including the Hollywood sign. So it's not surprising that the film Lynch named for it would be a love letter, albeit a poisonous one, to his adopted city, its myths and its movies, and most of all its light. 'I feel lucky to live with that light,' he wrote in his book *Catching the Big Fish*. 'I love Los Angeles ... The golden age of cinema is still alive there, in the smell of jasmine at night and the beautiful weather.'[1]

But however much Lynch may have idolized that golden age, he never had any illusions about what Hollywood had become. Written right through *Mulholland Drive* would be a seething hatred for the anti-creative aspects of film production, the financially motivated executives whose demands make life impossible for artists like Lynch, and the way the system chews up those who come to it with an honest vision. LA may be beautiful, cinema itself may be beautiful, but underneath that fragile beauty lies a whole squirming mass of betrayal, greed, cynicism and exploitation.

167

According to Tony Krantz, the agent and producer who would lure David Lynch back to television, the idea for *Mulholland Drive* had first been mooted as early as 1990, as a potential spin-off series from *Twin Peaks* following Sherilyn Fenn's character Audrey Horne as she attempted to make a career for herself in Hollywood. Lynch, however, was unsure: though he admitted in *Room to Dream* that the idea could have been 'something I might've talked about for ten minutes with Mark Frost',[2] he would always claim *Mulholland Drive* as solely his own creation, and he's backed up by the fact there's never even a remote suggestion in *Twin Peaks* that Audrey has any ambitions to be an actor.

For Lynch, the idea began – as so many of his films did – with a single image, this time of the titular road at night. 'Anybody who's driven on that road knows that there's not a lot of traffic,' he'd tell *LA Weekly* in 2001, 'and it's filled with coyotes and owls and who knows what … It's a road of mystery and danger. And it's riding on top of the world, looking down on the Valley and Los Angeles. You get these incredible vistas, so it's pretty dreamy as well as mysterious.'[3]

Whatever the project's true origins, it was undoubtedly Krantz who urged Lynch to develop his early ideas into a two-page pitch that the two of them presented to the ABC network in 1998, before shooting commenced on *The Straight Story*. The network were keen, and along with the Disney-owned Touchstone Television, committed $7 million to the project – a modest budget for a feature, but a generous one for a television pilot. By February 1999, with *The Straight Story* still in the editing suite, shooting on *Mulholland Drive* had begun.

Like *Twin Peaks* before it, *Mulholland Drive* was designed as a mystery show, filled with plot twists and diversions, and questions that might never have been answered. And like *Twin Peaks* it would, at least at first, have told a relatively direct story, with only occasional abstract touches – he may have been working without the reining influence of a TV veteran like Mark Frost, but Lynch was determined to craft a pilot that would appeal not just to ABC

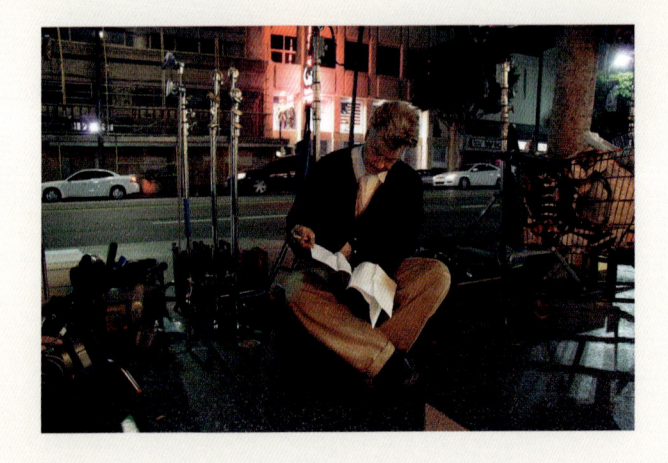

168

City of angels: David Lynch filming *INLAND EMPIRE*
on Hollywood Blvd (above) ; and the Los Angeles skyline
as seen from Mulholland Drive (opposite)

170

A conscious gesture: David Lynch shooting *Mulholland Drive*
in LA with actors Laura Elena Harring and Justin Theroux (top);
and Naomi Watts (bottom)

executives, but to a mass audience. So, in its opening scenes, *Mulholland Drive* sets up a trio of recognizable characters: a mysterious *femme fatale*, Rita (Laura Elena Harring), who following a car accident finds herself stricken with amnesia; a young film director, Adam (Justin Theroux), whose world falls apart when his film is taken away from him and his wife has an affair with the pool guy; and an ingenue, Betty (Naomi Watts), who arrives in Hollywood filled with dreams of stardom.

—

'It's no longer your film'

As with *Twin Peaks*, shooting on a TV budget restricted the kind of cast Lynch was able to attract, with the result that *Mulholland Drive* would be peopled almost exclusively with unknowns, aside from brief turns by B-list character actors like Robert Forster and Dan Hedaya, and the final appearance by legendary Hollywood musical star Ann Miller as an eccentric landlady. But again, Lynch's knack for casting didn't fail him: selecting his leads based on photographs and a brief interview, he and Johanna Ray discovered a genuine A-lister in Naomi Watts, whose career to that point had been in Australian TV and B-movies, but who – ironically, given the role she was playing – delivered a star-making performance as Betty. Her fellow leads, Harring and Theroux, would also go on to greater – if slightly less spectacular – success, and all three would work with Lynch again on future projects.

With *Lost Highway* cinematographer Peter Deming and production designer Jack Fisk both returning, shooting *Mulholland Drive* was a smooth six-week process, though Fisk would later complain that ABC and Disney were unnecessarily tight with the purse strings. Gary d'Amico would construct the most impressive physical stunt in a Lynch movie since *Dune* for the opening car crash, while Angelo Badalamenti turned in yet another peerless score, as well as playing a small but pivotal role as an enigmatic, coffee-obsessed movie executive who may bear a passing similarity to Dino De Laurentiis. Working again with editor Mary Sweeney, Lynch turned in a 125-minute cut of the pilot to ABC – which, inevitably, was where everything went wrong.

In retrospect, it's easy to see why ABC balked. Lynch may have been trying to curb his weirder impulses, but this long cut of the pilot still included a scene where two characters who don't appear anywhere else discuss in detail a dream that one of them had only to find it coming true, not to mention an appearance from a koan-speaking cowboy who appears to rule Hollywood from a corral in the hills. The pace was slower than ABC were used to – a criticism also levelled at *Twin Peaks* – and featured small-screen no-nos like smoking, gunshot wounds and a close-up of dog faeces. In a bare-faced display of old-fashioned sexism, the executives also complained that both Watts (30) and Harring (34) were too old for their roles.

173

'No hay banda!': Rebekah Del Rio pours her heart out
at Club Silencio (opposite); and Melissa George
in the studio (above) in *Mulholland Drive*

But the main problem was the length. Lynch was contracted to produce a pilot running no longer than 88 minutes, and Tony Krantz was determined to hold him to it. But hacking the footage down only produced a broken, hobbled mess: 'I was forced to butcher it because we had a deadline,' Lynch would complain, 'and there wasn't time to finesse anything. It lost texture, big scenes and storylines.'[4] When, in May, Lynch received the entirely expected news that *Mulholland Drive* wouldn't be picked up as a series, he would admit to feeling a sense of relief. Busy with the Cannes premiere of *The Straight Story*, he fully expected *Mulholland Drive* to simply vanish in his rearview mirror.

—

'It'll be just like in the movies. We'll pretend to be someone else'

Happily, events took a different turn. Thanks in large part to the efforts of French producer Pierre Edelman – who had also shepherded Lynch's 1992 deal with Ciby 2000 – the full-length cut of the pilot was purchased wholesale from ABC and Disney by the Paris-based Studio Canal, with the intention of turning *Mulholland Drive* into a feature. Initially, Lynch was doubtful – a previous attempt to provide a tacked-on ending to an intentionally open-ended TV pilot, with the studio-mandated 'European cut' of *Twin Peaks*, had led to some terrific imagery but precious little sense of closure. 'It was panic,' he told *Interview* magazine in 2001. 'Because people were spending a lot of money ... and I was having big doubts about whether or not I should pull the plug on it.'[5]

174

Careless whisper: Laura Elena Harring
and Melissa George in the big-screen
version of *Mulholland Drive*

Then, without warning, it all came together. 'I didn't have any ideas to make it into a feature – nothing. And then I sat down one night at 6.30, and at 7 o'clock, there they were.'[6] In Lynch's new vision for the film, the bulk of the narrative – essentially the pilot – would seem to have been a fever dream in the mind of a dying woman, Diane Selwyn, a struggling actress who has committed suicide after paying a hitman to murder her former lover and professional rival, Camilla Rhodes (there are clear echoes here of both *Industrial Symphony No. 1* and *Premonition Following an Evil Deed*, each of which depict the inner states of traumatized women, and of *Lost Highway*, another 'bifurcated' film in which the identities of the main characters shift abruptly). Tying up many if not all of the pilot's loose threads, the result would be a looping, labyrinthine Hollywood tragedy filled with unanswered questions and non-sequiturs, but still emotionally resonant and true to its characters and their experience.

Actually pulling the feature together would be a complicated process, however: in the year or more since the pilot, the sets had been taken apart and junked, and the actors had moved on to other projects. And while the cast were uniformly keen to revisit what had been a creatively fulfilling experience, they were also aware that not only had they been paid a low rate – in big-screen terms – for their work so far, but the new footage would require far more explicit behaviour, including a love scene between Harring and Watts and an excruciating scene of Watts's character – distraught, homicidal and losing her mind – furiously masturbating on a filthy sofa.

175

The director's director: David Lynch schools
Justin Theroux on the set of *Mulholland Drive*

It would all be worth it. *Mulholland Drive* premiered at Cannes on 16 May 2001 to a rapturous reception, winning Lynch the Best Director prize (which he shared with Joel Coen for *The Man Who Wasn't There*), and reaping some of the best reviews of his career – '*Mulholland Drive* makes movies feel alive again',[7] raved *Rolling Stone*, while even Roger Ebert was back in the fold, calling it 'a movie to surrender yourself to'[8] – along with a handful of his very worst: respected critic Rex Reed seemed personally offended by the film, calling it 'a load of moronic and incoherent garbage ... loathsome, incomprehensible and dismayingly amateurish'.[9]

The film would lead to Lynch's third Best Director nomination at the Oscars – he lost, hilariously, to Ron Howard for the instantly forgettable maths-based weepie *A Beautiful Mind* – and in the years since, *Mulholland Drive*'s reputation has only grown: in 2009 it was named Best Film of the Decade by publications including *The Village Voice*, *Time Out New York*, *IndieWire* and the cineaste's bible *Cahiers du Cinema*, while in a 2016 BBC poll of critics and tastemakers it was named the Best Film of the Twenty-first Century. Even more remarkably, in the 2022 edition of *Sight and Sound*'s once-a-decade international critics' poll, *Mulholland Drive* was named the eighth best film of all time, ahead of *Singin' in the Rain* (1952), *The Godfather* (1972), *Seven Samurai* (1954) and most of the films that had influenced Lynch in the first place.

176

The business of show: David Lynch with Naomi Watts
and Laura Elena Harring at the 2001 Cannes Film Festival (above)

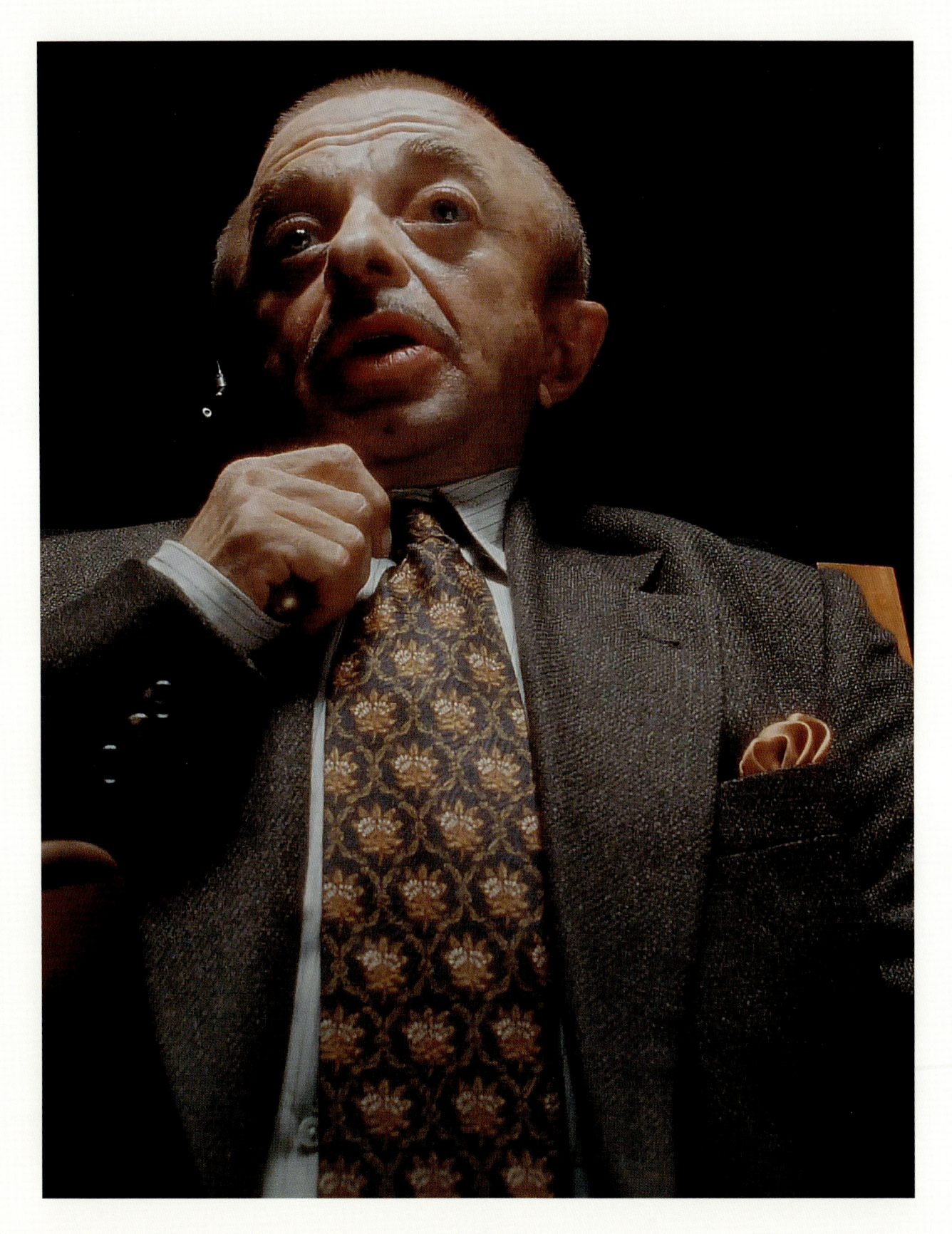

177

Michael J. Anderson as a shadowy movie mogul
in *Mulholland Drive* (above)

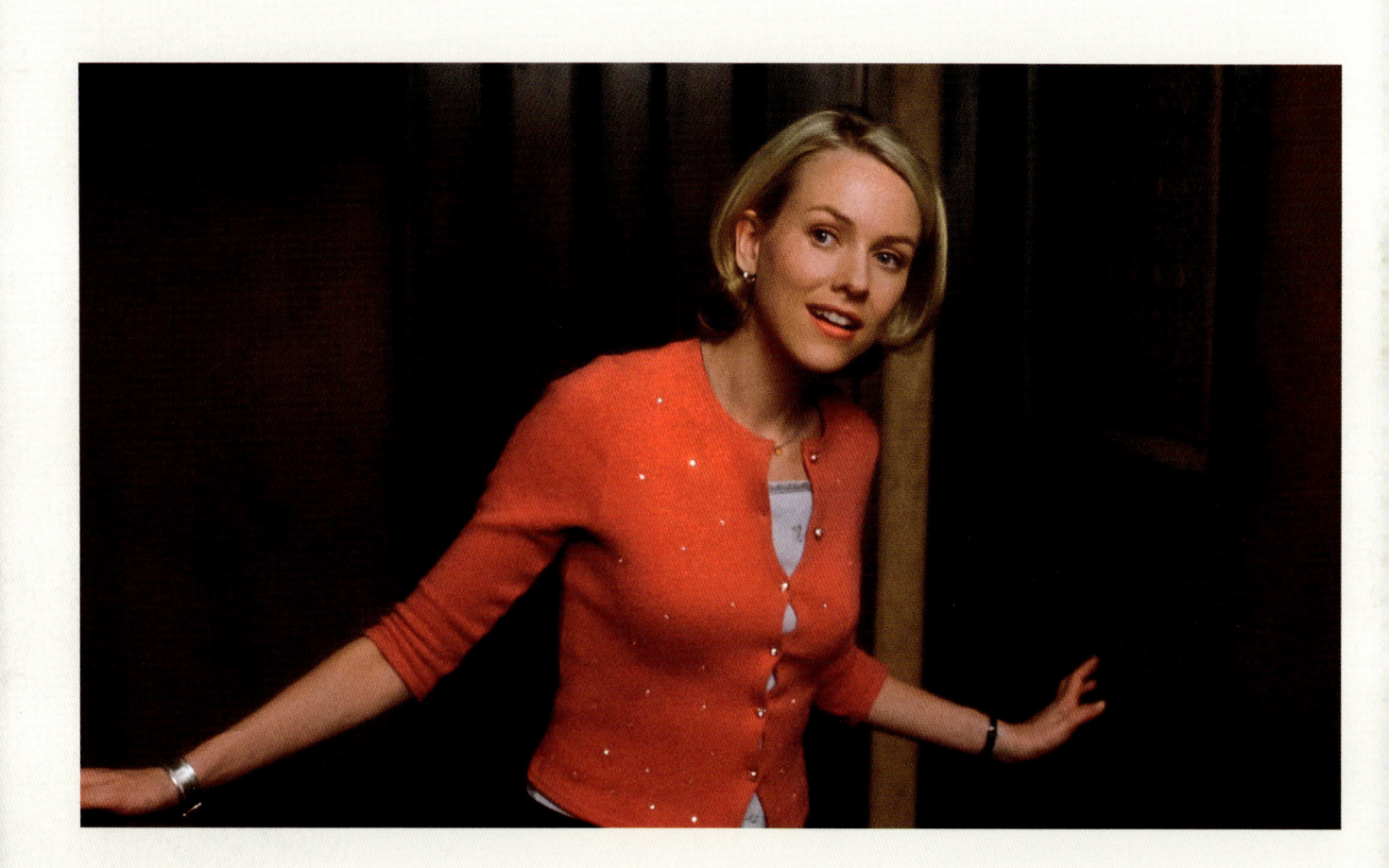

179

'This is the girl': Naomi Watts as broken-down Diane (opposite)
and as bright-eyed Betty (above) in *Mulholland Drive*

'It is ... an illusion!'

Over the past two decades, a veritable cottage industry has sprung up around the idea that it's possible to 'explain' *Mulholland Drive*: from online articles and YouTube videos to the film's own Wikipedia page, theories abound as to what the film 'really means', and how all of its various strands might pull together. In 2002, Lynch stirred the pot further by including with the film's first DVD release a list of '10 Clues to Unlocking This Thriller',[10] ranging from 'Notice the robe, the ashtray, the coffee cup' to 'Where is Aunt Ruth?', and he has been known to insist that all of the film's seemingly disparate threads do tie up, if you watch the movie enough times and think about it hard enough.

But how seriously should we take these 'clues'? Lynch himself would admit that they were 'pretty abstract',[11] while in *Catching the Big Fish* there's a chapter entitled 'The Box and the Key' which consists simply of the words 'I don't have a clue what those are'.[12] He was always taken with the idea that people love to try and unpick a mystery – 'Clues are beautiful because I believe we're all detectives'[13] – and indeed, detectives of one kind or another appear in almost all of his films, *Mulholland Drive* included.

In interviews, Lynch would often express admiration for films that, like Roman Polanski's *Chinatown* (1974), refuse to reach a satisfactory resolution – 'the film ends but there's still room to dream ... It just opens up this mystery and the film continues even though it's over'[14] – and he would also, repeatedly and forcefully, argue that mysteries don't need to be solved in order to be appealing, and that in fact the opposite may be true. Given the choice, Lynch might never have revealed who murdered Laura Palmer, and in its initial form *Mulholland Drive* seems to have been constructed expressly to set up a number of narrative knots that might never have been untangled.

There's also the question of what Lynch may have meant when he talked about those threads tying up – if he were ever to have sat down and really 'explained' *Mulholland Drive*, would such an explanation have made sense to anyone other than its creator? For Lynch, finding meaning was an intuitive, personal process. 'I think people know what *Mulholland Drive* is to them but they don't trust it,' he said. 'They want to have someone else help them out. I love people analyzing it but they don't need me to help them out.'[15] Above all, Lynch was convinced that audiences are smarter than most studio executives give them credit for. 'People are treated like idiots, and people are not idiots. We're hip to the human condition, the human experience, and we love mysteries.'[16]

Finally, and perhaps most importantly of all, is the question: what does it matter? If *Mulholland Drive* captures the viewer's imagination, then why the need to explain it? There are those who continue to insist that Lynch always knew exactly what he meant at all times, that every apparently unconnected scene or seeming non-sequitur was just a piece of a puzzle that existed complete within its designer's head, and might one day be fully 'understood'. But reading Lynch's interviews, it's clear this wasn't the case: 'Some things

are just, you know, abstractions,' he would say. 'It would be the greatest thing if you could be left with some vagueness, some imagination at the end of a film, when so often you're robbed of the magic. That vagueness makes me dream, and I love it.'[17]

For Lynch, it was all about the ideas – receiving them, recognizing them, working with them, investigating them, but not necessarily understanding them: 'You gotta be true to the ideas that you have. They're almost like gifts, and even if you don't understand them 100 per cent, if you're true to them, they'll ring true at different levels.'[18] Or, to put it even more bluntly: 'If you start worrying right away about the meaning of everything, chances are your poor intellect is only going to glean a little portion of it. If it stays abstract ... and it hooks in the right way, and it thrills you ... That's the only thing you have to go by.'[19]

'The film continues, even though it's over': Faye Dunaway
prepares to shoot the final scene of *Chinatown*, 1974

Internet Shorts and INLAND EMPIRE
2002-2006

'An ocean of possibilities'

It may not have been a box office smash, but *Mulholland Drive* was a cultural sensation: the film's exotic blend of glamorous, old-world Hollywood opulence and raw sexuality were tailor-made for the turn of the century, inspiring fashion designers, photographers and magazine editors in equal measure. For the first time in a decade David Lynch became a style icon, appearing on newsstands and fuelling endless coffee shop debates, university theses and a small industry in books about his work, which was being extensively reissued on DVD. It would've been easy for Lynch to capitalize on this sudden revival in his fortunes, to dive into production on a new movie, perhaps even to resurrect *Ronnie Rocket*. Instead, he quit cinema altogether.

By this point, Lynch had been intrigued by the possibilities of the internet for several years – he'd even been one of its earliest stars. 'There was so much talk on the internet about *Twin Peaks*,' he would recall. 'People would bring in reams and reams of paper and say, "You've gotta see what's happening."' A decade later, his staff were no longer having to print out web pages for Lynch to look at: instead he was growing increasingly savvy, enthusing in a 1999 interview about the opportunities offered by the new medium. 'With

'Tell me if you've known me before': Laura Dern as Nikki Grace in *INLAND EMPIRE*

the internet everyone will have their own television station,' he said excitedly. 'Everything will be possible.'[1] In a way, the very existence of the web seems inherently Lynchian – a vast alternate reality that appears to exist and not exist at the same time, like a digital Black Lodge. 'It's so strange to me that it wasn't there, and then it's there, and I don't know where exactly it is!' he'd laugh. 'Suddenly a whole other opportunity, a whole other world popped up.'[2]

By 2001, it was time to step boldly into this new world. As *Mulholland Drive* raked in the awards, Lynch was busy doing what would come to be known as 'creating content': shooting experimental footage, taking photographs, scanning artworks and designing pages for what would eventually become his own website, davidlynch.com. Initially charging subscribers $10 per month, the website was conceived as a kind of grassroots studio, whereby the revenue from subscriptions – as well as t-shirts, coffee cups, posters, film stills and other merchandize available through the site – would provide Lynch with the budget to create more unique content, which would then entice more subscribers, and so on. Like most beautiful dreams, it wouldn't go quite to plan.

—

In fact, David Lynch's first major online statement wasn't a film or an art project but an album, his first of original music, issued exclusively on his website in 2001 under the *Twin Peaks*-evoking title of BlueBOB. The material had been written and recorded by Lynch in collaboration with John Neff, an audio engineer who four years earlier had been hired to design and build a recording studio in Lynch's home. That initial brief had soon expanded, however, as Neff was tapped to assist Lynch in the production of another music project, arguably his strangest to date.

For reasons which remain obscure, in 1996 Lynch had booked in a five-minute meeting with the fiddle player and vocalist Jocelyn Montgomery, formerly of ethereal London-based madrigal singers Miranda Sex Garden, whose exotic name and flowery Goth aesthetic had led to a period of brief indie-scene celebrity in the early 1990s. Now living in the US, Montgomery hit it off with Lynch, and as their meeting overran, they decided to sit down and collaborate on a song. The result was 'And Still', with music by Angelo Badalamenti, lyrics by Lynch and Estelle Polemisis, and vocals by Montgomery: still unreleased in any physical format, it's one of the loveliest, least-known songs Lynch ever worked on.

But the album Lynch and Montgomery would end up making together was altogether different. Fascinated by the life and work of Hildegard von Bingen, the twelfth-century German abbess whose trailblazing efforts as a writer, philosopher, composer, poet, medic and scientist were being widely rediscovered and celebrated at the time, Montgomery set out on a pilgrimage to visit many of Von Bingen's holy sites, stopping at convents along the Rhine valley and being inspired to create an entire album of Von Bingen's music.

She pitched the idea to Lynch and he accepted, agreeing to act as the album's producer. With Neff as engineer and multi-instrumentalist, the album would be a truly collaborative effort, as Lynch 'directed' Neff and Montgomery to craft a singular sonic world.

A receiver of mystic visions and a deeply spiritual figure, perhaps it's not surprising that Von Bingen should appeal to Lynch. 'I hear the word "elements" and hear "nature" and I hear "animals" or "birds" and Jocelyn's interpretation and it sort of flows together,' he would enthuse. 'Then I hear the words "twelfth-century" and it conjures up certain things and then to feel the spiritual thing of it, that roars in and pretty soon you have a feeling coming through.'[3] A collection of choral chants sparsely backed with off-kilter drones and sound effects manipulated by Lynch – including the sounds of bulls and swords – the resulting album would be entitled *Lux Vivens*, or Living Light.

And all the while Lynch and Neff were working on their own, largely unplanned project, running tests and experiments that over the years would morph into the BlueBOB album. Inspired by early rock 'n' roll, electric blues and the work of Don Van Vliet aka Captain Beefheart, the musician, poet and experimental painter whose *Trout Mask Replica* LP Lynch used to blast in the stables between takes on *Eraserhead* and with whom he had since struck up a very likely friendship, BlueBOB was largely comprised of distorted guitar riffs over pre-programmed beats, with Lynch's lyrics sung-spoken by Neff (though Lynch himself occasionally provides reedy backing vocals). With song titles reflecting Lynchian obsessions – 'Marilyn Monroe', 'City of Dreams' – and a smoky, night-time feel redolent of *Lost Highway*, BlueBOB showed Lynch stepping out of the voluminous shadow of Angelo Badalamenti, and starting to take himself seriously as a musician and songwriter.

—

Over the next few years Lynch would flood his website with exclusive features, directing more than twenty short films, along with three web series and numerous music videos, art pieces and oddities including his ironic 'weather reports' from his home, which ran from 2005 until 2009 and 2020 to 2022, the joke being that the weather in LA is always basically the same. Much of this material is unashamedly experimental, consisting of lengthy footage of shadows crawling across a wall (*Intervalometer Experiments*, 2007) or animated beetles creeping around a shadowy house (*Bug Crawls*, 2005), while other shorts are intentionally absurd, like 2001's oddly upsetting *Pierre and Sonny Jim*, in which a pair of inflated surgical gloves with faces drawn on them make

Receiving a vision: Hildegard von Bingen
in a 13th-century miniature

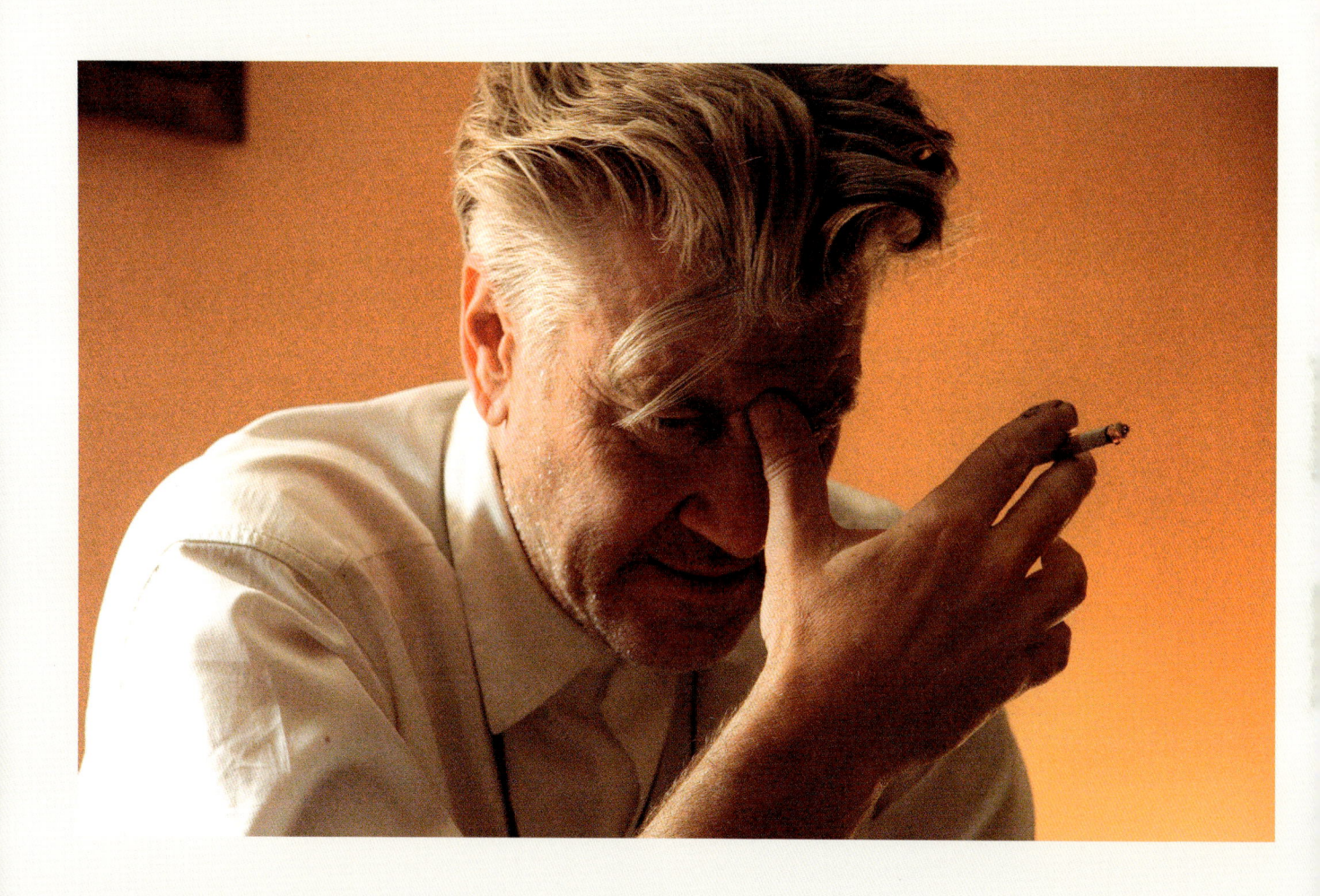

'I figured one day I'd just wake up and find out
what the hell yesterday was all about'

187

'In a boat, trying to get the idea for a paddle': David Lynch
plans his next move on the set of *INLAND EMPIRE*
(above) and Laura Dern as Nikki (opposite)

idiotic squeaking noises until one of them suffers a tragic accident. 'I started working on just small experiments,' Lynch would recall later. 'I was shooting the things that were coming, the little fragments.'[4]

A handful, however, are well worth exploring. In 2002, *Rabbits* would reunite *Mulholland Drive* stars Naomi Watts, Laura Elena Harring and Scott Coffey, then render them completely unrecognizable beneath huge, stiff-eared rabbit masks. A pastiche of TV sitcoms, the eight-part series takes place entirely within a green, 1950s-style set designed by Lynch in his garden, where the three rabbit characters converse, iron their clothes and are occasionally subjected to disturbing interruptions, like the appearance of a burning hole in the wall. Another of Lynch's experiments in dread, *Rabbits* creates an atmosphere of unease through the use of rumbling sound and ominous music, unemotional dialogue, sinister lighting and sudden, grating bursts of laughter from an invisible audience.

A much goofier, more approachable affair, 2007's three-part series *Out Yonder* would mark the first time that one of Lynch's children had taken a leading role in one of his projects, as the director and his son Austin play a pair of good-natured yokels who converse in their own high-pitched, vaguely Southern-inflected dialect, until they're interrupted by the appearance of a vast, unseen creature. The same year, *Boat* would cut together seemingly random snippets of Lynch's home movie footage of a boat trip, then overlay a voiceover spoken by a young woman named Emily Stofle, who had been a photographic muse for Lynch since 2003, and with whom he would soon be in a long-term relationship.

—

Indeed, while the early 2000s may have been a relatively quiet period in terms of major artistic statements, Lynch's personal life was undergoing something of an upheaval. In 2004, his parents were involved in a car accident and his mother died soon afterwards; the family had always been close, and the nature of her death was shocking. Around the same time, Lynch's relationship with Mary Sweeney – by then the longest of his life – was drawing to an end, in an apparently amicable fashion: in May 2006 they were legally married, only to file for divorce the following month.

By that point, however, Lynch had another project to occupy his mind. The initial seeds of what would become *INLAND EMPIRE* (the title is all capitals) lay in the shorts Lynch had been making for his website: large portions of the *Rabbits* series appear unedited in the film, which would be shot, like those early experiments, on digital video. The second spur was a chance encounter on the street with Laura Dern, with whom Lynch hadn't worked since *Industrial Symphony* some 13 years earlier. The pair agreed to collaborate on something, and soon afterwards Lynch announced that he'd written a scene for Dern to perform – a near-monologue, delivered by

189

His latest flame: David Lynch with Emily Stofle
at the *INLAND EMPIRE* Paris premiere in 2007 (bottom);
and Stofle (far right) in the movie (top)

a bruised, embittered woman to an unnamed man who may be a lawyer or a policeman. Shot in four hours on a set built inside Lynch's studio, the scene was at first just another experiment, presumably intended to sit alongside the other shorts on davidlynch.com.

But after filming the scene, Lynch became inspired. 'What if this is a movie?' he asked assistant Jay Aaseng,[5] and from there, *INLAND EMPIRE* started rolling. The film would be constructed differently from any Lynch movie – and perhaps *any* movie – before it. Working with a small team including producer Jeremy Alter and dedicated all-rounders Aaseng and Erik Crary – who had played the taciturn man in that first scene – Lynch began to write and shoot one scene at a time, operating his own camera and editing in his home studio, relying to an unprecedented degree on his own gut instincts. Indeed, more than any other Lynch film with the arguable exception of *Eraserhead*, *INLAND EMPIRE* would be built almost entirely on intuition. 'Intuition is the number one tool, really, of the human being,' he would say later. 'Intuition ... is mind and emotion, intellect and emotion together. It's a feel-thinking ... And it is extremely important.'[6]

Through all of this, Laura Dern could only hang on and trust that Lynch knew what he was doing – which at times, as he freely admitted, he didn't. 'I don't have a script,' he would say in an interview conducted during filming. 'I write the thing scene by scene ... and I don't have much of a clue where it will end. It's a risk, but I have this feeling that because all things are unified, this idea over here ... will somehow relate to that idea over there ... It's a hair stressful because I'm out there in a boat, trying to get the idea for a paddle.'[7]

But as they worked, the film began to coalesce in Lynch's mind: other actors came on board, including returnees Harry Dean Stanton and Justin Theroux, along with a very game Jeremy Irons as a self-involved British film director. Again Lynch turned to Studio Canal, who kicked in four million dollars to fund further shooting, much of which would take place during the winter of early 2006 in Lodz, where far below freezing temperatures meant that the underdressed cast could only shoot for a few minutes at a time. Returning home with the footage, Lynch and his editorial assistant Noriko Miyakawa set about honing a mountain of often unconnected rushes into an almost exactly three-hour feature – a length reached, one suspects, because Lynch knew it was the longest he could make the film and still expect cinemas to show it.

—

But show it, they did: after premiering at the 2006 Venice Film Festival, where Lynch also received a Golden Lion Award for Lifetime Achievement, *INLAND EMPIRE* would be given a limited release in the US overseen by the director himself, and promoted with a ten-city tour during which Lynch – often accompanied by a live cow, because 'I ate a lot of cheese during the film,

'Laura Dern ... understands the human condition,
she's pretty much 100 per cent fearless, and she's a great soul'

191

Soulmates: Laura Dern and David Lynch
on the set of *INLAND EMPIRE*

192

Grace Zabriskie as the Neighbour in *INLAND EMPIRE* (top) Lynch with actors Jeremy Irons and Harry Dean Stanton (bottom)

Lynch and Dern discuss the day's script (top)

and it made me very happy'[8] – personally introduced the film to audiences. Distribution outside the US would be handled in the traditional fashion, but Lynch and his cow would reappear later that year on the corner of Hollywood Boulevard and La Brea in Los Angeles, as part of a campaign to land an Oscar nomination for Laura Dern. Seated in an elevated director's chair facing the traffic, Lynch and his bovine companion would be accompanied by one giant poster featuring Dern's face and the words FOR YOUR CONSIDERATION, and another reading simply WITHOUT CHEESE THERE WOULDN'T BE AN INLAND EMPIRE.

Despite these intrepid efforts, however, Dern would not receive an Oscar nomination – the award would go instead to Helen Mirren for *The Queen*, a turn as fluffy and reassuring as Dern's is abrasive and demanding. Indeed, her performance is perhaps the most committed, complex and fearless in any Lynch film. Dominating almost every scene, Dern appears to play (at least) four separate characters, each of whom may or may not be different aspects of the same woman, actor Nikki Grace, who takes the central role in a melodrama entitled *On High in Blue Tomorrows*, only to learn that the film itself may be cursed.

These introductory scenes feel relatively straightforward: we're introduced to Nikki and her Polish husband Piotrek (Peter J. Lucas); to her priapic co-star Devon Berk (Justin Theroux), their preening British director Kingsley Stewart (Jeremy Irons) and his strange, money-grubbing fixer Freddie Howard (Harry Dean Stanton). But who is the weeping sex worker (Karolina Gruszka) who appears to be watching all this on a hotel TV screen? Who is Nikki's neighbour (Grace Zabriskie), and what is the meaning of the tales she insists on telling, about the birth of evil and a girl 'lost in the marketplace'? And – perhaps

Cheesy does it: Lynch and his cow on Hollywood Boulevard,
promoting *INLAND EMPIRE*

most perplexingly, for those viewers who weren't already subscribers to davidlynch.com – what's with the giant talking rabbits?

The answers to these questions will never be revealed. Instead, the film splinters even further, as Nikki appears to transform first into her character, suburban housewife Sue Blue, and then into the abused woman from the initial scene Dern and Lynch shot together; later she'll die slowly on Hollywood Boulevard, before returning – perhaps – to her initial persona. Meanwhile, we're offered glimpses of other lives, other worlds: a group of Polish gangsters; a woman, Doris (Julia Ormond), who insists that she's been hypnotized to kill someone; a gang of sex workers who dance The Locomotion and seem to offer the hope of some sort of kinship for the lost and wandering Nikki/Sue; and a trio of street people, among whom the appearance of former American football player turned movie star Terry Crews – fresh from his role in 2004's colour-swap comedy *White Chicks* – might be the most puzzling thing in the entire movie.

More than any Lynch project before or since, *INLAND EMPIRE* actively and even aggressively resists rational interpretation: promoting the film, Lynch would reveal only that it was 'about a woman in trouble, and it's a mystery, and that's all I want to say about it'.[9] A number of regular Lynch concerns do arise, notably the nature of human identity and how the craft of acting relates to the loss of self; the more poisonous and exploitative aspects of Hollywood filmmaking and how these affect art; and the cyclical nature of trauma and abuse. Like Fred Madison in *Lost Highway*, Nikki is a successful performer who transforms into someone else; like Laura Palmer, she's victimized by forces she can't understand or control. Both Theroux's slippery movie star and Stanton's barbed caricature of Hollywood money-men could've wandered straight out of *Mulholland Drive*, while the gangsters who haunt the film's peripheries could easily join Mr Reindeer's crew in *Wild at Heart*.

—

'There certainly would be consequences to wrong actions. Dark they would be, and inescapable'

But as befits its piecemeal creation, there are many respects in which *INLAND EMPIRE* stands apart from the rest of Lynch's filmography – most notably in terms of its photography, and its soundtrack. To a large extent, Lynch shot the film himself on a Sony DSR-PD150 camcorder, an over-the-counter model designed for home movies and industrial work. Employing a variety of lenses – notably the fish-eye, which gives the film's many close-ups a leering, grotesque intensity – shooting digitally also gave Lynch the freedom to capture as much footage as he wanted and deal with it in the edit. Indeed, making the film would lead Lynch to declare in 2006 that he was finished with celluloid altogether: 'I love digital video and I'm through with film … It scratches, it breaks … it's a nightmare.'[10]

196

Pure intuition: David Lynch crafted *INLAND EMPIRE*
in pieces, trusting star Laura Dern to follow him on the journey

For Lynch, the immediacy and flexibility of digital video – not to mention the cost-effectiveness – allowed for a much freer and more reactive approach to filmmaking. 'Seeing what you're really and truly going to get and being able to tweak it right there, is priceless. To be able to maintain spontaneity on set without killing the magic of the moment by having to reload the camera is a whole new way of working.'[11] Lynch would later backtrack at least partially on these comments, telling Italy's Rai television in 2014 that 'now I'm falling back in love with celluloid'[12] – but *Mulholland Drive* would nonetheless prove to be his last project shot on 35mm film.

With *INLAND EMPIRE*, digital video would be as much an aesthetic choice as a financial necessity: Lynch could easily have afforded to use a higher-quality camera, to make the footage look more 'professional' and film-like, but chose not to. The result is grainy, cheap, even downright ugly, closer to the aesthetic of a kidnap video or DIY porn than the sumptuous darkness of the director's earlier work. And this is entirely intentional: for Lynch, the indistinctness of digital video, the amount of 'noise' and pixelation in the image was actually a good thing: 'Some information is lost,' he told an American Film Institute audience in 2010, 'and it made me feel like there was more room to dream ... it was a beautiful experience.'[13]

For those critics who responded to *INLAND EMPIRE*, Lynch's use of digital video was a vital part of the experience: the film's aesthetic was not just a rebuke to the slickness of Hollywood product, but served to make the film's multiple time and location jumps more explicable. 'Not only does *INLAND EMPIRE* often look like it belongs on the internet,' wrote *Slate*'s Dennis Lim, 'it also progresses with the darting, associative logic of hyperlinks.' It's perhaps testament to Lynch's high cultural standing at the time of the film's release that *INLAND EMPIRE* received near across-the-board acclaim: far more oblique and challenging than critical flops like *Fire Walk With Me* and *Lost Highway*, the film was nonetheless widely embraced as a dizzying, highly personal rollercoaster, the work, as Peter Travers wrote in *Rolling Stone*, of 'an artist following his own maverick instincts and inviting us to jump with him into the wild blue'.[14] In the years since, the film's enigmatic nature and single-minded construction have seen it become something of an arthouse classic, regularly cited alongside *Mulholland Drive* as one of the finest films of the century.

—

One core element of *INLAND EMPIRE* that received rather less attention was its music. For the first time since *Dune* Lynch would work without Angelo Badalamenti, choosing to score the film himself. Assisting him would be Polish composer Marek Żebrowski – with whom Lynch would later collaborate on a series of improvised live shows and, in 2008, release an entire album of ambient sounds and drones, entitled *Polish Night Music* – and Dean Hurley, who had taken over from John Neff as engineer at Lynch's home studio in 2005,

and with whom Lynch would go on to have a long and fruitful collaboration. Alongside selections from Polish avant-garde composer Krzysztof Penderecki and pieces of popular music ranging from Nina Simone to Beck, the *INLAND EMPIRE* soundtrack would also feature Lynch's first lead vocal on a track called 'Ghost of Love', as well as his first released collaboration with vocalist Chrystabell on the co-written 'Polish Poem'.

And the years after *INLAND EMPIRE* would see an explosion in Lynch's musical productivity. In 2007, he and Hurley would release an experimental soundtrack to accompany *The Air is On Fire*, a major exhibition at the Fondation Cartier pour l'Art Contemporain in Paris; by 2011, the pair had written and recorded enough songs to make an album, *Crazy Clown Time*, the first to be released by David Lynch under his own name, and to feature him as lead vocalist and guitar player. A collection of reverb-drenched Blues songs with electronic and avant-garde influences and Lynchian song titles like 'Pinky's Dream' and 'Strange and Unproductive Thinking', the album would hit the independent music charts in the US, UK and Belgium, and be followed in 2013 by the equally successful *The Big Dream*.

2011 would also see the long-delayed release of Lynch's first album-length collaboration with Chrystabell, *This Train*, with lyrics by Lynch set to music written by the singer. Born Chrysta Bell Zucht in San Antonio, Texas, the actress turned singer-songwriter would form a lasting and productive working relationship with Lynch, ultimately resulting in a second album, 2024's *Cellophane Memories*, which would prove to be the last major project that Lynch released in his lifetime. And their collaboration would not be confined to music: in 2017, for better or worse, Bell would also take the central role of FBI Agent Tammy Preston in *Twin Peaks: The Return*.

Meanwhile, Lynch's musical career continued to flourish, leading to a collaboration with producer Danger Mouse and singer-songwriter Mark Linkous aka Sparklehorse on the album *Dark Night of the Soul*, which was also released in a limited edition accompanied by a book of Lynch photographs. Taking its title from one of two tracks penned by Lynch, the album would be released in 2010 in the wake of Linkous's death by suicide. Around the same time, Lynch would also prove his worth as a remix artist, working on tracks by Duran Duran, Zola Jesus and Moby, among others.

Then, in 2021, Lynch would undertake his first musical collaboration with an artist with whom he had already shared countless stages in the previous two decades: the Scottish folk singer Donovan. An apparently unlikely pairing – one a hippie troubadour known for winsome ditties about sunshine and witches, the other an unflinching avant-garde artist infamous for his depictions of extreme sex and violence – Donovan Leitch and David Lynch had been brought together by their love of Transcendental Meditation, and the work they undertook together in that capacity would, more than any single film, piece of music or work of art, come to dominate Lynch's time and effort in the first two decades of the twenty-first century.

Musical muse: Lynch's longtime collaborator Chrysta Bell
as Agent Tammy Preston in *Twin Peaks: The Return* (opposite, top)

On the promotional trail: Lynch signs copies of *Crazy Clown Time*
at LA's Amoeba Music in 2011 (bottom left); and joins TM pioneer Bob Roth
to promote the David Lynch Foundation in 2013 (bottom right)

By 2003, David Lynch no longer felt any need to conceal his love of Transcendental Meditation – the subject would come up in just about every interview he conducted from this period onwards, and his enthusiasm never wavered. That year, he gave a press conference at New York's Plaza Hotel, announcing a plan to build meditation centres known as 'peace palaces' in 300 cities around the world, with the aim of reducing stress, crime and violence, and bringing about world peace. 'This is all about establishing peace,' he was quoted as saying by the *New York Post*. 'Right now, we gotta get peace back in the world. Peace is a real thing ... I'm going all out for this. It's kind of important to have peace on earth.'[15]

The following year, Lynch was invited by longtime Transcendental Meditation practitioner Bob Roth, who had studied in the 1960s under the Maharishi Mahesh Yogi himself, to give a talk to a group of students in New York. Always wary of public speaking, Lynch nonetheless charmed both his audience and his host. 'I realized what an effective spokesperson he could be,'[16] Roth would recall. The following year, Roth met with former quantum physicist turned TM practitioner John Hagelin, later to become president of the Maharishi International University in Fairfield, Iowa, to discuss the possibility of starting a foundation to spread the gospel to parts of the population who might not be aware of it. They asked Lynch if they could use his name and he readily agreed, so later that year, The David Lynch Foundation for Consciousness-Based Education and World Peace – generally shortened to DLF – was established.

Initially formed with the idea of teaching TM in high schools through a programme of voluntary, parent-approved 'quiet time' classes – the early 2000s had seen a wave of post-Columbine school shootings, and TM is proven to work as a stress-relieving measure – the DLF would later expand its remit to include other groups including military veterans suffering from PTSD, the homeless, prison populations and those with longtime depression, anxiety and substance abuse issues.

Following the establishment of the Foundation, Roth invited Lynch to undertake a 13-date tour of universities entitled Consciousness, Creativity and the Brain. Speaking largely off the cuff in response to students' questions, the answers Lynch gave would in 2006 form the basis of his first book, *Catching the Big Fish: Meditation, Consciousness, and Creativity*, a witty and highly readable collection of observations, reminiscences, enthusiastic discourses on the practice of meditation and handy tips for those looking to expand their creative horizons. With a title taken from one of Lynch's key aphorisms – 'Ideas are like fish. If you want to catch little fish, you can stay in the shallow water. But if you want to catch the big fish, you've got to go deeper'[17] – the book would be an unexpected success, with all proceeds going directly to the DLF. The following year he would embark on a two-part, 16-country tour of Europe and the Middle East, the highlights of which would be compiled into the short 2012 documentary *Meditation, Creativity, Peace*.

'Beyond the beyond': The Maharishi Mahesh Yogi is taken
for cremation in Allahabad, India, 2008 (opposite, top)

'I believe that there's much more going on than we can see, feel, touch
... smell, hear, taste or kick'

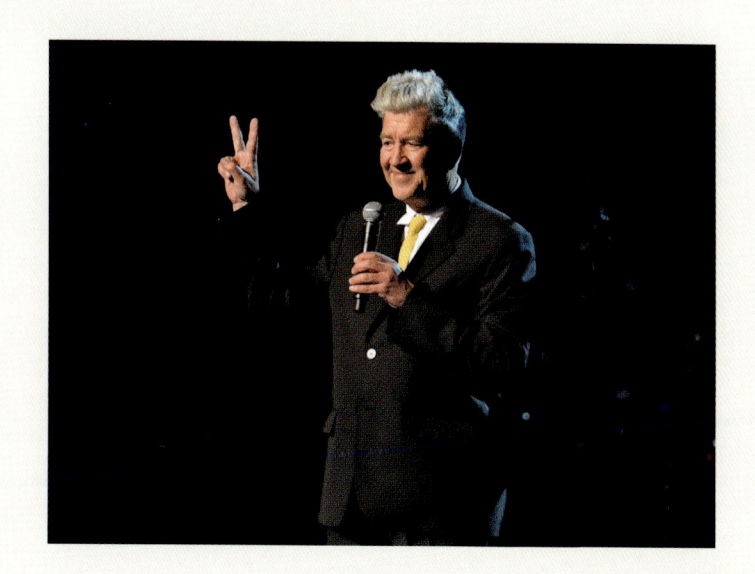

201

Lynch addresses the DLF Music Celebration in LA, 2015 (bottom)

On 5 December 2007, his 92nd birthday, Lynch's father Donald died; the family said their goodbyes, then Lynch meditated at his hospital bedside. Soon after, in early 2008, the world of TM was rocked when the movement's founder, the Maharishi Mahesh Yogi, died at the age of 90. Invited and accompanied by Bob Roth, Lynch would travel to the Maharishi's ashram in Allahabad, India for the funeral, a journey that required taking three planes and driving for four hours along perilous roads. It would all be worth it: following the immolation of the Maharishi on a great funeral pyre, his ashes were scattered at the confluence of the Yamuna, Saraswati and Ganges rivers, as hundreds of mourners including Lynch spoke prayers and immersed themselves in the holy river.

Later, Lynch would learn that another funeral attendee had been Richard Beymer, the former *West Side Story* star who'd played Benjamin Horne in *Twin Peaks*; not only that, but he'd taken a camera along and filmed much of the ceremony. Lynch had been considering the idea of a documentary about the Maharishi – a project he would carry with him for the rest of his life – so in 2009, the director returned to India with Bob Roth to make a pilgrimage from the Himalayan mountains to the southernmost point of India, a journey taken by the Maharishi following the death of his own teacher, Guru Dev, in 1953. Accompanying them on their week-long journey would be Beymer with his camera; in 2014, his footage would be edited into a documentary entitled *It's a Beautiful World*, a sweet-natured travelogue following Lynch as he smokes his way down the Indian subcontinent, travelling by helicopter and SUV, sampling the local delicacies and visiting the same sites as the Maharishi a half-century before.

In its first decade, the DLF would host a number of high-profile fundraising events, notably 2009's Change Begins Within concert compered by Lynch and Laura Dern and featuring a performance by both surviving Beatles, Paul McCartney and Ringo Starr, alongside future and former Lynch collaborators including Donovan, Moby, Eddie Vedder and Angelo Badalamenti. In 2012, the equally star-studded A Night of Comedy would feature appearances from the likes of Jerry Seinfeld, Garry Shandling, Chris Rock and Russell Brand, who would go on to donate funds from his live shows to the Foundation before disappearing down a rabbit hole far darker than anything Lynch could have dreamed up (the same year, Lynch would also make a rare acting appearance in the TV sitcom *Louie*, just a few years before star Louis CK experienced a very public reckoning of his own).

And the DLF would continue to play a huge role in David Lynch's life, raising funds and awareness through public appearances and live events. The Foundation would open TM centres in countries including France, the UK and Australia, and in 2022 announced a scheme to raise $500 million to train 30,000 international students in the practice of TM. For Lynch, his involvement in TM was as central to his existence as any movie project, and the influence of the Maharishi on his work cannot be understated. 'He changed things cosmically and profoundly,' Lynch would write in *Room to Dream*, 'and everything else pales in comparison.'[18]

Peace and love: Lynch participates in a ceremony
to bury a foundation stone for the 'Invincible Belgium University'
in Brussels, 2007 (opposite, top) ...

... and joins surviving Beatles Paul McCartney
and Ringo Starr at a press conference in New York, 2009 (bottom)

Twin Peaks: The Return and Beyond
2009-2025

'Watch and listen to the dream of time and space'

In 2009, David Lynch and Emily Stofle were married at the Beverly Hills Hotel in Los Angeles, a ceremony attended by around 100 friends and an Elvis impersonator who happened to be hanging around the hotel. The couple spent their honeymoon in Moscow, where Lynch's career-encompassing multi-disciplinary exhibition *The Air is On Fire* had recently transferred following its successful Paris debut two years earlier. '*The Air is On Fire* was the first time I was able to see a lot of my work together,' Lynch would recall in *Room to Dream*, 'and that was a beautiful thing.'[1]

Following the release of *INLAND EMPIRE* Lynch once again retreated into his studio, turning his attention to living the art life that he'd always dreamed of. 'I love my life and I'm a happy camper,' he would tell *The Guardian*. 'It would be nice if we were all able to fulfil our desires and live good, long, happy lives.'[2]

Pledging my love: Emily Stofle and David Lynch
attend the *Twin Peaks* premiere at the 2017 Cannes Festival

He'd always longed for what he called a *good setup* – 'a place to work, and the materials to do the work'[3] – and now he had exactly that: his studio and workshop were just as he wanted them, he could smoke, dream, create and even pee in the sink. There was no need to ever leave.

Over the years, the experimental nature of Lynch's art had not abated – if anything, his paintings had become ever more extreme, inventive and unusual. 'I use, you know, a whole bunch of different things,' he told *ARTnews* in 2018. 'I use a lot of glue, acrylic paint, watercolours, tempera, cigarette ashes ... I like this thing I call "organic phenomena" – when you mix this with that, you get a fantastic thing sometimes. It's total mixed media.'[4] But while he may not always have held his own artistic output in particularly high regard – 'my paintings are crude, child-like, ridiculous, bad paintings,' he would say, 'and I love them' – between 2007 and his death in 2025, not a year would go by without at least one major David Lynch exhibition somewhere in the world, from Belgrade to Buenos Aires, Milan to Middlesbrough, from lithographs and woodcuts at the Gallery Wolfgang Jahn in Munich to watercolours at the Sperone Westwater in New York, from his *Infinite Deep* photography exhibit to his gloriously titled *Big Bongo Night* mixed-media extravaganza.

Shot over four years and released in 2016, the documentary *David Lynch: The Art Life* found the director settled into his routine, utilizing whatever materials came to hand to create huge, instinctive works of art, in between teaching his little daughter Lula how to paint. Born in 2012, Lula Bogina Lynch (her middle name means *goddess* in Polish) was David's gift to Emily Stofle – in *Room to Dream* she speaks openly of his doubts about having another child, and his commitment to his work above all else. 'You gotta be selfish,' Lynch would admit. 'And it's a terrible thing. I never really wanted to get married, never really wanted to have children. One thing leads to another and there it is.'[5]

But at the same time, David Lynch never shied away from involving his children in his art. It's hardly a coincidence that his eldest child, Jennifer, would go on to become a filmmaker herself: having cut her teeth as an assistant on the set of *Blue Velvet,* she would direct a handful of features – including the baffling, excoriated *Boxing Helena* (1993) with *Twin Peaks* star Sherilyn Fenn, and efficient cop thriller *Surveillance* (2008) – before going on to become one of the most well-regarded directors in television, with episodes of *The Walking Dead, Daredevil, Gossip Girl* and *American Horror Story* under her belt.

Austin Lynch, meanwhile, would appear as the mysterious creamed-corn-carrying little boy in *Twin Peaks* and star alongside his father in the *Out Yonder* shorts, before turning cameraman for one of Lynch Senior's most ambitious but least-known experiments: 2009's *Interview Project*. Shot during a 70-day, 20,000-mile (32,000-km) road trip, this 121-episode series would find David Lynch sitting down for unscripted conversations with randomly chosen 'regular' Americans, from truck drivers to tribesmen, from survivors of addiction to a man who owns a snake museum. In 2017, Austin would go on to co-direct his first film, the experimental feature *Gray House*.

206

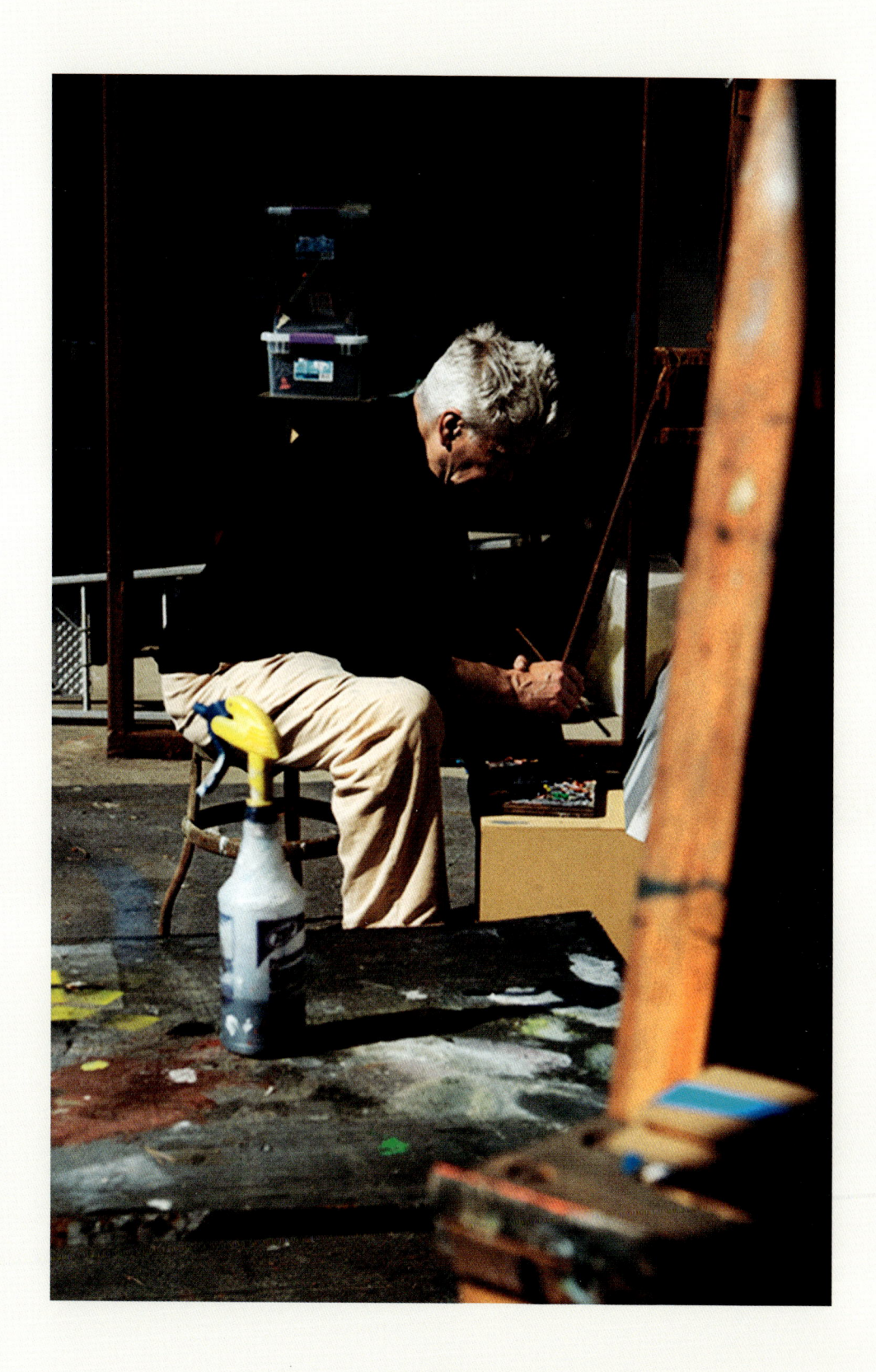

207

A good setup: the artist in his studio, as seen in the documentary
David Lynch: The Art Life

To complete the hat-trick, in 2021 Riley Lynch would also direct his own movie: 12-minute short *Hardcore Halbert*. Like his older siblings, Riley had trained on his father's sets, pitching in as part of the ever-fluctuating art department on *INLAND EMPIRE*. It would be David Lynch's next project, however, that would utilize Riley's talents to the fullest, employing him not just as a full-time production assistant, but showcasing his skills as a musician. Indeed, the project Lynch had secretly begun working on would require contributions not just from his blood relations, but from almost every surviving member of his creative family as well, stretching all the way back to *Eraserhead*. After nearly a quarter of a century, to the astonishment of almost everyone, David Lynch was returning to Twin Peaks.

—

In 2010, David Lynch completed his first solo, self-penned feature film script since *Blue Velvet* some 25 years before. Entitled *Antelope Don't Run No More*, the screenplay was set in LA and featured aliens, talking creatures and connecting threads leading back to *Mulholland Drive* and *INLAND EMPIRE.* Perhaps unsurprisingly, Hollywood passed – but it must've reinvigorated Lynch's passion for writing, because around Christmas of 2011 he met Mark Frost for lunch and the pair got to talking.

For both men, *Twin Peaks* remained unfinished business: Special Agent Dale Cooper was still trapped in the Black Lodge, while his doppelgänger ran rampage in the 'real' world. In the very first Red Room scene, initially shot for the 'European cut' of *Twin Peaks* (see page 174) then repurposed as a dream sequence for Episode 3, Laura had whispered to an aged Cooper that she would see him again in 25 years. Given that the first episode was shot and set in 1989, that gave Lynch and Frost a ticking clock of around three years. It was a target they would miss, but not by much.

For a long time, the project was a secret confined to Lynch, Frost and a handful of close family members: asked in 2013 about future *Twin Peaks*, Frost flatly denied it. 'We would write over Skype,' Lynch would recall afterwards. 'Mark being in Ojai, California and me being in Los Angeles. And at night, because I smoke cigarettes, my wife Emily would put me outside and I would face east and I would have yellow pads and a ballpoint pen – black – and cigarettes and red wine – Bordeaux – and I'd sit in this lawn chair and work like that. And if you have a yellow pad on your lap and a ballpoint pen then pretty soon words will come out.'[6]

One thing that both men apparently agreed on was that the new series would not be an exercise in sentimental fan service – in fact it would be quite the opposite, taking anti-nostalgia to an almost punishing level. Just as *Fire Walk With Me* had upended entrenched ideas about *Twin Peaks* as a quirky, inoffensive show full of oddball humour, dancing dwarfs and cherry pie, so the new series would push things even further, expanding the world of the show

'That's family': David Lynch with daughter
Jennifer and granddaughter Sydney in 2008 (opposite, top)

209

Lynch's elder son Austin in 2011 (bottom left)

David Lynch with daughter Lula, wife Emily
and youngest son Riley in 2015 (bottom right)

far beyond the town of Twin Peaks itself, not just geographically but spiritually and cosmically. Just as the original series had challenged the contemporary rules of small-screen entertainment, so the reboot would confront the new orthodoxy that had, to a large extent, come about as a result. In fact, what Lynch and Frost were writing wasn't a TV show at all, but one of the longest and most ambitious feature films ever made. 'It's an 18-hour film,' Lynch would say afterwards. 'You could see it all at once without the opening credits each time. Stick it together and it'd be a long film.' [7]

Twin Peaks: The Return begins in another dimension: the Black Lodge, not the 'hidden land of unmuffled screams and broken hearts'[8] spoken of by pantomime villain Windom Earle in the second series of *Twin Peaks*, but a far more ambiguous and haunted realm where time moves differently and the denizens speak in code, if at all. After 25 years, it's time for Cooper to leave – but in order for him to do so, his 'shadow self' must take his place. Which this dark doppelgänger has no intention of doing: going by the name of Mr. C and still carrying within him the 'wandering spirit' known as Bob, this snarling, perma-tanned Bad Cooper has spent the past quarter of a century searching – with the assistance of forces both within the Lodge and outside it – for a way to resist the call, and remain in our reality.

On his trail are a trio of FBI agents: Tammy Preston (Chrysta Bell),[9] Albert Rosenfeld (Miguel Ferrer) and FBI Director Gordon Cole, played by Lynch himself. Assisted (and at times hindered) by Cooper's former assistant Diane (Laura Dern) – or at least a version of her – these three follow a trail of corpses, including that of the long-lost Major Garland Briggs, gradually piecing together the mystery of what happened to Agent Cooper. After a number of switchbacks, dead-ends and close calls they ultimately arrive in Twin Peaks itself, where Deputy Hawk (Michael Horse), Sheriff Truman (Robert Forster) and Bobby Briggs (Dana Ashbrook) have also been investigating Cooper's disappearance.

But the town isn't what it used to be. The homely Double R Diner is now a franchise restaurant. Doctor Jacoby is no longer a psychiatrist, but a crackpot conspiracy theorist living in the woods high atop Swallowtail Mountain. The Twin Peaks Sheriff's Department has become a nest of vipers, running drugs into the town with the aid of the genuinely psychotic Richard Horne (Eamon Farren). Some stories will end happily, but any attempt to simply resurrect the past is doomed, like Cooper's efforts to save Laura, to abject failure.

—

On 3 October 2014, the *Twin Peaks* fan community – and the viewing public at large – was sent into a frenzy by a simultaneous post on both Lynch and Frost's social media feeds: 'Dear Twitter Friends: That gum you like is going to come back in style. #damngoodcoffee'. After three days of crazed speculation, confirmation arrived in the form of a second shared post: an image of the

'Compromise is not an option'

Giant, along with the words 'It is happening again in 2016'. Soon afterwards, Kyle MacLachlan would join the party, promising to 'Fire up that percolator and find my black suit'.

At this point, however, all Lynch and Frost actually had was a massive 334-page script – enough material, they judged, for a 9-episode miniseries – and a still-to-be-finalized deal with the pay-per-view television network Showtime. None of the cast had formally signed on: even MacLachlan, despite his enthusiasm, wouldn't be confirmed until January of the following year, and it would take several months before key cast members including Sheryl Lee, Sherilyn Fenn, Richard Beymer and David Patrick Kelley were also locked in. 'These people are like family,' Lynch would recall afterwards, 'so it was so beautiful calling them and talking to them again and getting together like for a family reunion.'[10]

Other performers, however, were unable to commit. Asked to return in the now-pivotal role of FBI Agent Philip Jeffries, David Bowie was forced for health reasons to turn Lynch down; he would succumb to cancer in January 2016 while the show was still in production, and be replaced on screen by a hissing, clanking, steam-powered machine. Michael Ontkean, who played

213

'Nervous about meeting J tonight': Lynch directs
Jake Wardle and James Marshall on the Roadhouse
set of *Twin Peaks: The Return*

Sheriff Harry S. Truman, had retired from acting; in classic TV-serial fashion his role would be picked up by another actor, Robert Forster, playing Harry's heretofore unheard-of brother, Frank. And although he was offered the role of The Man From Another Place, Michael J. Anderson chose to turn it down before, in one of the saddest, strangest episodes in the *Twin Peaks* saga, going on a social media rampage and accusing Lynch – though not by name – of rape and child abuse (the episode would later be attributed to a mental breakdown, and Anderson would retire from acting altogether soon afterwards).

But as Lynch and Showtime worked to thrash out a deal, more serious challenges would soon present themselves. In April 2015, the director would abruptly announce his departure from the project, citing budgetary concerns. Following major script revisions he had begun to realize that the original 9-episode estimate wouldn't be adequate to realize his vision, and that more would be required. The outcry was immediate: 'Dear Showtime. ... I hope you're happy,' cast member Kimmy Robertson wrote on her Facebook page. 'P.S. you really really suck.'[11]

Happily, Lynch's strongarm tactics worked: Showtime revised their budget, and within a month the director was back on board; it would be confirmed soon after that those 9 projected episodes had in fact doubled to 18. It was also becoming clear that the proposed 2016 release date would have to be pushed back, with Frost revealing that the following year would be more likely. *Twin Peaks: The Return* would undergo a significant evolution between the original Lynch-Frost script and the finished product, as Lynch invented new scenes and toyed with the narrative - the hour-long Episode 8, for example, was reportedly based on just 12-15 written pages. As well as taking a small cameo in the show, Frost would keep busy penning a pair of books to accompany the series – published in 2016 and 2017 respectively, the heavily illustrated hardbacks *The Secret History of Twin Peaks* and *Twin Peaks: The Final Dossier* would end up bearing only a loose connection to the new series.

—

Filming on *Twin Peaks: The Return* would run from September 2015 to April the following year – an epic schedule for a director who turned 70 during the shoot. But Lynch's energy and enthusiasm never wavered: though both cast and crew may have been significantly larger, he was as involved in every aspect of the production as he had been on *Eraserhead* or *INLAND EMPIRE*, not just briefing the cast, costume and camera departments but designing and building props and working on everything from make-up effects to set design to hand-picking the bands and artists who appeared on the Roadhouse stage.

For the first time, David Lynch also chose to place himself front and centre in the frame. The character of FBI Regional Bureau Chief Gordon Cole had begun as a *Twin Peaks* in-joke, a voice on a phone provided by Lynch, only

215

How's Dougie? Agent Dale Cooper (Kyle MacLachlan) struggles to find his true self in *Twin Peaks: The Return*.

to be written into the show by Harley Peyton and Robert Engels. Though he would never appear in a Lynch-directed series episode, Cole would return in *Fire Walk With Me*, the first time since a small cameo in *Dune* that Lynch had directed himself in a speaking role. In *The Return*, Cole would become the closest thing there is to a leading man: the show may be an ensemble piece, but with Agent Cooper out of commission, it's left to Cole to head up the investigation that forms the spine of the narrative.

Lynch would've been the first to admit that his range as a thespian wasn't huge – Gordon Cole is essentially a louder, deafer version of the director himself, possessed of many of Lynch's own mannerisms and enthusiasms. But that never stopped him taking occasional acting jobs when the mood struck him, appearing alongside Isabella Rossellini in future *Twin Peaks* director Tina Rathborne's sweet, sentimental 1950s-set melodrama *Zelly and Me* (1988), co-written by his old teacher Frank Daniel; getting typecast as a morgue attendant in Michael Almereyda's hipster vampire flick *Nadja* (1994); appearing alongside Harry Dean Stanton in his final lead role in the bittersweet *Lucky* (2017); and perhaps most pleasingly, making an unannounced cameo as legendarily irascible Hollywood icon John Ford in Steven Spielberg's thinly disguised auto-fiction *The Fabelmans* (2022). This last was a role that Spielberg doggedly pursued Lynch to accept – a suggestion, perhaps, that while many of Lynch's 1970s contemporaries may have scaled greater commercial heights, they continued to harbour genuine respect for those artists who carved their own path and refused to compromise.

—

Lynch's music, too, was all over *The Return*. Angelo Badalamenti may take the main soundtrack credit but Lynch incorporated several pieces of his own, from tracks he created with Dean Hurley to experimental sounds from the Thought Gang project. The acts who appear on the stage at the Roadhouse have clearly been selected to reflect Lynch's own personal taste, from former collaborators like Trent Reznor and 'the' Nine Inch Nails to acts like Au Revoir Simone, whose shimmering dream-pop can be traced directly back to the music Lynch made with Badalamenti and Julee Cruise.

Cruise herself would also return, on Lynch's insistence, before being largely edited out of the penultimate episode – an act that she called 'a slap in the face'.[12] The following year, the singer would announce that she was suffering from lupus; she would die in June 2022, to be followed just months later by Badalamenti himself, at the age of 85. After almost four decades, David Lynch's closest and most rewarding collaboration had come to an end.

Interestingly, however, it's in the soundtrack that *Twin Peaks: The Return* most obviously diverges from the original series. While each episode opens, reassuringly, with the instrumental version of 'Falling' – there'd have been a public outcry if it hadn't – from there *The Return*'s soundscape differs

significantly from its predecessor. In the original series, Badalamenti's score was a constant, soothing presence – 'There's always music in the air',[13] as the Man From Another Place reassured us. By contrast, *The Return* is filled with silences, its dialogue punctuated by pauses, its scenes stretching out far longer than is comfortable. And when the music does arrive, it tends to be either ominous and atonal or else raw and aggressive, like the slowed-down 'David Lynch remix' of Muddy Magnolias' 'American Woman' that accompanies Mr C's arrival.

And this rawness – this abrasive, intentionally anti-nostalgic and at times awkwardly comical sense of *wrongness* – can be felt throughout the 18-episode series. It's in the painfully extended scenes following Dougie Jones – really Agent Cooper, following a memory wipe – as he shuffles, Jacques Tati-like, through the gleaming, identikit office blocks of Las Vegas. It's in the multiple scenes of characters screaming, yelling at one another and threatening violence if they don't get their way. It's in the absolutely devastating scene in which Richard Horne commits a hit-and-run murder, mowing down a child in the street as his mother looks on; arguably the most traumatizing scene in Lynch's entire body of work.

And it's there most of all in the final episode, as Cooper's efforts to 'rescue' Laura Palmer go inexplicably awry, and he and Diane embark on a journey to yet another dimension where they appear to fall in love, forget each other's names and drift apart, leaving Cooper to complete his quest alone. In

217

Stanton's swansong: David Lynch played a cameo role
alongside his old friend Harry Dean Stanton in 2007's *Lucky*

218

On the other side of the lens: Lynch with Isabella Rossellini
in *Zelly and Me* (top) and as John Ford in Steven Spielberg's
auto-biopic *The Fabelmans* (bottom)

the series' harrowing final scene the lines between dimensions, and between fiction and reality, become more blurred than ever, as Cooper returns to the Palmer family home with a woman who looks like Laura but calls herself Carrie Page, only to encounter not Laura's mother but Mary Reber, the woman who actually owns the property in real life.

And this more than anything is what marks *Twin Peaks: The Return* out from everything else Lynch directed (with the possible exception of *The Interview Project*): its sense of unvarnished reality. Yes, *The Return* features talking trees, dimensional shifts and a wandering spirit who takes the shape of a black sphere in order to fight a cheeky Cockney wearing a green gardening glove, but it still feels closer to the real world – to our own crumbling, violent, desperate society – than any other Lynch film. Recognizing, perhaps, that the cosy nostalgia of the original series would feel like an anachronism in these embattled times, Lynch – with, one suspects, a lot of input from the politically astute Mark Frost – offers scenes of deprivation and poverty, trailer parks and cheap housing developments, crimes of desperation and need rather than simply of passion (though there are plenty of those too).

Lynch, of course, would take pains to undermine this reading of the show: 'A lot of people see things and they see politics from start to finish,' he said after *The Return* was broadcast. 'It's all in the mind's eye – different viewers get so many different things.'[14] But surely it's hard for even Lynch to look at certain characters and scenes – the unnamed 'drugged-out mother' (Hailey Gates) who screams '119!', or the domestic violence inflicted by Steven (Caleb Landry-Jones) on his partner Becky (Amanda Seyfried) – and not draw parallels. The show even has its very own Voice of the People, Las Vegas housewife Janey-e Jones (Naomi Watts), who takes a committed stand against the crooks trying to extort the man she believes to be her husband. 'We are not wealthy people,' she tells the gangsters. 'We drive cheap, terrible cars. We are the 99 percenters. And we are shit on enough ... What kind of world are we living in where people can behave like this? Treat other people this way without any compassion or feeling for their suffering? We are living in a dark, dark age, and you are part of the problem.'[15]

—

David Lynch's relationship with the real world always seemed to fluctuate according to his state of mind. On the one hand, he would often invoke reality when asked about the violence in his films: 'People have asked me why ... are my films so dark, and there's so much violence? There are many, many dark things flowing around in this world now, and most films reflect the world in which we live.'[16] But at the same time, those films were clearly fantasies, not just in the way they played with time, space and sanity, but in the often outlandish nature of their violence, or the extremity of their emotions. 'I see films more and more as separate from whatever kind of reality there is anywhere else,'

he said, contradictorily, in 1990. 'They are not, to me, political or, like, any kind of commentary or any kind of teaching device. They're just *things*.'[17]

In his personal life, Lynch seemed determined to avoid reality as much as possible, shutting himself off inside his ever-expanding Hollywood compound, where he could live the art life and not have to engage. His political persona was generally one of slightly bumbling naivete: while he admitted that he voted for Ronald Reagan in the 1980s, the reasons he gave were hardly incisive: 'Reagan cleared brush. That's what I liked about him. My father grew up on a ranch in Montana ... So I liked him for that.'[18] Later in the same interview, he would call himself a Democrat – but only up to a point. 'I don't like the Democrats a lot, either, because I'm a smoker, and I think a lot of the Democrats have come up with these rules for non-smoking ... House pets are treated way better than smokers.'[19]

In 2000, Lynch would temporarily switch allegiance to the Natural Law Party, a political movement founded by TM advocates whose candidate for President, quantum theorist John Hagelin, had been instrumental in the creation of the David Lynch Foundation, and would go on to become President of Maharishi International University. When Lynch writes in *Catching the Big Fish* about the 'ocean of pure consciousness ... known by modern science as the Unified Field',[20] he's referring to Hagelin's theories, though it should be noted that these have been largely discredited in mainstream scientific circles.[21]

It was in 2018, however, that David Lynch would endure his trickiest brush with the world of politics, as he appeared to endorse Donald Trump's candidacy for President. 'He could go down as one of the greatest presidents in history,' he told *The Guardian*, 'because he has disrupted the thing so much. No one is able to counter this guy in an intelligent way.'[22] The outcry would be immediate, a fact seized on by Trump himself, who smirkingly thanked Lynch for his words, but warned that 'his career in Hollywood is officially over'[23] (if he'd been paying attention, Trump might've noticed that Lynch's 'career in Hollywood' wasn't exactly thriving anyway).

Lynch hurriedly backtracked, penning an open letter to Trump urging him, in a determinedly naive but typically Lynchian fashion, to stop 'causing suffering and division', and turn to the light. 'It's not too late to turn the ship around,' he wrote. 'Point our ship toward a bright future for all. You can unite the country. Your soul will sing. Under great loving leadership, no one loses ... It's something I hope you think about and take to heart.'

Whether Trump ever read this letter – or had it read to him by one of his advisers or children – remains unknown. Either way, by the time of the 2024 election, Lynch appeared to have given up on politics altogether. 'The Republicans hate Democrats,' he told *Sight and Sound*. 'And the Democrats hate the Republicans ... And a nation divided is going to fall. It's just insane what's going on. Absolutely fucking insane. And it doesn't have to be this way. Grow up! Get a fucking life!'[24]

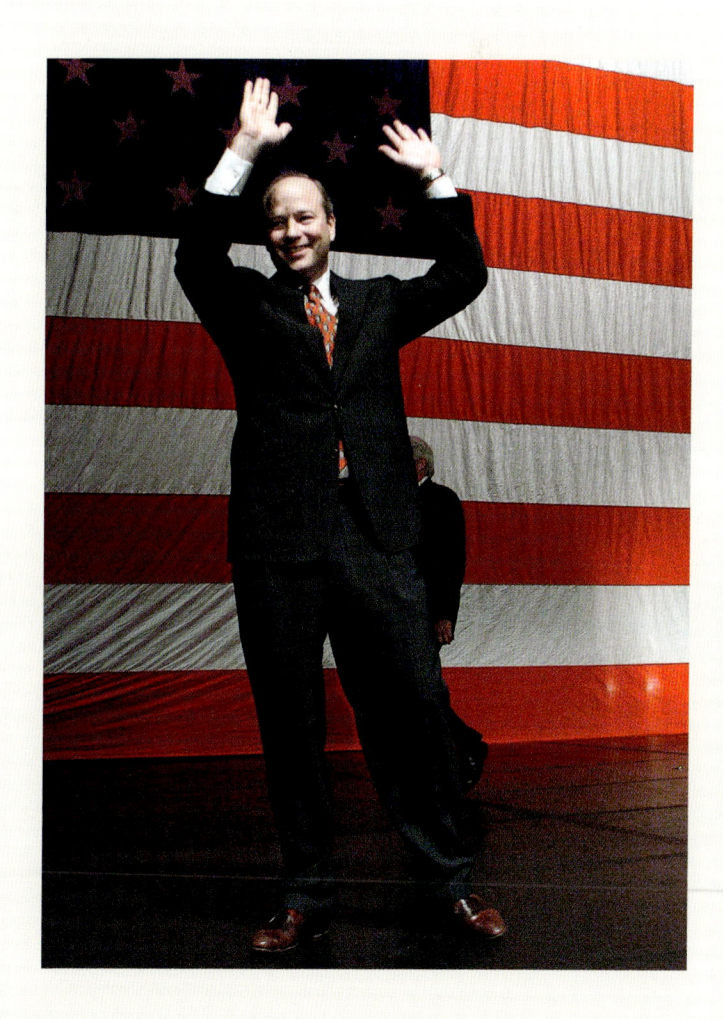

221

Political animal: Lynch's support for Ronald Reagan (top) led to an invite for him
and wife Mary Fisk to visit the White House in 1984 (bottom left); later, he would
vote for fellow TM enthusiast John Hagelin (bottom right)

222

A meditation on ageing: Lynch as FBI Deputy Director
Gordon Cole (top); and fellow old-timer (and TM enthusiast)
Richard Beymer (bottom) in *Twin Peaks: The Return*

'Never, oh! Never, Nothing will die.
The stream flows / The wind blows,
The cloud fleets / The heart beats,
Nothing will die'

But if *Twin Peaks: The Return* felt like a valedictory lap for Lynch, it also at times felt – appropriately, as it turned out – like a swansong. Intense, baffling, heartbreaking, hysterical and wild, the series not only rivals Lynch's entire filmed output to date in terms of length, but would act almost as a summation of his entire career, containing nods to just about every one of his major projects. So, the eccentric, almost deliberately lo-fi animated effects recall both *The Alphabet* and *The Grandmother.* The fleshy, creeping 'frogmoth' resembles the *Eraserhead* baby, while the lonesome death of The Log Lady mirrors the ending of *The Elephant Man*. The inter-dimensional oceans glimpsed by Cooper within the Lodge hark back to *Dune*. Lynch himself would draw links to *Blue Velvet*: if Cooper was always a more mature version of Jeffrey, then Diane is, as the director admitted, 'almost like a grown-up Sandy'.[25]

The show's extreme violence and gangland villains are straight out of *Wild at Heart*. The many night-time driving scenes recall *Lost Highway*. The frequent meditations on ageing – personified by characters like the Log Lady and Carl Rodd – can't help but evoke *The Straight Story*. The Fireman's ancient theatre resembles Club Silencio in *Mulholland Drive*, while the sudden shifts in tone, moments of extreme psychological dread and utterly unpredictable nature of the entire venture go straight back to *INLAND EMPIRE*.

But it doesn't end there. The monochrome landscapes in which Cooper finds himself resonate all the way back to Lynch's 'dark' paintings (see page 94), while the internal details of the Black Lodge – the buzzing electrical devices and strange machines – resemble those miniature drawings he used to sketch at Bob's Big Boy Diner in the 1980s. We've already seen how the demonic Woodsmen were inspired by his unfinished dabbling in the world of video games, while The Evolution of the Arm, a talking tree-sculpture which could have stepped right out of one of his 'mixed media' artworks, was designed and built by Lynch as a replacement for Michael J. Anderson. The horrific hit-and-run murder of the boy and the ascendence of his flaming soul is yet another example of death and transcendence in Lynch's work, as inspired by the Maharishi. There's even a character named Bushnell after his very first mentor, Bushnell Keeler, while in the plaza outside his office stands a statue of a cowboy explicitly modelled after his father Donald Lynch.

And though they offer absolutely no sense of closure, the final moments of *The Return* do feel like the climax of something. Lynch's work always venerated emotion and mistrusted words, so what better place to end than a full-throated, heart-shattering scream of absolute confusion and terror?

223

At the time, there was of course no intention that *The Return* would be Lynch's final major film project: on stage at the 2017 Twin Peaks UK Festival, executive producer Sabrina Sutherland seemed offended by the very suggestion, telling me in no uncertain terms that Lynch would be back. And for a time, that prospect seemed a live one: first screened the same year as *The Return* and released onto the streaming service Netflix in 2020 to mark Lynch's 74th birthday, *What Did Jack Do* would be his most high-profile short in years. Another home-made exercise in eerie, bone-dry comedy, it stars Lynch as a homicide detective interviewing a suspect who happens to be a capuchin monkey, alongside Emily Stofle as a waitress and a chicken named Toototabon. Naturally, it shot to the top of the viewing charts.

Lynch's marriage to Emily Stofle came to an end in 2023, following a lengthy separation. But throughout this period, Lynch seemed entirely content within his setup: painting, designing, making music, dropping occasional clips onto YouTube and of course meditating. He would at times hint vaguely at the possibility of more *Twin Peaks*, perhaps exploring the character of Carrie Page, who like Laura seemed to hold a certain mysterious attraction for him. 'It's calling,' he told Kristine McKenna, 'but the signal has a lot of disturbances.'[26] Lynch retrospectives continued to be hosted in art and design museums across the world, while his second album with Chrystabell, *Cellophane Memories*, was released in 2024, accompanied by four Lynch-directed videos released to his David Lynch Theater YouTube channel.

In the wake of the album's release, however, came a revelation that many Lynch fans had dreaded. In an interview with *Sight and Sound*, Lynch admitted that he had for some time been suffering from emphysema brought on by his years of smoking, and that given the rise of COVID-19 it would be extremely dangerous for him to work anywhere as public as a film set. 'I'm homebound whether I like it or not,' he revealed. 'I can't go out. And I can only walk a short distance before I'm out of oxygen ... It would be very bad for me to get sick, even with a cold.'[27] Unsurprisingly, such statements were interpreted as an announcement that Lynch was retiring from filmmaking, an idea that the director was quick to dispel, insisting on social media that 'I am in excellent shape except for emphysema. I am filled with happiness, and I will never retire.'[28]

One possibility that Lynch floated – albeit reluctantly – was directing from a distance. 'They've now invented ways where you can direct from home. I wouldn't like that so much. I like to be there amongst the thing and get ideas there. But I would try to do it remotely if it comes to it.'[29] Another was animation – in the early 2000s, it had been reported that Lynch and *Nightmare Before Christmas* co-writer Caroline Thompson were collaborating on an 'old-fashioned fairytale'[30] entitled *Snootworld*, an animated film that as late as 2024 Lynch seemed keen to revive, despite the project having been turned down by Netflix. 'It's something that children and adults can both appreciate,' he told *Deadline*. 'I've never really done a straight animation but with computers today it's possible to do some spectacular things.'[31]

But of course, it was not to be. On 7 January 2025, a series of wildfires swept through Los Angeles and the surrounding area, exacerbated by hurricane-force winds and drought conditions brought on by climate change. Days later, the fires forced David Lynch and his family to be evacuated from their Hollywood home; Lynch would take refuge at the house of his daughter Jennifer, but the damage was already done. Reports suggest that the smoke inhalation had precipitated a steep decline in his health, and he died surrounded by his family on 15 January.

The outpouring of grief was immediate and full-throated – tributes poured in from fans, fellow filmmakers and of course from Lynch's creative family, with Laura Dern and Kyle MacLachlan offering particularly heartfelt testimonies. 'I always found him to be the most authentically alive person I'd ever met,' MacLachlan wrote. 'David was in tune with the universe and his own imagination on a level that seemed to be the best version of human.'[32]

For Lynch, as a committed transcendentalist, the inevitability of death was never a cause for fear: as the final scenes of *Eraserhead*, *The Elephant Man* and *Twin Peaks: Fire Walk With Me* reassure us, the passage from life into death is not an end, but just the start of another journey.

'The physical body drops off, but we'll all know each other again,' Lynch told *Sight and Sound* in 2024. 'Enlightenment is stepping off the wheel of birth and death into immortality.'[33] For David Lynch, whether it's by virtue of Transcendental Meditation, spiritual enlightenment and the Unified Field or simply down to the extraordinary body of work he created over six decades, immortality is surely a done deal.

225

A place to dream: David Lynch in his
private screening room in 2010

Bibliography

Books

Alexander, John. *The Films of David Lynch,*
Charles Letts & Co, London, 1993.

Barney, Richard A. (editor). *David Lynch Interviews,*
University Press of Mississippi, Jackson, MS, 2009.

Breskin, David. *Inner Views: Filmmakers in Conversation,*
Da Capo Press, Boston, 1997.

Chion, Michel. *David Lynch (English edition),*
British Film Institute, London, 1995.

Evry, Max. *A Masterpiece in Disarray: David Lynch's Dune,*
An Oral History, 1984 Publishing, Cleveland, OH, 2023.

Hughes, David. *The Complete Lynch,* Virgon Books,
London, 2001.

Jousse, Thierry. *Masters of Cinema: David Lynch*
(English edition), Cahiers du Cinema, Paris, 2010.

Lim, Dennis. *David Lynch: The Man From Another Place,*
Amazon Publishing, New York, 2015.

Lynch, David and Gifford, Barry. *Lost Highway,*
Faber and Faber, London, 1997.

Lynch, David. *Catching the Big Fish: Meditation,*
Consciousness, and Creativity, Jeremy P. Tarcher /
Penguin, New York, 2006.

Lynch, David. *The Air is On Fire,* Fondation Cartier,
Paris, 2007 (includes bonus interview CD).

Lynch, David and McKenna, Kristine. *Room to Dream,*
Canongate Books, Edinburgh, 2018.

Odell, Colin and Le Blanc, Michelle. *David Lynch,*
Kamera Books, Harpenden, UK, 2007.

Rodley, Chris (editor). *Lynch on Lynch (revised edition),*
Faber and Faber, London, 2005.

Woods, Paul A. *Weirdsville USA: The Obsessive Universe*
of David Lynch, Plexus Publishing, London, 1997.

Articles, Interviews and Online References

Andrew, Geoff. 'Naked Lynch', *Time Out London,* 18 Nov 1992.

Attwood, Chris and Roth, Robert. 'A Dog's Trip to the Chocolate Shop –
David Lynch', *Healthy Wealthy N Wise,* Sept 2005.

Barlow, Jason (interviewer). 'David Lean Lecture: David Lynch',
BAFTA, 27 Oct 2007. (www.bafta.org/media-centre/transcripts/
bafta-television-lecture-david-lynch)

Barnes, Freire. 'David Lynch interview: "There is something so incredibly
cosmically magical about curtains"', *Time Out London,* 13 Jan 2014.
(www.timeout.com/london/art/david-lynch-interview-there-is-
something-so-incredibly-cosmically-magical-about-curtains)

Carroll, Rory. 'David Lynch: "You Gotta Be Selfish. It's a Terrible Thing"',
The Guardian, 23 Jun 2018.

Chute, David. 'Out to Lynch', *Film Comment,* Sept/Oct 1986.

Dollin, Stuart. 'You Can Have Any Colour So Long as It's Black',
Moviemaker, Oct 1985.

Douridas, Chris (interviewer). David Lynch on the *Morning Becomes*
Eclectic radio show, KCRW Los Angeles, 19 Feb 1997.

Ferry, Jeffrey. 'Blue Movie', *The Face,* Feb 1987.

Gilmore, Mikal. 'The Lost Boys', *Rolling Stone,* 6 Mar 1997.

Greenberger, Alex. '"I Like Dogs with a Human Head": David Lynch
Shows New Paintings in Los Angeles', ARTnews, New York, 7 Sept 2018.
(www.artnews.com/art-news/artists/like-dogs-human-head-david-
lynch-shows-new-paintings-los-angeles-10936/)

Henry, Michael. 'David Lynch: A 180-Degree Turnaround', *Positif,* Nov 1999.

Hewitt, Tim. 'Is There Life After *Dune?*', *Cinefantastique,* 1986.

Hughes, David. 'David Lynch, Weird on Top', *Empire,* Nov 2001.

Indiana, Gary. 'Good Eraserhead: Indiana', *East Village Eye,* Feb 1980.

Jensen, Jeff. 'Wild at Art', *Entertainment Weekly,* 19 Oct 2001.

Kermode, Mark. 'Guardian Interviews: David Lynch', *The Guardian,*
Thu 8 Feb 2007. (www.theguardian.com/film/2007/feb/08/davidlynch)

Mabey, Stuart. *David Lynch: The Idea Dictates Everything,* Jan 2006.
(www.youtube.com/watch?v=5SV5whQGZI8)

Mitchell, Elvis. *David Lynch Interviewed by Elvis Mitchell,* Los
Angeles County Museum of Art, May 1998. (www.youtube.com/
watch?v=2jGS9ShytTs)

Pizzello, Stephen. 'Highway to Hell', *American Cinematographer,*
March 1997.

Powers, John. 'Getting Lost is Beautiful', *LA Weekly,* 17 Oct 2001.

Rodley, Chris. '*The Icon* Profile: David Lynch', *Icon,* Apr 1997.

Rodrigues, M.D. 'David Lynch's presence has been haunting video games
for decades', *The Verge,* 24 Feb 2024. (www.theverge.com/23906355/
david-lynch-video-games)

Romney, Jonathan. 'Mr Weird Plays it Straight', *The Guardian,*
19 Nov 1999.

Saban, Stephen and Longacre, Sarah. '*Eraserhead:* Is There Life After
Birth?', *Soho Weekly News,* Oct 1977.

Simon, Brett. 'A Beautiful Mind', *Entertainment Today,* Los Angeles,
8 Mar 2002.

Simonini, Ross. '"Daydreaming Is So *Important* To Me": How David
Lynch Fishes For Ideas', *ArtReview,* 5 Jan 2021. (artreview.com/
daydreaming-is-so-important-to-me-how-david-lynch-fishes-for-ideas/)

Snead, Elizabeth. 'David Lynch, Driven by a Unique Vision', *USA Today,*
3 Mar 1997.

Spohr, Katrin. 'The World Reveals Itself', *Form,* Feb 1997.

Sragow, Michael. 'I Want to Dream When I Go to a Film', *Salon,* Oct 1999.

Summers, Jimmy. 'Director David Lynch – From Cult Film to *Elephant*
Man', *Box Office,* Oct 1990.

Szebin, Frederick and Biodrowski, Steve. 'David Lynch on *Lost Highway*',
Cinefantastique, Apr 1997.

Uncredited interviewer. 'Artist Talk mit David Lynch', *Film Festival*
Cologne, 4 Jul 2022. (www.youtube.com/watch?v=cvrihQS0T1A)

Unnamed author. 'David Lynch: "Stories Should Have the Suffering"',
The Talks, 2024. (the-talks.com/interview/david-lynch/)

Unnamed director. *MasterClass: David Lynch Teaches*
Creativity and Film, 2019. (www.masterclass.com/classes/
david-lynch-teaches-creativity-and-film)

Wigley, Sam. 'I Like to Call it Experimentation', *Sight and Sound,* Sep 2024.

Filmography
Directed by David Lynch unless otherwise noted

Feature Films

Eraserhead (1977)
Screenplay by David Lynch

The Elephant Man (1980)
Screenplay by Christopher De Vore, Eric Bergren
and David Lynch

Dune (1984)
Screenplay by David Lynch, from the novel by Frank Herbert

Blue Velvet (1986)
Screenplay by David Lynch

Wild at Heart (1990)
Screenplay by David Lynch

Industrial Symphony No. 1: The Dream of the Brokenhearted (1992)
A film by David Lynch and Angelo Badalamenti

Twin Peaks: Fire Walk With Me (1992)
Screenplay by David Lynch and Robert Engels

Lost Highway (1997)
Screenplay by David Lynch and Barry Gifford

The Straight Story (1999)
Screenplay by Mary Sweeney and John Roach

Mulholland Drive (2001)
Screenplay by David Lynch

Eraserhead Stories (2001)
Documentary by David Lynch

INLAND EMPIRE (2006)
Screenplay by David Lynch

Twin Peaks: The Missing Pieces (2014)
Screenplay by David Lynch and Robert Engels

Television

Arena: Ruth, Roses and Revolver (1987)
Directed by Helen Gallacher
Presented by David Lynch

Twin Peaks (1990–1991)
Created by David Lynch and Mark Frost
Listed below, the specific episodes directed or written by Lynch:

'Pilot / Episode 1.1': Northwest Passage (1990)
Written by David Lynch and Mark Frost

'Episode 1.2': Traces to Nowhere (1990)
Directed by Duwayne Dunham
Written by David Lynch and Mark Frost

'Episode 1.3': Zen, or the Skill to Catch a Killer (1990)
Written by David Lynch and Mark Frost

'Episode 2.1': May the Giant Be With You (1990)
Written by Mark Frost and David Lynch

'Episode 2.2': Coma (1990)
Written by Harley Peyton

'Episode 2.7': Lonely Souls (1990)
Written by Mark Frost

'Episode 2.22': Beyond Life and Death (1991)
Written by Mark Frost, Harley Peyton and Robert Engels
(Uncredited rewrites by David Lynch)

On the Air (1992)
Created by Mark Frost and David Lynch
Listed below, the specific episodes directed or written by Lynch:

'Episode 1.1' (1992)
Written by Mark Frost and David Lynch

'Episode 1.7' (1992)
Directed by Jack Fisk
Written by David Lynch and Robert Engels

Hotel Room (1993)
Created by David Lynch and Monty Montgomery
Listed below, the specific episodes directed or written by Lynch:

'Episode 1: Tricks' (1993)
Written by Barry Gifford

'Episode 3: Blackout' (1993)
Written by Barry Gifford

Twin Peaks: The Return (2017)
Created by David Lynch and Mark Frost
Written by David Lynch and Mark Frost

Short Films
A selection of notable works. All films written by David Lynch

Six Men Getting Sick (1967)
The Alphabet (1968)
The Grandmother (1970)
The Amputee (1974)
The Cowboy and the Frenchman (1988)
Lumiere and Company: Premonition Following an Evil Deed (1995)
Pierre and Sonny Jim (2001)
Darkened Room (2002)
Boat (2007)
Bug Crawls (2007)
Intervalometer Experiments (2007)
Lady Blue Shanghai (2010)
Idem Paris (2013)
What Did Jack Do? (2017)

Web Series

Dumbland (2002)
Created, directed, written and animated by David Lynch

Rabbits (2002)
Created, directed and written by David Lynch

Weather Reports (2005–2009 and 2020–2022)
Created, directed and written by David Lynch

Out Yonder (2007)
Written by David Lynch

David Lynch Interview Project (2009)
Interviews conducted by David Lynch

Today's Number Is … (2020–2022)
Written by David Lynch

Discography
A selection of notable works

Music Videos
A selection of notable works

Wicked Game, Chris Isaak (1990)
Longing, X Japan (1995)
Thank You, Judge, BlueBOB (1999)
Shot in the Back of the Head, Moby (2009)
I Touch a Red Button Man, Interpol (2010)
Crazy Clown Time, David Lynch (2012)
Came Back Haunted, Nine Inch Nails (2013)
I Have a Radio, David Lynch (2020)
I Am the Shaman, Donovan (2021)
The Answers to the Questions, David Lynch and Chrystabell (2024)
Sublime Eternal Love, David Lynch and Chrystabell (2024)

Commercials
A selection of notable works

Obsession by Calvin Klein (1988)
New York Department of Sanitation (1991)
Gio by Armani (1992)
Opium by Yves Saint Laurent (1992 and 1999)
Adidas (1993)
Georgia Coffee (1993)
Clearblue Easy (1997)
Parisienne (1998)
PlayStation 2 (2000)
Nissan Micra (2002)
Dior (2004)
L'Oréal (2004)
Gucci (2007)
David Lynch Signature Brand Coffee (2011 and 2012)

Films about David Lynch
A selection of notable works

For One Week Only: David Lynch (1990)
Directed by Andy Harries

Pretty as a Picture: The Art of David Lynch (1997)
Directed by Toby Keeler

Lynch (One) (2008)
Written and directed by Jason S.

It's a Beautiful World (2014)
Directed by Richard Beymer

Blue Velvet Revisited (2016)
Written and directed by Peter Braatz

David Lynch: The Art Life (2016)
Directed by Rick Barnes, Olivia Neergaard-Holm and Jon Nguyen

Lynch/Oz (2022)
Written and directed by Alexandre O. Philippe

Eraserhead (1982)
Soundtrack album credited to David Lynch and Alan R. Splet

Julee Cruise, *Floating Into the Night* (1989)
Music by Angelo Badalamenti, lyrics by David Lynch

Julee Cruise, *The Voice of Love* (1993)
Music by Angelo Badalamenti, lyrics by David Lynch

Jocelyn Montgomery with David Lynch, *Lux Vivens* (1999)
Arranged and composed by Jocelyn Montgomery and David Lynch

David Lynch's Mulholland Drive – Music From the Motion Picture (2001)
Soundtrack album credited to Angelo Badalamenti and David Lynch

David Lynch and John Neff, *BlueBOB* (2001)
Music by John Neff and David Lynch, lyrics by David Lynch

David Lynch, *The Air is On Fire* (2007)
Exhibition soundtrack composed by David Lynch and Dean Hurley

Marek Zebrowski and David Lynch, *Polish Night Music* (2007)
Improvised music written and produced by Marek Zebrowski
and David Lynch

Various artists, *INLAND EMPIRE* (2007)
Soundtrack album including songs and instrumentals by David Lynch

Danger Mouse and Sparklehorse, *Dark Night of the Soul* (2010)
'Star Eyes' and 'Dark Night of the Soul', lyrics and vocals by David Lynch

David Lynch, *Crazy Clown Time* (2011)
Music by David Lynch and Dean Hurley, lyrics by David Lynch

Chrystabell, *This Train* (2011)
Music by Chrystabell, production and lyrics by David Lynch

David Lynch, *The Big Dream* (2013)
Music by David Lynch and Dean Hurley, lyrics by David Lynch

Thought Gang, *Thought Gang* (2018)
Music and lyrics by Angelo Badalamenti and David Lynch

Chrystabell and David Lynch, *Cellophane Memories* (2024)
Written by David Lynch and Chrystabell, produced by David Lynch

Endnotes

Introduction

1. *Lynchian*, Oxford English Dictionary, Sept 2018. (www.oed.com/dictionary/lynchian_adj?tl=true)
2. *Twin Peaks,* Episode 1.2.
3. His only rival for the crown might be John Waters, but describing Waters as a rock star feels wrong, somehow. He's a punk, through and through.
4. This is in fact untrue: according to Google there is a LucasFest in Virginia, but it's dedicated to a dog breed named the Lucas terrier, and has nothing whatsoever to do with Wookiees.
5. Desta, Yohana. 'David Lynch Gave the Shortest Oscar Acceptance Speech Imaginable', *Vanity Fair*, Oct 28, 2019 (www.vanityfair.com/hollywood/2019/10/david-lynch-oscar-acceptance-speech?srsltid=AfmBOoq1Hxn_Cjdje769cl0Wyr94GY-qkvzd_lbT314g3--JfjtwMG1-o)
6. Simonini.

Chapter One

1. Rodley, p10. If this wistful view of the past feels rather too good to be true, even Lynch would concede that there may be an element of romantic revisionism at work. 'An accurate memory of the past would be depressing, probably,' he has said. (Rodley, p13).
2. *David Lynch: The Art Life.*
3. *Room to Dream*, p23.
4. Rodley, p10–11.
5. *MasterClass: David Lynch.*
6. Indiana (as reprinted in Barney, p62).
7. Rodley, p8.
8. *Room to Dream*, p25.
9. Rodley, p5.
10. Ibid, p11.
11. *The Air is On Fire* interview CD.
12. Attwood and Roth.
13. *Pretty As A Picture: The Art of David Lynch.*
14. Rodley (1997) (as reprinted in Barney, p185).
15. *David Lynch: The Art Life.*
16. Rodley (1997) (as reprinted in Barney, p185).
17. *Room to Dream*, p51.
18. *MasterClass: David Lynch.*
19. *Room to Dream*, p51.
20. Uncredited interviewer (2022).
21. *MasterClass: David Lynch.*
22. Simon.
23. *The Late Late Show*, Feb 26, 1997.
24. *For One Week Only: David Lynch.*
25. Ibid.
26. *MasterClass: David Lynch.*
27. *Room to Dream*, p79.
28. *The Air is On Fire* interview CD.
29. Rodley, p17.
30. Ibid, p16.
31. *The Air is On Fire* interview CD.
32. *Catching the Big Fish*, p13.
33. *The Air is On Fire* interview CD.
34. Ibid.
35. Dollin (reprinted in Barney, p26).
36. Breskin (reprinted in Barney, p65).
37. *Room to Dream*, p84.
38. Breskin (reprinted in Barney, p63).
39. Ibid, p90.

Chapter Two

1. Rodley, p56.
2. Breskin (reprinted in Barney, p69).
3. Simonini.
4. *Catching the Big Fish*, p19.
5. *The Air is On Fire* interview CD.
6. Mitchell.
7. *Catching the Big Fish*, p36.
8. *For One Week Only: David Lynch.*
9. Mitchell.
10. *Catching the Big Fish*, p3.
11. *Beatles '64* (2024), documentary directed by David Tedeschi.
12. This quote comes from a conversation between myself and David Lynch for *Time Out* in 2008 to promote a reissue of *The Elephant Man* – sadly, the original article is no longer online so all quotes are from my original interview transcript.
13. *Room to Dream*, p131.
14. Indiana (reprinted in Barney, p14).
15. *Catching the Big Fish*, p33.
16. *Blue Velvet.*
17. Indiana (reprinted in Barney, p11).
18. Quoted in Rosenbaum, Jonathan. 'Twin Peaks', *Chicago Reader*, Chicago, Apr 20, 1990.
19. *Catching the Big Fish*, p137.
20. Dalton, Stephen. 'David Bowie: Film Fan', *British Film Institute*, 5 Jan 2022. (www.bfi.org.uk/features/david-bowie-film-fan)
21. Breskin (reprinted in Barney, p69–70).
22. *Arena: Ruth, Roses and Revolver.*
23. Ibid.
24. Ibid.
25. Though the series exists under a multitude of names – *Twin Peaks: A Limited Event Series* and *Twin Peaks Season 3* among them – for this volume I've decided to go with the title under which it was initially announced, and by which Lynch himself refers to it: *Twin Peaks: The Return.*
26. *Arena: Ruth, Roses and Revolver.*

Chapter Three

1. *Room to Dream*, p140.
2. Again, from my own interview with Lynch.
3. Summer (reprinted in Barney, p20).
4. *Room to Dream*, p164-165.
5. Uncredited interviewer (2022).
6. Barnes.
7. Again, from my own interview transcript.
8. *Room to Dream*, p167.
9. Jensen.
10. Barnes.
11. *The Air is On Fire* interview CD.
12. *Room to Dream*, p153.
13. Uncredited interview (2022).
14. Barnes.
15. *David Lynch on William Eggleston* (2013). (www.youtube.com/watch?v=-sHqTfg0rhA)
16. Ibid.
17. Ibid.

Chapter Four

1. Simon.
2. *MasterClass: David Lynch.*
3. *For One Week Only: David Lynch.*
4. Evry, p51.

5 Ibid, p46.
6 *MasterClass: David Lynch.*
7 Evry, p381.
8 Jensen.
9 Attwood and Roth.
10 Hewitt (reprinted in Barney, p30).
11 Rodley, p115.
12 Evry, Max. 'I Found David Lynch's Lost *Dune II* Script', *Wired*, San Francisco, Jan 18, 2024. (www.wired.com/story/david-lynch-dune-sequel-script-unearthed/)
13 Ibid.
14 Mabey.

Chapter Five
1 Unnamed author (2024).
2 Ibid.
3 *David Lynch on Writing a Script* (2021). (www.youtube.com/watch?v=yngWNmouhP0)
4 Mitchell.
5 Ferry (reprinted in Barney, p43).
6 *Catching the Big Fish*, p39.
7 Wallace, Amy. 'FALL SNEAKS: David Lynch, Mild at Heart: The creator of the creepy 'Twin Peaks,' 'Blue Velvet' and 'Eraserhead' is making a G-rated Disney road picture', *Los Angeles Times*, Sept 12, 1999.
8 *For One Week Only: David Lynch.*
9 Ibid.
10 Mabey.
11 Ibid.
12 Simon.
13 *Lynch (One).*
14 *MasterClass: David Lynch.*
15 Mabey.
16 Unnamed author (2024).
17 Ibid.
18 Pizzello (reprinted in Barney, p172).
19 Quoted in Mogg, Ken. 'Great Directors: Alfred Hitchcock', *Senses of Cinema*, Melbourne, July 2005. (www.sensesofcinema.com/2005/great-directors/hitchcock/#1)
20 Ebert, Roger. 'review: *Blue Velvet*', *Chicago Sun-Times*, Chicago, Sept 19, 1986.
21 *Charlie Rose interviews David Foster Wallace* (1997). (www.youtube.com/watch?v=vAT9V2wHx3M)
22 Wallace, David Foster. *A Supposedly Fun Thing I'll Never Do Again: Essays and Arguments*, Little, Brown and Co, New York, 1997.
23 Ferry (reprinted in Barney, p43).
24 *Catching the Big Fish*, p89.
25 *Pretty as a Picture: The Art of David Lynch.*
26 *Pretty as a Picture: The Art of David Lynch.*
27 *The Air is on Fire* interview CD.
28 Ibid.
29 Ibid.
30 Douridas, reprinted in Barney, p160.
31 Hewitt (reprinted in Barney, p32).
32 Young, Paul. 'Talking Art: Wild at Art', *Buzz*, 1993. (www.lynchnet.com/talkart.html)
33 Ibid.
34 *The Air is On Fire* interview CD.
35 Greenberger.
36 Ibid.
37 Breskin (reprinted in Barney, p99).
38 Greenberger.
39 Ibid.

Chapter Six
1 *Room to Dream*, p273.
2 Ibid, p272.
3 Breskin (reprinted in Barney, p86).
4 Introduction to the above, on *The Short Films of David Lynch* DVD.
5 *On the Air*, Episode 1.1.
6 *Room to Dream*, p351.
7 Ibid.
8 Ibid.
9 Hughes.
10 *Twin Peaks*, Pilot.
11 Mitchell.
12 Shales, Tom. 'Troubling, Transcendent *Twin Peaks*', *Washington Post*, Apr 7, 1990.
13 Zoglin, Richard. 'Like Nothing Else on Earth', *Time*, Apr 9, 1990.
14 Hack, Richard. '*Twin Peaks*: THR's 1990 Review', *The Hollywood Reporter*, Oct 6, 2014. (www.hollywoodreporter.com/news/general-news/twin-peaks-original-1990-tv-738436/)
15 Gilmore.
16 Rose, Steve. 'An oral history of Twin Peaks by its unforgettable stars', *The Guardian*, Jan 23, 2025. (https://www.theguardian.com/tv-and-radio/2025/jan/23/an-oral-history-of-twin-peaks-david-lynch-madchen-amick-joan-chen)
17 Rodman, Howard A. '*Twin Peaks*: The Series That Will Change TV', *Connoisseur*, Sept 1989.
18 Dockterman, Eliana. 'Creators of *Lost, Fargo, The Sopranos* and Other Shows on How *Twin Peaks* Influenced Them', *Time*, May 11, 2017. (time.com/4769270/twin-peaks-lost-fargo-sopranos/)
19 *MasterClass: David Lynch*

Chapter Seven
1 Mitchell.
2 Rodley, p193.
3 Ibid, p298.
4 *Room to Dream*, p299.
5 *MasterClass: David Lynch.*
6 *Wild at Heart.*
7 Jensen.
8 Gilmore.
9 Chute (reprinted in Barney, p35).
10 *Room to Dream*, p298.

Chapter Eight
1 *MasterClass: David Lynch.*
2 Saban and Longacre (reprinted in Barney, p6).
3 Mabey.
4 Wigley.
5 *Dune.*
6 *Twin Peaks: The Return*, Part 15.
7 *Room to Dream*, p234.
8 *Room to Dream*, p323.
9 Rodley, p184.
10 *Twin Peaks*, Episode 1.5. Written by Robert Engels, directed by Tim Hunter.
11 Rodley, p185.
12 Peary, Gerald (ed.). *Quentin Tarantino: Interviews*, University Press of Mississippi, Jackson, MS, 1998.
13 Canby, Vincent. 'One Long Last Gasp for Laura Palmer', *New York Times*, Aug 29, 1992.
14 McCarthy, Todd. 'Film Review: *Twin Peaks: Fire Walk With Me*', *Variety*, May 18, 1992.
15 Andrew (reprinted in Barney, p145-146).

16 Ibid, p146.
17 Hughes.
18 *Twin Peaks*, Episode 1.3.
19 Hughes.
20 *Room to Dream*, p326.
21 Kermode.
22 *Room to Dream*, p312.
23 Powers.
24 Breskin (reprinted in Barney, p91).

Chapter Nine
1 Rodley (2005), p216.
2 Chute (reprinted in Barney, p38).
3 *MasterClass: David Lynch*.
4 Szebin and Biodrowski.
5 Mabey.
6 Jensen.
7 Ebert, Roger. 'review: *Lost Highway*', Chicago Sun-Times, 27 Feb 1997.

Chapter Ten
1 Spohr (reprinted in Barney, p163-164).
2 Ibid, p165.
3 Uncredited interviewer (2022).
4 Henry (translated and reprinted in Barney, p213).
5 Hughes.
6 Ibid, p216.
7 Sragow (reprinted in Barney, p210).
8 Maslin, Janet. '*The Straight Story*: An Unlikely Filmmaker Takes on a G-Rated Challenge', The New York Times, 15 Oct 1999.
9 Rodrigues.
10 Romney.
11 Ibid.

Chapter Eleven
1 *Catching the Big Fish*, p31.
2 *Room to Dream*, p383.
3 Powers.
4 Rodley, p281.
5 Barney, p236.
6 Ibid, p236.
7 Travers, Peter. 'review: *Mulholland Drive*', Rolling Stone, Oct 19, 2001.
8 Ebert, Roger. 'review: *Mulholland Drive*', Chicago Sun-Times, Oct 12, 2001.
9 Reed, Rex. 'A Festival of Flops', Observer, Oct 15, 2001.
10 *Mulholland Drive* DVD insert.
11 Rodley, p289.
12 *Catching the Big Fish*, p115.
13 Rodley, p287.
14 *MasterClass: David Lynch*.
15 Rodley, p287-288.
16 Snead.
17 Andrew (reprinted in Barney, p148).
18 Chute (reprinted in Barney, p40).
19 Breskin (reprinted in Barney, p81).

Chapter Twelve
1 Henry (reprinted in Barney, p221).
2 Mabey.

3 Diliberto, John. 'Abbess of the Abyss', *Amazon.com*. (Original article is no longer online, republished here: thecityofabsurdity.com/montgarticle.html)
4 Uncredited interviewer (2022).
5 *Room to Dream*, p416.
6 *MasterClass: David Lynch*.
7 Attwood and Roth.
8 Goldstein, Gregg. 'Lynch Set to Self-Release "Empire"', *The Hollywood Reporter*, Nov 16, 2006. (www.hollywoodreporter.com/business/business-news/lynch-set-release-empire-143369/)
9 Blatter, Helene. 'David Lynch turns his eye to "Inland Empire"', *WFAA.com*, Sep 3, 2006. (web.archive.org/web/20070928045413/www.wfaa.com/sharedcontent/dws/ent/stories/090406dnGLempire.64579170.html)
10 Mabey.
11 Unnamed author. 'Film is dead, long live digital movies says David Lynch', *Sydney Morning Herald*, Jan 7, 2007. (www.smh.com.au/national/film-is-dead-long-live-digital-movies-says-david-lynch-20070127-gdpc89.html)
12 Dom, Pieter. 'David Lynch Is Falling Back In Love With Film, But Keeps Movie Plans Top Secret', *Welcome to Twin Peaks*, Mar 2, 2014. (welcometotwinpeaks.com/news/david-lynch-film-top-secret/)
13 *David Lynch on Video vs. Film*, American Film Institute, May 10, 2010. (www.youtube.com/watch?v=pjtnOCfuPVQ)
14 Travers, Peter. 'review: *INLAND EMPIRE*', Rolling Stone, Nov 21, 2006.
15 Unnamed author. 'David Lynch's $1B Peace Plan' *New York Post*, 22 Oct 2003.
16 *Room to Dream*, p421.
17 *Catching the Big Fish*, p1.
18 *Room to Dream*, p505.

Chapter Thirteen
1 *Room to Dream*, p461.
2 Carroll.
3 *MasterClass: David Lynch*.
4 Greenberger.
5 Carroll.
6 *MasterClass: David Lynch*.
7 Simonini. Arguments over whether *Twin Peaks: The Return* is a TV show or a film began almost immediately, as numerous critics and filmmakers placed the show on their favourite films of 2017 lists. The debate still rages on social media from time to time, but as the above quote proves, Lynch always viewed the piece as a movie – albeit one that, for largely financial reasons, had to be screened in sections.
8 *Twin Peaks*, Episode 2.19.
9 The rule seems to be that she is Chrystabell for music, and Chrysta Bell for acting roles.
10 Wise, Damon. 'Encore: David Lynch Refuses To Explain *Twin Peaks: The Return* — "Ideas Came, And This Is What They Presented"', *Deadline*, 20 Aug, 2018. (deadline.com/2018/08/twin-peaks-the-return-david-lynch-interview-showtime-emmys-news-1202407985/)
11 From Kimmy Robertson's Facebook page: www.facebook.com/kimmyr1/posts/10152927777280000.
12 Sharf, Zack. 'Julee Cruise No Longer Cares About *Twin Peaks*, Calls the Finale "Trash" and a "Slap in the Face"', *IndieWire*, 6 Sept, 2017. (www.indiewire.com/features/general/julee-cruise-twin-peaks-finale-reaction-trash-slap-in-the-face-1201873440/)
13 *Twin Peaks*, Episode 1.3.
14 Wise (see above).

Quote Sources

15 *Twin Peaks: The Return,* Part 6.
16 *Catching the Big Fish,* p91.
17 Breskin (reprinted in Barney, p74).
18 Gillespie, Nick. 'Was David Lynch the Original Libertarian Democrat?', Reason, 11 Dec, 2006. (reason.com/2006/12/11/was-david-lynch-the-original-l/)
19 Ibid.
20 *Catching the Big Fish,* p47.
21 Wikipedia: John Hagelin (en.wikipedia.org/wiki/John_Hagelin)
22 Carroll.
23 Unnamed author. 'David Lynch Clarifies He Didn't Praise Trump, Tells Him "You Are Causing Suffering and Division"' *Frieze,* 28 Jun, 2018. (www.frieze.com/article/david-lynch-clarifies-he-didnt-praise-trump-tells-him-you-are-causing-suffering-and-division)
24 Wigley.
25 *MasterClass: David Lynch*
26 Dom, Pieter. 'David Lynch Cryptic About Carrie Page Tempting Him Into *Twin Peaks* Season 4', *Welcome to Twin Peaks*, 22 Jun, 2018. (welcometotwinpeaks.com/news/david-lynch-carrie-page-season-4-calling/)
27 Wigley.
28 Murphy, Chris. 'No, David Lynch Is Not Retiring Due to Emphysema', *Vanity Fair,* Aug 6, 2024. (www.vanityfair.com/hollywood/story/no-david-lynch-is-not-retiring-due-to-emphysema)
29 Ibid.
30 Wiseman, Andreas. 'David Lynch Is Still Hoping To Make Animated Movie *Snootworld* Which He Scripted With *The Addams Family* and *Edward Scissorhands* Writer Caroline Thompson: "It's A Story That Children And Adults Can Appreciate"', *Deadline,* 8 Apr, 2024. (deadline.com/2024/04/david-lynch-animated-movie-snootworld-netflix-addams-family-edward-scissorhands-writer-caroline-thompson-1235877710/)
31 Ibid.
32 Soteriou, Stephanie. 'You Need To Read Kyle MacLachlan's Seriously Poignant Tribute To David Lynch After His Death', Buzzfeed, Jan 17, 2025. (www.buzzfeed.com/stephaniesoteriou/twin-peaks-kyle-maclachlans-tribute-to-david-lynch)
33 Wigley.

p11 'Euphoric 1950s chrome optimism'
 David Lynch, *The Air is On Fire* interview CD
P15 'The fifties are still here. They're all around us. They never went away'
 David Lynch, *Lynch on Lynch (revised edition)*, (ed.) Chris Rodley, 2005
p16 'I like to think of myself as one of the happy generation'
 Albert Rosenfield, *Twin Peaks*, Episode 2.2
p20 'Even though I lived in fear, it was thrilling to live the art life in Philadelphia'
 David Lynch, *David Lynch: The Art Life*
p22 'Please remember, you are dealing with the human form'
 The Alphabet
p27 'Everybody has a subconscious and they put a lid on it. There's things in there'
 David Lynch, '*Eraserhead*: Is There Life After Birth?', Stephen Saban and Sarah Longacre, *Soho Weekly News*, 1977
p29 'In heaven, everything is fine'
 The Lady in the Radiator, *Eraserhead*
p35 'The word harmony would make me want to puke'
 David Lynch, 'David Lynch's Shockingly Peaceful Inner Life', *The New York Times*, Alex Williams, 2006
p41 'A dream of dark and troubling things'
 Tagline for *Eraserhead*
p45 'Surrealism is the subconscious speaking'
 David Lynch, *Ruth, Roses and Revolver*
p47 'The face of an angel'
 John Merrick, *The Elephant Man*
p51 'People are frightened by what they don't understand'
 John Merrick, *The Elephant Man*
p52 'You see this thing through the lens and you just get filled with euphoria'
 David Lynch, 'David Lynch interview: "There is something so incredibly cosmically magical about curtains"', *Time Out London*, Freire Barnes, 2014
p56 'Luck, my friend, luck. Who needs it more than we?'
 'Plumed Dwarf', *The Elephant Man*
p59 'It is by will alone I set my mind in motion'
 Piter de Vries, *Dune*
p61 'By the time you learn the game, you've already been hurt bad'
 David Lynch on Hollywood in 1990, David Breskin, *Inner Views: Filmmakers in Conversation*, 1997
p63 'Cinema can create another world. That's what's so beautiful about it'
 David Lynch, 'David Lean Lecture: David Lynch', BAFTA, 2007
p67 'I will never be yours to control'
 Paul Atreides, *Dune*
p73 'You're a mystery. I like you very much'
 Jeffrey Beaumont, *Blue Velvet*
p75 'It's like a dream of strange desires wrapped inside a mystery story'
 David Lynch on *Blue Velvet*, 'Out to Lynch', *Film Comment*, David Chute, 1986
p77 'It's a strange world'
 Jeffrey, *Blue Velvet*
p78 'I like to sing "Blue Velvet"'
 Dorothy Vallens, *Blue Velvet*
p81 'I love you, love me!'
 Dorothy Vallens, *Blue Velvet*
p91 'He put his disease in me'
 Dorothy Vallens, *Blue Velvet*

Index

Acknowledgements

Thanks first of all to John Parton, who gave the whole project a big thumbs up, and to 'it was' Laura Bulbeck, who kept it all rockin' when things got rocky. Thanks as ever to my guardian angel Ella Diamond Kahn; to Rosie, the other half of my heart; and to our beautiful monster baby Jonah Hope. Oh, you are sick ...

I was 14 years old when *Twin Peaks* rearranged everything, including my head. Thanks to my Dad, who dutifully pressed record on the VCR every Tuesday at 9pm, and to the original *Peaks* crew: Kether Fryer, Joe Humphrey, Adam Worralo, Darran Fearn, Andrew Shewan and everyone who gathered round to watch and rewatch my increasingly worn-out videotapes. *You lied to me, Colin!* Also, huge respect to Linda Fryer for marching our entire class out of school to watch the finale – I'm guessing no other teacher on the planet did that.

Then in 2010, a press release led me to email a complete stranger named Lindsey Bowden and tell her I'd do anything – literally – if she'd let me be part of her Twin Peaks UK Festival. The result was a lifelong friendship and some of the most mindblowing experiences of my life, from going up the London Eye with Michael Horse to scaring Kimmy Robertson so bad she almost fell to her death from the roof of Hornsey Town Hall. Not to mention a hug and a log from Catherine Coulson, a personal backwards-speak lesson from Al Strobel, a great big belly laugh from Kenneth Welsh, and the opportunity to see Julee Cruise sing 'The World Spins', Rebekah Del Rio sing 'Llorando', Chris Mulkey sing 'Fever' (where is Chris Mulkey, anyway?) and James Marshall sing 'Just You'.

I could write a book about the TPUK and perhaps one day I will, but for now let me just thank the people who worked so hard to make it such a beautiful experience, year upon year: Rose Thorne, Benjamin Louche and the entire Double R team (*don't let 'em rattle ya, Coop!*); the mighty DJ Yoda; Sean Berry and the Bang Bang Band: Arran Goodchild, Kyriaki Karadelis, Ian Thorn, Will Emms and Nicola Calvert; everyone who played on the Roadhouse stage, particularly Aloha Dead, The Hey Las, Thee Windom Earles and Prom Queen, who came all the way from Washington; Helen Henson; Claire Laffar; and of course all the wonderful regulars.

This book was largely researched and written in the spring and summer of 2024, before Lynch's passing the following year. Thanks to all those writers whose work I drew on during my research, to Rumsey Taylor for allowing me to recycle my own words, to Steady Eddy Frankel for advising me on the 'art stuff', to the hosts of all the wonderful Lynch fansites and to anyone who's ever uploaded a Lynch interview, TV commercial, obscure piece of music or other ephemera online – your work was invaluable. Finally, thanks to DKL himself, whose influence has resonated through every creative project I've ever put my name to. *Beautiful!*

About the Author

Tom Huddleston is an author, freelance film & TV journalist and former Q&A host at the Twin Peaks UK Festival. His books include *The Worlds of Dune*, *The Worlds of George R.R. Martin* and, for younger readers, the acclaimed *FloodWorld* trilogy. His first grown-up novel *The Cracks* publishes in 2026. He has written for publications including *Time Out*, *The Guardian* and *Little White Lies*, and currently lives in London.

The author moderates a Q&A at the 2017 Twin Peaks UK Festival with (l-r) Sherilyn Fenn, James Marshall, Amy Shiels, Jake Wardle, Michael Horse, Sean Bolger, Debbie Zoller and Sabrina Sutherland

Picture Credits